A Fable
of
Modern Art

A Fable of Modern Art

DORE ASHTON

With 48 illustrations

THAMES AND HUDSON

© 1980 Thames and Hudson Limited, London

First published in the USA in 1980 by
Thames and Hudson Inc., New York

Library of Congress Catalog card number 79–66137

Printed in Great Britain at The Camelot Press Ltd.,
Southampton, Hampshire
Bound in Great Britain

Contents

Acknowledgments

I affectionately thank the following:

V. S. Pritchett for sending me to the right place; Professor Rudolf Arnheim for his painstaking and inspired criticism and suggestions; Dr A. M. Hammacher for our fruitful discussions; Roger Shattuck for his unflagging support; Andrew Forge for his insights and encouragement; Ronald Christ for his many helpful gestures and his good talk; Adja Yunkers for his special response to Rilke; Silvia Tennenbaum for her German translating; Patrick O'Brian for our correspondence; Una E. Johnson for her enthusiasm and help; M. M. Wright of the National Gallery in Washington for aid in research; Matti Megged, for his goading and help with Rilke translations; Octavio Paz, for everything; Octavio Armand for his confidence and his publication of the Rilke chapter in the magazine *Escandalar*; Inga Karetnikova for the Russian documents on Rilke; Madame Jacqueline Sarment, Curator of the Maison Balzac for her exceptional cordiality and help; and Lester Trimble for his kind reading of the Schoenberg chapter.

Synopsis of Balzac's 'The Unknown Masterpiece'

Part I – 'Gillette'

In 1612 young Poussin arrives at the studio of Porbus, Henry IV's painter abandoned by Marie de Médicis. Simultaneously, the old legendary painter Frenhofer arrives. Young Poussin listens while the old master criticizes Porbus's painting; makes a drawing which Frenhofer praises, and is invited to breakfast at the old master's studio. There he hears of Frenhofer's secret painting, *La Belle Noiseuse*, on which he has worked ten years. Seized with the desire to learn Frenhofer's secret, Poussin returns to his young mistress Gillette and proposes that she pose for 'another', in order to assure his future renown. She weeps, but finally consents.

Part II – 'Catherine Lescault'

Three months later Porbus visits Frenhofer offering to 'lend' Poussin's beautiful young mistress in return for his letting them see his masterpiece. The old man agitatedly demurs, saying his portrait of Catherine Lescault, the courtesan known as La Belle Noiseuse, would never be submitted to the criticism of fools. At that point Poussin and Gillette arrive. Frenhofer falters, and finally consents to compare the living beauty with his painted master-piece. They go into the studio and a few minutes later Frenhofer calls in the other two painters, having determined that no live woman rivals his Belle Noiseuse. The two enter, seek the painting but cannot find it. Frenhofer indicates a painting on which they can see only 'colours piled upon one another in confusion and held in restraint by a multitude of curious lines which form a wall of painting'. Gradually they discern the only part of the painting which has escaped 'that most incredible, gradual progressive destruction' – a foot. After some polite evasion, Poussin lets slip that he can see nothing there. The old master at first submits, and calls himself an idiot and madman, but then calls them jealous, and turns them out of the studio. 'The next day, Porbus called once more at his house and learned that he had died during the night after burning his pictures.'

CHAPTER ONE

Who was Frenhofer?

I

Balzac's literary biographers scarcely mention *The Unknown Masterpiece*. From 1831, when it first appeared, throughout the rest of the century, there were scores of illustrations of characters in Balzac's works, but in all the voluminous archives of prints, there appears to be no embodiment of Frenhofer. For countless artists, nonetheless, Frenhofer was and remains legendary. That paradoxical word 'legendary' is suitable in the case of Frenhofer's renown among artists: it emerges only partway from its root – to read – and then flies off into its opposite. The fact is that many artists who found in themselves the image of Frenhofer were not altogether familiar with Balzac's text. Picasso, whose illustrations for *The Unknown Masterpiece* are celebrated, may well never have read it through; yet, as we know from his frequent references, Frenhofer excited him. Like a tenacious myth, Frenhofer gathers around his name a host of cultural meanings.

As an inspiring mythos, *The Unknown Masterpiece* accompanies the turbulent fortunes of modern art. The most dramatic reference remains Emile Bernard's memory of a certain night late in Cézanne's life when the old painter, already the solitary eccentric stoned by village boys, unexpectedly responded to Bernard's mention of Frenhofer:

One evening when I was speaking to him about *The Unknown Masterpiece* and of Frenhofer, the hero of Balzac's drama, he got up from the table, planted himself before me, and, striking his chest with his index finger, designated himself – without a word, but through this repeated gesture – as the very person in the story. He was so moved that tears filled his eyes.

Cézanne's excitedly jabbing his finger at himself, seeing himself in Frenhofer, leaves little doubt of the significance of the fable. In his turn, Cézanne has become legendary. Modern artists of great stature, such as Picasso and Matisse, revered him. What Picasso specifically admired in Cézanne was the Frenhofer in him: 'What forces our interest is Cézanne's anxiety – that's Cézanne's lesson.'

The Balzac to whom Cézanne responded so profoundly was himself endowed with boundless anxiety. Even his most persistent critics acknowledged the elemental positive force of his anxiety. Balzac spoke repeatedly, if obliquely, of his pestilential need to expend all his forces, and in several characters, most notably Louis Lambert, the great stress of ambitious anxiety results in complete breakdown. Balzac associated anxiety with the nature of

the artist. *The Unknown Masterpiece* represents one of Balzac's most intense efforts to analyse the condition of being an artist. Balzac's visual artist Frenhofer emerges from certain specific historical circumstances and reflects Balzac's experiences in the volatile Parisian art world; but, much more compellingly, Frenhofer is the archetypal artist for Balzac. His legend embraces the profound, recurrent questions that artists have always raised. Balzac took seriously the task of presenting Frenhofer's problems, as is apparent from the number of revisions of the story. It was Balzac's practice, as his contemporaries repeatedly reported, to return obsessively to all his works, making countless revisions. Gautier tells us how

Balzac would again set to work, amplifying, always adding a feature, a detail, a description, an observation upon manners, a characteristic word, a phrase for effect, uniting the idea more closely with the form, always approaching nearer his interior design, choosing like a painter, the definite outline from three or four contours.

Few of Balzac's works underwent such major revisions and dilations as *The Unknown Masterpiece* did over a period of six years. There are two major versions, the first published in 1831 and the seemingly final version in 1837, and several in between. He apparently conceived the story sometime in 1830 or 1831, probably after having read some of the tales of E. T. A. Hoffmann that first started appearing in *Mercure* in 1829. In the manner of Hoffmann, Balzac called the first version of his story a 'conte fantastique', publishing it in two brief instalments: the first, subtitled 'Gillette', on 31 July, and the second, subtitled 'Catherine Lescault', on 4 August. They appeared in the journal *L'Artiste*, which all the young artists read.

In the first version, the tale assumes its 'fantastic' dimensions through Balzac's schematic juxtaposition of three artist types, the most broadly drawn being the mad genius Frenhofer. By the time Balzac settled on his final version, Frenhofer no longer seemed unequivocally deranged. In fact, he emerges in his discourse as a credible personage, an artist Balzac created from his own artistic experience, an artist whose attributes made him instantly identifiable to Picasso, Matisse, Cézanne, Rilke, deKooning and scores of others. This Frenhofer of the final version is all the more compelling since he carries the residue of the earlier, 'fantastic' version. It seemed important to Balzac to reinforce the fantastic quality by uncharacteristically distancing his tale, which takes place two centuries earlier. All the characters except Frenhofer had existed in history. Balzac could consult documents for necessary factual backgrounds, and, inveterate researcher that he was, carefully selected a few well-known facts around which his fantasy could play. Both Mabuse, who was Frenhofer's eccentric, alcoholic teacher, and François Porbus, who was born in 1570 and would have been forty-two in 1612 when the story takes place, were recorded in art history books easily enough available to Balzac. Even more accessible at the time were numerous documents about Nicolas Poussin. In 1824 Quatremère de Quincy had published a collection of Poussin's letters in which he quotes Quintilian:

Art is not different from nature, nor can it pass beyond the bounds of nature. The light of doctrine which, by a natural gift, is scattered here and there and appears in many

men at different times and places can be reunited by art; such light is never found completely or even largely in a single man.

In addition to the recent edition of Poussin's letters, Félibien's *Entretiens sur les vies et sur les ouvrages de plus excellens peintres anciens et modernes* had been continuously in print since 1705, and Félibien had known Poussin well. In the Félibien collection, dated 1666–68, Poussin is quoted, 'Art cannot exceed the boundaries assigned it by nature'; Balzac cited this in slightly modified form in *The Unknown Masterpiece* and it was the philosophic cornerstone of his tale.

If Balzac drew upon historical documents for the framework of his tale, he drew upon his own experience as an artist, and as an artist witnessing his time, for the body of his story. Although the story takes place in 1612, the correct date for Poussin's arrival in Paris, Balzac makes his interest in the parallels clear by launching immediately into a contemporary discussion of an idea very much on the minds of the artists of his own period: the question of genius. He makes young Poussin tremble on the threshold of his encounter with the veteran painter Porbus. Poussin 'felt the profound emotion which must cause the heart of every great artist to beat fast, when, in the flower of youth, he enters the presence of a man of genius or of a masterpiece'. Balzac speaks of a noble enthusiasm and remarks that 'the man who, with slender purse and genius that is budding, has not trembled with emotion upon presenting himself before a master, will always lack a chord in his heart, an indefinable touch of the brush, true feeling in his work, a certain poetry of expression'.

Balzac's reverence for genius and 'noble enthusiasm' had been nourished by his broad reading and his encounters with the young artists of the late 1820s and early 1830s. It was not, however, unqualified reverence, for *The Unknown Masterpiece* and several other stories about artists (writers, composers, sculptors and painters) are challenging examinations of the received idea of genius. Balzac meditated constantly on the problem of genius and was not prepared to render it simplistically. He sometimes drew upon earlier discussion, as when he posed genius in a dialectical relationship to industry (an eighteenth-century habit), showing for instance that Poussin worked hard while Frenhofer squandered his art in theory spawned by his genius. But sometimes, as in the final version, he doubts the efficacy of such equations, and introduces a host of qualifying arguments.

Balzac's concern with genius in the first version reflects his general education rather than his education in art, which, as Gautier pointed out after meeting Balzac in 1836, was incomplete. That general education included the efforts of many late eighteenth-century authors to define the notions of genius and enthusiasm. Diderot in France and Kant in Germany addressed themselves repeatedly to the problem of defining genius. Diderot regarded genius as natural aptitude, and maintained that enthusiasm was the first requirement of creation. In the mature artist, however, enthusiasm gives way to imagination, skill and discipline. Kant also regarded genius as an innate natural aptitude, but in the *Critique of Judgment* (1790) warned that alone, without industry and learning, genius was of little account. When

Mme de Staël brought news from Germany, her own enthusiastic version of enthusiasm stressed emotional and instinctive perceptions. In Balzac's time Mme de Staël's warning to the French that calculation and cold reason were hazards to their moral health and that enthusiasm, or 'universal harmony', was essential, was regarded seriously.

Balzac seemed to reflect Mme de Staël's views in his first important 'philosophical' story, *Peau de Chagrin*, in which his young hero sounds a Kantian note: 'I dilated on the subject that ideas were organic beings, complete in themselves, living in an invisible universe whence they influenced our destinies.' When he embarked on *The Unknown Masterpiece*, his vision of Frenhofer was well within the traditions staked out in the eighteenth century. He uses the conventional romantic idea of noble enthusiasm, calling Poussin a 'born painter', and sketches Frenhofer within the moral framework his general education had supplied. Schematically, Frenhofer had overstepped the boundaries established for genius. His *hubris* was too great. The governing principles designed by eighteenth-century thinkers to keep genius at work, as Kant insisted, never permitted it to forget 'mechanical' aspects in any work of art. These principles were flouted by Frenhofer, who accordingly had to suffer a tragic fate.

Even in a 'philosophic' work, Balzac was fortunately able to infuse the text with the stupendously varied experiences he had managed to pack into his creative life to date. By 1831 he had many resources for vivifying Frenhofer's myth. Although he was certainly inadequately educated in modern art when he wrote the first version, he was well acquainted with its broad bases. His ear for timely conversation registered snippets of studio gossip garnered from his friend Achille Devéria, whom he had met as early as 1825 when Devéria made a watercolour portrait of him. Through Devéria and his circle of young artists Balzac learned of various discussions in the studios and knew of the great debates over classicism and romanticism. No doubt he himself had run into the same blunt questioning that his character, Lucien de Rubempré, encounters when he comes to Paris to make his name. Lucien, arriving in the mid-1820s, is asked, 'Are you a classicist or a romantic?' When Lucien betrays ignorance of the state of affairs, his mentor exclaims: 'My dear fellow, you have arrived in the middle of a pitched battle and you must take sides immediately.'

Balzac's side, as a youth in his twenties, was obviously the romantic. He circulated among the young writers and painters who eventually congregated at the home of the slightly older Victor Hugo. Hugo's acquaintances, and his future accomplices in his grand polemic gestures, included many art students who, as Gautier remarked, were equally interested in painting and poetry. 'The young art students loved literature.' Among them were Delacroix, the Devéria brothers and young Gautier himself who at the time was a student of a conventional painter, Pioult. What these young enthusiasts were talking about when Balzac knew them included the line-versus-colour controversy; Géricault's audacity in the *Raft of Medusa*, which was exhibited in 1819; Delacroix's growing disdain for academic restraints; German romantic theories as purveyed by Mme de Staël; the lessons of Goethe's *Werther* and

his *Faust*, newly translated by the young Gérard de Nerval. Many of these preoccupations are reflected in Balzac's first version of *The Unknown Masterpiece*.

Like the young artists, Balzac was much attracted to Victor Hugo, who, in the late 1820s, had managed to awe the art students. The youngest of them, the 'rapins', stood at their easels fervently discussing the issues he raised. The climax of these excited explorations of new ideas was finally Hugo's riotous opening night known as the Battle of *Hernani*, but it seems likely that it was his earlier reading of the preface to *Cromwell* to his young acolytes, including Gérard de Nerval, that shaped the character of their romanticism. Gautier tells us of the art students' response to the reading: 'Though not yet affiliated to the Romantic troop, we had already been won over in our hearts. The preface to *Cromwell* was as radiant in our eyes as the Tables of the Law on Mount Sinai, and its arguments seemed to us beyond contradiction.'

It is not hard to imagine the unruly 'rapins' revelling in the daring phrases punctuating Hugo's powerful manifesto. 'It's time to say loudly that everything that is in nature is in art.' The modern muses, he said, would see things at a glance as higher and grander, and poetry would begin to work as does nature, mixing in her creations light and shadow, the grotesque and the sublime. He attacked 'pedants' and their 'scholastic labyrinths', urging his listeners to bypass their rules. Art, he declared, leafs rapidly through the centuries, through nature; it interrogates chronicles and restores what annalists have truncated, divining their omissions. The modern poet, he told them, must even include the vulgar and trivial, for nothing must be abandoned. 'Like God, the true poet is present everywhere at once in his work.'

Such was the news in the studios of 1827. Balzac, who was frantically trying to shore up his failing printing business, had little time to frequent studios and cafés, but he always knew how to keep in touch with the slightest alterations in ambiance. He was naturally on hand for the inspiring chaos of the opening of *Hernani* on 25 February 1830, and did not fail to notice the extraordinary array of rebellious bohemian youths with their outlandish costumes, pugnacious attitudes, and exaggerated enthusiasm. In April he published an article about *Hernani* and Hugo, saying: 'his name is a banner; his work the expression of a doctrine, and he himself a sovereign.'

Many of the youths who had fought the symbolic battle of *Hernani* were on the real barricades six months later during the so-called glorious days – the three days of fighting that preceded the flight of Charles X and the installation of Louis-Philippe as 'King of the French'. Balzac was far from Paris that summer, but when he returned in September the July Monarchy was in full spate and the hopeful young had already bitterly recognized their error. Within a matter of weeks the quicker intelligences among the artists had understood that Louis-Philippe, for all his previous liberalism, was, as the caricaturists quickly declared, a philistine king. He was the accomplice of the worst bourgeois exploiters, those whom the angry caricaturists pictured comfortably ensconced in their drawing rooms congratulating themselves that the poor and the young were fighting their battles for them on the

barricades. Balzac's reaction to Louis-Philippe's treachery was couched in the language of deepest sarcasm. His printed words paralleled the fury of his friend Philippon whose caricature of Louis-Philippe as a pear brought upon his weekly, *La Caricature*, the police raiders. Balzac wrote several editorials for *Caricature* under a pseudonym. His opinion of the new regime was consonant with that of Karl Marx who later wrote that Louis-Philippe and his ministers formed a stock company, of which he was the director, for the exploitation of France's wealth. The crude grocers and ambitious pharmacists who peopled Balzac's human comedy were stockholders, forming the caste of *nouveaux-riches* that so enraged the Republican veterans of the barricades.

In the course of establishing his policy, broadly based on the slogan 'enrichissez-vous', Louis-Philippe had announced: 'As regards domestic policy, we will endeavour to maintain a *juste milieu*.' That fateful phrase was to become a characteristic epithet in the art world which, as Albert Boime has pointed out, was deeply affected by Louis-Philippe's politics. At first, Louis-Philippe's ministrations to art seemed to offer long-awaited liberalization. One of the first moves of the new regime was to placate the independent artists who chafed under the rules of the Academy. The annual Salon was opened to artists of both the romantic and classic positions, and the new landscape painters were admitted to public scrutiny. Louis-Philippe led the bourgeoisie in his initial months in office by stepping up the government's official interest in artists with commissions, and by calling attention to the positive good of keeping artists on the public payroll. The new patronage of the bourgeoisie affected artists directly and, in many cases, adversely. The public, longing to be 'modern', but finding Delacroix-influenced painters *too* modern, was only too happy to follow the bourgeois king in his taste for the *juste milieu*. A reviewer of the Spring Salon of 1831, writing in *L'Artiste*, saw a school of 'transition' forming, its characteristics being 'conscientious drawing, but not of the jansenistic kind practised by Ingres; the effect, but without everything having been sacrificed in its behalf; colour, but which will approximate as closely as possible the tones of nature, and not result from bizarre tones veiling the real with the fantastic . . .' In short, the *juste milieu*.

Balzac followed the arguments in *L'Artiste* and other journals. He recognized instinctively, and early in Louis-Philippe's reign, that the opportunistic propensities of the *juste-milieu* philosophy boded ill for art. He had had almost a year to absorb the new ambiance when he started *The Unknown Masterpiece*, and by that time the government had moved decisively to neutralize the extremes in the visual arts. The strategy was to harness the energies of the restive painters by putting them to work in the interest of the state. It was an effective policy. Even Delacroix was eager to win a commission, and others in the romantic circle did not hesitate to alter, just a little, their habitual styles in the hope of sharing in the promised prosperity and state honours. Balzac noticed all this with profound distaste. When the middle-of-the-road bourgeois began really to matter, in matters of taste, something was amiss. He sensed, as he demonstrated in many of his stories, the beginning of the fateful breach between bourgeois and modern artist, and located it in those first months of the July Monarchy.

Of the three artists Balzac selected for characterization in *The Unknown Masterpiece*, two were outcasts and one potentially an outcast. Porbus, as Balzac states in the opening lines, had been 'abandoned' in favour of Rubens by Marie de Médicis after Henry IV's assassination in 1610. His masterpiece was to be seen only 'by those self-willed individuals to whom we owe the preservation of the sacred fire in evil days'. Frenhofer, by his own eccentric choice and innate genius, is also far beyond the range of the ordinary *juste-milieu* citizen. The young Poussin is destined by his very sensitivity to a similar role. He is one of those 'self-willed' independent geniuses who finds his way to the master Porbus although the world has turned its back on its former favourite. Not one of Balzac's trio could possibly accommodate the brightly lit world of the *juste milieu*. Balzac stresses the solitary, introspective character of his artists by setting them in the chiaroscuro atmosphere of their northern contemporary – another distinctly isolated genius – Rembrandt. The studio Poussin enters is illuminated dimly by a very high skylight, leaving corners in blackness. A few stray gleams light up a cuirass hanging on the wall and an old-fashioned dresser laden with curious vessels studded with bright specks. There are heavy draperies and numerous bottles. In the dim light Balzac depicts Frenhofer, styled after Rembrandt. The first 'conte fantastique' models him as a Hoffmannesque magician: a painted Kreisler, mysterious and indefinably superhuman. There was a diabolical cast to his face, Balzac writes, and his eyes, though dim with age, were capable of 'magnetic flashes'. Frenhofer's face was 'strangely seamed, too, by the exhaustion of old age, and even more, by the thoughts that undermine body and mind alike'. The Frenhofer of the first version bears the stigma of Promethean ambitions. He is Balzac's personification of the agonies of creative life and its profound abysses, whereas in the final version he is something more than a Hugoesque fusion of the grotesque and the sublime.

II

When Balzac published the final version of *The Unknown Masterpiece* in 1837 he no longer called it a 'conte fantastique' but included it among his 'philosophic' works. If Frenhofer casts a shadow over modern thought, it is because Balzac brought to this final version enough convincing detail to make his character not simply an exemplar of the creative principle gone mad, but a plausible painter. Balzac himself offers the reason why we can still read this story with a sense of recognition: 'It is the property of a good fable that the author himself does not know all the riches it contains.'

Balzac could not foresee with what astonishment the twentieth-century reader finds a description of an abstract painting deftly rendered, nor could he have known that the issues he covered in the conversations among the three seventeenth-century painters could be cast in a modern light and offer convincing parallels. What he did know was that in revising his story he brought it into the modern world of nineteenth-century France and deliberately reflected its artistic turmoil.

Two important encounters enriched Balzac's fund of detail. By the

mid-1830s he was famous, much in demand, and frequently caricatured in the press. It was necessary, he wrote to Mme Hanska on 8 March 1836, to leave behind his habits of modesty and to have himself painted by a good artist. He surveyed the scene with some thoroughness and settled on a painter he had probably met the year before, Louis Boulanger. As a student, Boulanger had shared a studio with Eugène Devéria, whose brother Achille had made one of the earliest portraits of Balzac. Boulanger had been a twenty-four-year-old rebel from the classic tradition of David when he met both Delacroix and Hugo. Like Delacroix, he admired Titian, Veronese and Rubens, and he was eager to enter the ranks of romantic rebels led by Hugo. His great fondness for romantic literature endeared him to the writers. Hugo addressed him in a letter of 1830 as 'Ami, mes deux amis, mon peintre, mon poète'; Gautier wrote tercets on his work, and Sainte-Beuve regarded him as the best of travelling companions. (Years later, Baudelaire was to say that Hugo ruined Boulanger as a painter.) At the time Balzac encountered Boulanger, he was acknowledged as an intelligent, skilful and well-endowed romantic painter whose portraits, in particular, were excellent. The fact that, as Gautier wrote, his work was full of reminiscences of Giorgione, Titian, Guido, Ribera, Raphael, Bonnington and Lawrence did not detract from his stature.

Balzac was well pleased with his choice. Two weeks after the first mention of the portrait to Mme Hanska, he wrote to say that Boulanger had just left with the intention of making of the portrait a 'grande oeuvre'. During the next nine months Balzac continued to mention his sittings with Boulanger and on 1 December he wrote: 'there is a bit of Titian and a bit of Rubens mixed . . . You will have a work in which Boulanger has put all his forces, and for which I posed thirty days.' During the many sittings Balzac had ample time to note the techniques of an accomplished painter. He watched how Boulanger mixed his paints, how he altered the portrait from sitting to sitting, and how he built up the beautiful surfaces to impasto depths. His well-trained ear attended the language of his portrayer. Perhaps he remembered Félibien's boast of his access to Poussin: 'He made me see as he worked, by visible demonstration, the truth of the things he taught me in his conversation.' During all those months of sittings Balzac questioned Boulanger about the lively disputes in the art world. Undoubtedly he pumped Boulanger, who saw Delacroix frequently, for news of the great painter and his current opinions.

In both versions Balzac has Frenhofer take up a brush. But in 1837 he takes it up with real paint on it. The odour of turpentine pervades the final version. If Balzac's education in the technical aspects of modern painting took place in Boulanger's studio, his education in theory was enriched through his close association with one of the most important young art critics of the day, Théophile Gautier. The former art student was still closely allied to the world of modern painters though he had already made his literary sensation with the romantic novel *Mademoiselle de Maupin*, published in 1835. Balzac read it immediately and was so deeply impressed that he sent Jules Sandeau, who was his assistant for a few months in 1835–36, to inquire if Gautier would collaborate with him on his new venture, *La Chronique de Paris*.

Gautier was only twenty-four at the time, and eager to meet Balzac. He still spent his time with the young circle of poets and painters who had fought the battle of *Hernani* and was, like them, in full reaction against the stagnation, after so much promise, of the *juste milieu*.

Gautier and the other members of Hugo's band had managed to stay together for several years after the heroic evening at the theatre. Towards the end of 1831 they formed a version of Hugo's 'cénacle' and called it 'le petit cénacle'. The group was high-spirited, much given to scandalizing the bourgeoisie through their extravagant modes of dress and behaviour. In the fall of 1834, Gautier, Nerval and several others settled in the Doyenne, an old, slumlike section of Paris behind the Louvre, where they led a life Gautier later described as 'wild and truculent'. Their hair flowed over their shoulders, he wrote, like the manes of lions, and they looked 'more than Merovingian'. He looked back affectionately to this 'gypsy encampment' where he, Nerval, Arsène Houssaye and assorted others lived what he called the life of Robinson Crusoe, and where they held spectacular parties. For one of these grand affairs the rooms were painted with decorations by Corot, Nanteuil and Chassériau, among others. Gautier's allusion to the life of Robinson Crusoe was not playful. He and his friends saw themselves shipwrecked in a monstrously commercial society. The world that appeared so suddenly, and so brazenly, with the advent of Louis-Philippe deeply shocked them. Their complex attitudes, which in histories of the period are too neatly sealed off in the phrase 'l'art pour l'art', were consonant in many details with the attitude of the slightly older novelist, Balzac.

From his early youth Gautier had demonstrated a generous nature, capable of friendship and exceedingly tolerant of others who, like himself, had devoted themselves passionately to the arts. This led him to soften his judgments, and he was criticized frequently for his over-generous comments and his eclecticism. But even so acerbic a critic as Sainte-Beuve, who was certainly not notable for his generosity to fellow writers, wrote admiringly of Gautier's tact as a critic in his *Nouveaux Lundis*, and called attention to Gautier's most important basic attitudes. Sainte-Beuve cites a passage from an article Gautier had written on Casimir Delavigne, to prove Gautier's acuity as a critic despite the ostensible mildness of his writings. Gautier had written: 'In the world of art there stands always, below each genius, a man of talent, preferred to him. Genius is uncultivated, violent, tempestuous; it seeks only to satisfy itself, and cares more for the future than the present.' The man who could write this was well equipped to understand Balzac; in fact Gautier understood Balzac better than any of his contemporaries. The memoir he wrote of him in 1858 is still the most vivid account.

The memoir begins in 1835 – perhaps making an unconscious reference to *The Unknown Masterpiece* – with the young Gautier arriving with a couple of friends for breakfast. 'My heart beat violently, for never have I approached without trembling a master of thought . . .' Balzac quickly put his young friends at ease. From that day a close friendship developed between the novelist and the young painter-poet-novelist who would, eventually, call Balzac a 'seer'. Gautier was quick to recognize in Balzac what few others at

the time would grant: the tempestuous genius that seeks only to satisfy itself and cares more for the future than the present.

Given the close association formed by these two writers, and Balzac's respect for his young colleague, it seems certain that Balzac, who was thinking about the revision of *The Unknown Masterpiece*, called upon Gautier's knowledge as an erstwhile painter and art critic. Balzac now had a chance to study not just the painters' manuals and academic textbooks that were widely consulted in nineteenth-century France, but the minds and mores of living artists. Gautier suggests that he and his friends, who were at that time mostly painters and poets, educated Balzac. Their task was not difficult. Balzac had already shown a certain aptitude in his enthusiasm for their hero Delacroix. When Delacroix showed his *Femmes d'Alger* in the Salon of 1834, Balzac had longed to purchase it. Since Gautier prided himself on having written as early as 1832 of Delacroix's genius, he and Balzac got off to a good start. Fortunately for Balzac's education, Gautier was not only a discriminating art critic, but a broad-minded one. He had been sensitive enough to praise, in his Salon of 1833, not only Delacroix, but also his chief rival, Ingres. His great enthusiasms during his term as an art student had been Raphael, Teniers, Tiepolo, Michelangelo and Rembrandt (who remained a major interest). Later, as a young art critic he had been one of the first writers to recognize the deeper significance of Spanish painting – he had mentioned Goya's *Caprichos* as early as 1832 and was largely credited with impressing the public with the importance of both Goya and El Greco.

Balzac had met many painters in passing, including the King's favourite *juste-milieu* painter, Ary Scheffer, whom, as he told Mme Hanska, he had definitely resisted. But he had never had the kind of searching discussions characteristic of Gautier's circle. Until he became intimate with Gautier his general ideal in art was mystical and literary. Gautier's modifications of that mysticism were not based so much on principle, since he himself was much given to mystical formulations, as on practical considerations. He taught Balzac to look closely at works of art, and he impressed on Balzac his fundamental belief that the making of art excluded mere imitation. Long before Baudelaire, Gautier had said that nature was a dictionary, and that copying nature was 'only stenography'.

By the time he breakfasted with Balzac, Gautier's view was already well-formulated, despite his youth. He already believed, as he put it years later, that 'the painter carries his painting within himself, and between nature and him the canvas serves as intermediary'. He thought that when a painter wanted to make a landscape, it was not the desire to copy this tree or that rock or horizon that impelled him, but a certain dream of agreeable freshness, country repose, amorous melancholy: in short, an ideal beauty that he sought to translate into the language proper to him. He chided the artist who 'closed his microcosm and painted from the exterior model', and he repeatedly stressed the 'interior model'. Above all, he brought into relief the crucial role of intuition. Balzac made Frenhofer reflect this aesthetic in his obsessive adventuring into his interior vision. But, as Balzac underscored in the final version, Frenhofer lost the game when he no longer allowed the free play of

his intuition. Much of Gautier's argument can be found in the dialogue of this version. Like most romantic art students, Gautier had learned to cherish the first impulse and to trust its faithfulness to the interior vision. Since the late eighteenth century arguments for the unfinished qualities of the sketch as opposed to the excessive finish of the academically refined painting had been promulgated. By the 1830s the view had won wide acceptance. Delacroix's well-known letter on government competitions summed up the general attitude:

The artist, closeted in his studio, at first inspired by his work and buoyed by that supreme confidence which alone produces masterpieces, arrives by chance to cast his glance outward on the stage where it will be judged. He modifies it, he spoils it, he overworks it, all this civilizing and polishing in order not to displease.

More than once in his portraits of artists Balzac expressed his contempt for the painter who gives way to the crowd. In *Les Illusions Perdus* the painter Joseph Bridau reflects Delacroix. 'His friends have known him to destroy a picture because he thought it looked too highly finished. "It is too laboured," he will say, "art-school work." ' The sketch, Balzac had learned in Gautier's circle, was the germ, and a certain quality of roughness even in more ambitious works left room for the imagination. The nuance and abstraction available in the intuitive touch were highly valued. These views and their counter-arguments find ample expression in the final version of *The Unknown Masterpiece*, where the painters argue from several points of view.

The infusions of art talk enhancing the final version begin when Balzac shows the middle-aged master Porbus deferring to the impassioned criticisms of the old master Frenhofer. Frenhofer criticizes Porbus's figure of a female saint in terms that are surprisingly familiar even to painters today. She is glued to the canvas, he says, you cannot walk around her. She is a silhouette with a single face, a cut-out figure. 'I feel no air blowing between that arm and the background', he tells Porbus, sparing him little in his copious comments. He comes to the essential point – the point on which young painters of Balzac's acquaintance were quite insistent – when he characterizes the snare of the *juste milieu*: 'You have wavered uncertainly between two systems, between drawing and colouring, between the painstaking phlegm, the stiff precision, of the old German masters and that dazzling ardour, the happy fertility of the Italian painters.'

It is this 'unfortunate indecision' that hinders Porbus, Frenhofer states. The younger master attempts to defend himself, saying there are effects in nature that seem improbable on canvas, to which Frenhofer replies (in the voice of Gautier?), 'The mission of art is not to copy nature but to give expression to it.' This is one of Frenhofer's most uncompromising positions. Although in the range of his discourse Frenhofer encompasses the arguments of both the romantics and the classicists, he holds to a few principles that, given his age, distance him from the two younger painters. Perhaps because Gautier admired both Ingres and Delacroix, Balzac can have Frenhofer reflect the partisans of Ingres with their idealism when he scoffs at Porbus's mention of the 'effects' in nature. 'We have to grasp the spirit, the soul, in the features of

things and beings. Effects! Effects! why, they are the accidents of life, and not life itself.' He goes on to extol Raphael for his instinctive sense,

which in him seems to desire to shatter form. Form is, in his figures, what it is in ourselves, an interpreter for the communication of ideas and sensations, an inexhaustible source of poetic inspiration. Every figure is a world in itself, a portrait of which the original appeared in a sublime vision, in a flood of light, pointed to by an inward voice, laid bare by a divine finger which showed what the sources of expression had been in the whole past life of the subject.

Since the basic goal of independent artists in Balzac's day was the simplification of masses in favour of the effect, Balzac has Frenhofer run counter to the romantic position. The academics stressed the graded gamut of values – the half-tones – while the rebels from the academy tended to eliminate unwanted details in favour of a broad, general effect of chiaroscuro. Despite his own warm appreciation of Delacroix, Balzac apparently could not shake his earliest conviction that Raphael was the 'king of the painters' and that he was the king because he knew nothing of the rough naturalism of the romantics and only sought the ideal. Frenhofer scolds Porbus for stopping short before appearances; he doesn't 'go far enough into the intimate knowledge of form'. Unvanquished painters, he says, 'persevere until nature is driven to show itself to them all naked and in its true guise'.

To prove his point that what the painting lacks is a mere nothing, 'but that nothing is everything', Frenhofer turns up his sleeves and calls for a palette and brushes. In a scene that benefited from Balzac's thirty sittings to Boulanger, Frenhofer sets to work, muttering darkly about the poor quality of the colours. Once again Balzac conjures the old vision of Rembrandt, artfully describing the behaviour of the old painter who, 'with feverish animation', dipped the end of the brush in the different mounds of colour, sometimes 'running over the whole assortment more rapidly than a cathedral organist'. Holding forth in a running commentary, the old artist 'touched all the different parts of the picture: here two strokes of the brush, there a single one, but always so aptly that the result was almost a new painting, but a painting dipped in light'. As Balzac continues this intimate description of the old master at work his pen quickens and the Hoffmann 'fantastique' appears in the description of Frenhofer who 'worked with such passionate ardour that the perspiration stood on his bald head; all his motions were so impatient and abrupt, that it seemed to young Poussin that there must be a devil in his body, acting through his hands and forcing them to perform all sorts of fantastic antics against the man's will'. Nearing the end of his feverish performance, Frenhofer tells young Poussin, 'You see, my boy, it is only the last stroke of the brush that counts.'

Although Balzac sees something diabolic in Frenhofer's ardour, he knows artists – that is, himself – well enough to add a sequence of gradual deflation; that kind of slow drift towards depression that artists so often feel after having worked at a high pitch. Doubt, the artist's enemy, enters. This side of Frenhofer's psychic life is revealed when the two younger artists accompany him to his own studio. There Porbus tries, as he has often tried before, to get Frenhofer to show him his fabled portrait of the courtesan Catherine Lescault,

known as La Belle Noiseuse. The old man excitedly resists. He still has a few last touches, he says. The night before, he had thought he was finished, but in the morning he realized his error. With visible perturbation Frenhofer launches into a desperate peroration explaining that he has studied, analysed, dissected, layer by layer, paintings by Titian, the king of light; that he has studied shadows to the point that the shadow of flesh was not like that of other painters – wood or brass – but pure light; and in one of the most significant passages in the story, he discusses the nature of drawing:

I have not, like a multitude of ignorant fools who imagine that they draw correctly because they make a sharp, smooth stroke, marked the outlines of my figure with absolute exactness, and brought out in relief every trifling anatomical detail, for the human body is not bounded by lines. In that respect, sculptors can approach reality more nearly than we painters. Nature provides a succession of rounded outlines which run into one another. Strictly speaking, drawing does not exist! – Do not laugh, young man! Strange as that statement may appear, you will some day realize its truth. The line is the method by which man expresses the effect of light upon objects; but there are no lines in nature, where everything is rounded; it is in modelling that one draws, that is to say, one takes things away from their surroundings . . .

After continuing with a detailed description of his method, Frenhofer abruptly reminds himself of his anxiety:

But I am not content as yet, I have my doubts. It may be we ought not to draw a single line, perhaps it would be better to attack a figure in the middle, giving one's attention first to the parts that stand out most prominently in the light and to pass thence to the darker portions . . . O Nature, Nature! who has ever followed thee in thy flight? Observe that too much knowledge, like ignorance, leads to a negation. I doubt my own work!

So saying, the old man falls into a profound reverie, playing mechanically with his knife. The implications of this key speech range far. Balzac faithfully reflects the preoccupations of his widened circle of artistic acquaintances, as well as his own thoughts as an artist. The younger acolytes of Delacroix were familiar with his thoughts and knew he maintained that there are no lines in nature. Other artists of the period had also made similar observations. Goya asked, 'Where do they find lines in nature? As for me, I can distinguish only luminous and dark bodies'; to which Ingres responded, 'Where do you see touch in nature?' The challenge in the two positions lay in wait for every young painter. Balzac, however, carries the argument to its ingenious extreme when he concludes that, strictly speaking, drawing itself does not exist.

Balzac also reflects the ruminations of his friend Gautier in the suggestion that sculptors can approach reality more nearly than painters. But here Balzac was prescient, for it was not until the late 1840s that Delacroix himself could state clearly his view of the sculptor as he relates to the painter, who 'does not begin his work with a contour; with his materials, he builds up an appearance of an object which, rough at first, immediately presents the principal condition of sculpture: actual relief and solidity. The colourists, those who unite all the aspects of painting, must establish from the outset everything that is proper and essential to their art. They have to mass in with colour exactly as the sculptor does with clay, marble or stone; their sketch, like that of the

sculptor, must also render proportion, perspective, effect and colour.' In later years Gautier firmly maintained that 'la plastique est l'art supérieure'. Possibly inspired by Gautier, the important observation expressed by Frenhofer, that nature provides a succession of rounded outlines which run into each other, was to have serious consequences for Cézanne and the future of both modern painting and sculpture.

III

When Frenhofer, exhausted by his passion, falls into a profound reverie, Porbus tells young Poussin: 'He is conversing with his *spirit*.' At that word, Balzac tells us, Poussin is conscious of the pressure of an inexplicable artist's curiosity. The old painter assumes 'the proportions of a supernatural genius, living in an unknown sphere'. The spiritual argument of the fable begins here. Throughout the two parts, Balzac has woven the subtheme of love, slightly emphasizing the sensuous, earthly aspects of passion. In the first part Gillette, Poussin's submissive young mistress, is offered by Poussin as a model to Frenhofer in the hope that, through her sacrifice, he will learn the secrets of the old artist. In the second part, Gillette's unearthly counterpart, Catherine Lescault, overshadows the young, living model. This creation of the supernatural old painter is ideal, as Frenhofer sardonically points out when Gillette is first offered to him. How can a living, youthful being compare with his creation? Sooner or later, he says, Gillette will betray Poussin, while La Belle Noiseuse . . . Never! In the first version, this theme of passion assumes at least as much importance as the theme of the nature of art. In the final version, the story of the sacrifice of Gillette serves only to bring into relief Balzac's preoccupation with the spiritual. When Poussin senses that he is in the presence of someone living in an unknown sphere, we are introduced to one of Balzac's most persistent motifs: the assertion of the ascendancy of the spiritual element in true works of art.

The pronounced materialism of the July Revolution emphasized the need for such assertions. Never had French society so blatantly declared its materialistic bias, and never had artists felt the loss of the spiritual so keenly. Painters, poets, and novelists deplored the degrading conditions under which they worked. The *juste milieu* was visibly mediocre and the grand themes debased. Increasingly the most independent spirits in the nineteenth century turned their thoughts to matters of the spirit. From the 1830s on, throughout the century, there were resurgences of interest in the spiritual on the part of writers, sometimes manifested in the practice of allegory, as in the case of Flaubert, or in the actual study of mysticism, as in the case of Baudelaire and, later, Rimbaud. While Balzac and his successors cast side glances at science, and attempted to coordinate vanguard scientific thought with strands of creative mysticism, their repeated statements of anxiety centred largely on the loss of dignity of the arts through the loss of the spiritual base. The most inconsolable were the adherents of the principle of *art pour l'art*. From the beginning of the 1830s the little magazines and newspapers were filled with anxious observations that the age of individualism had robbed art of its

grandeur. The renewed vigour of the Saint-Simonians, whose mysticism did not apply to the arts (which they insisted must be 'useful'), disturbed observers in the press, and impelled them to call, as did Gustave Planche in 1835, for 'a spiritualist reaction in art'. Others, such as Heinrich Heine, avoided the embarrassing word 'spiritual', but took care constantly to remind their readers of the dangers of 'useful' art. 'You know', Heine wrote to a friend in 1837, 'that I stand for the autonomy of art which must not be the valet of either religion or politics, but on the contrary its own end, like the world itself.'

The impression of Frenhofer as registered by the young Poussin is an archetypal portrait of the spiritual artist. Poussin longs to penetrate the unknown sphere. His encounter with Frenhofer 'aroused a thousand confused ideas in his mind'. The one point that was clearly perceptible to Poussin was – and this is Balzac's most constant perception of artists – a 'complete image of the artist's nature, of the erratic nature to which so many powers are entrusted, and which too often misuses them, leading sober reason, and bourgeois intellects, and even some connoisseurs into a stony wilderness where they see nothing; whereas the winged maiden, in her sportive fantasy, discovers epics there, and castles, and works of art . . .' Thus to the enthusiastic Poussin 'the old man had become, by a sudden transformation, the personification of art, art with its secrets, its impulses, its reveries'.

In this secret world hedged by reverie, Balzac forages for meaning. From his earliest works he had pondered the nature of the creative principle, and tested it against the most varied approaches. He had scoured scientific treatises of such nineteenth-century figures as Cuvier and Lavater for an explanation of his own experience as an artist. And, just as assiduously, he had searched the horizons of the imaginative philosophers and theologians. There is hardly a work by Balzac, no matter how specifically committed to the faithful reflection of the human comedy, no matter how boldly and objectively reported, that does not have some touch, some fragment, of speculation about the deepest mystery he knew: the mystery of the created work. The secrets, impulses and reveries of art were Balzac's most insistent challenge. His search for their origins led him to consider the most extravagant explanations and to reach the very edge of a psychological abyss. '*Abyssus abyssum*,' Louis Lambert exclaims. 'Our minds are abysses which delight in abysses. Children, men, old men, are always greedy for mysteries under whatever form they present themselves.'

There are repeated allusions to the nature of the abyss in Balzac's work. He was among the first to see in its depths the positive value of what later generations were to celebrate as the 'void' or 'nothingness'. The narrator in *Louis Lambert*, who was closely modelled on Balzac himself, tells us:

I loved to plunge into that mysterious world, invisible to the senses, wherein everyone takes pleasure in living, whether he pictures it to himself under the indefinite form of the future or clothes it with the potent forms of the fable. These violent reactions of the mind upon itself taught me unwittingly to realize its power and accustomed me to the labours of thought.

Balzac, who had trained himself so carefully as an observer, made it a habit

to observe 'these violent reactions of the mind upon itself', and in his intensity prefigured the ultimate exercise undertaken by Paul Valéry in *Monsieur Teste*.

Balzac shared his attraction to the abyss with several of his more sensitive contemporaries. They all went to the same sources. The tenets of Swedenborg, for instance, were repeatedly examined by artists and writers throughout the nineteenth century, each generation finding solace or matter for extrapolation, from Balzac to Poe to Baudelaire and into the twentieth century to Kandinsky and Mondrian. But Balzac's interest in mysticism and angelism, tempered by his natural scepticism, offers a curious blend of objective notation and enthusiastic rhapsodizing. Like E. T. A. Hoffmann, whom he admired, Balzac was interested in psychological details that could illuminate the old argument over the dichotomy of spirit and matter. Both writers explored gestures, human tics, and the events occurring in sleep or half-sleep for keys to artistic behaviour. Both saw the artist as the most sensitive barometer of emotional climate, and as a fragile being always in danger from the assaults of the philistines.

In many works Balzac set himself the task of describing as precisely as possible how an artist felt and what impelled him during the crucial moments of creation. His belief in the *furor* was founded in his own experience when his imagination vaulted into the 'spaces of thought'. He checked against the experiences of close friends such as Gautier. The principal inquiry in what Balzac calls his 'philosophical' works is into the functioning of his own imagination, which he describes through various characters. Louis Lambert, destined to become insane, is overendowed with what Balzac thought of as the creative principle – as is Frenhofer. The necessary ability to observe the violent reactions of the mind upon itself is, in them, too highly developed. Before his breakdown, Lambert's capacity to imagine is clearly a reflection of Balzac's own process, always directed towards 'the spaces of thought'. There are many passages in *Louis Lambert* in which Balzac attempts to characterize the psychological experience; for example:

'When I choose,' he said in his peculiar language . . . 'I draw a veil over my eyes. I suddenly enter within myself and find there a dark chamber where the accidents of nature are reproduced in a purer form than that under which they first appeared to my external senses.'

Balzac explains that Louis Lambert's imagination was already highly developed at the age of twelve, 'either because he proceeded by analogy or because he was endowed with a species of second sight by virtue of which he embraced all nature.' The 'second sight' theory is fundamental to Balzac's aesthetic convictions. In another passage in *Louis Lambert* he elaborates:

When he thus put forth all his powers in reading he lost, in a certain sense, the consciousness of his physical life, and no longer existed save through the all-powerful working of his interior organs, whose scope of action was immeasurably extended; as he himself expressed it, *he left space behind him*.

Gautier, who wrote in his memoir on Balzac that, 'although it may be singular to say it in the full light of this nineteenth century, Balzac was a *seer* !',

stressed the importance of second sight (a concept a shade more complex than that of intuition). He cites the story *Facino Cane*, published in March 1836, in which Balzac describes his following working people in the streets and listening to their talk of the price of potatoes and the rising cost of coal:

I felt their rages upon my back, I walked in their dilapidated shoes; their desires, their needs all passed into my soul and my soul passed into theirs; it was the dream of an awakened man. To abandon my own habits, to become another than myself through this transport of the moral faculties, to play this game at will, such was my recreation. To what do I owe this gift? To a second sight? It is one of those faculties whose abuse would lead to madness: I have never sought the sources of this power; I possess it, and I avail myself of it, that is all.

In the preface to *Peau de Chagrin* he tells us that this faculty is a moral phenomenon that science finds difficult to account for. It is a power which transports poets and artists to where they must or wish to be, and which will perhaps permit them to abolish the laws of time and space.

Balzac speaks of the 'dream of an awakened man' – in short, of reverie – from his own experience. His one specifically Swedenborgian story, *Séraphita*, goes to the limit of the mystical aspect of the question, but there are other stories in which Balzac's insights are offered in less arcane terms. His Swedenborg adventure was an exercise in mysticism, an approach to the observation of the violence of the mind upon itself. Gautier claims that Balzac's phenomenal reading capacity allowed him to absorb his mother's entire set of the voluminous works of Swedenborg in a few days. André Maurois, on the contrary, says Balzac knew Swedenborg only through a French outline of his writings. It is also possible that Balzac came to Swedenborg through the writings of Charles Fourier, which in the late 1820s and early 1830s were becoming well known. First in 1803 and more definitely in 1808, Fourier had already put forward his doctrine of universal analogy, in which he likened the laws of the animal kingdom to the laws of the cosmos. Fourier's belief that he could scientifically analyse the movements of the spiritual and material worlds, and that 'human passions are animated mathematics', is reflected in numerous passages in *Louis Lambert*. Whatever Balzac's sources, in *Séraphita* he was chiefly using Swedenborg as an exemplar of the mystical principle, just as he used Frenhofer as the exemplar of the creative principle. Balzac himself said of Swedenborg, 'In reading him one must either lose one's mind or become a seer.'

In *Séraphita*, Balzac paraphrases Swedenborg so deftly that Baudelaire could lean more on Balzac than the original source for his own adventure in Swedenborgism. Balzac's paramount interest in *Séraphita* is the question of angelism. He speaks of 'the correspondences that exist between the visible and tangible things of the earthly world', and he describes angelism: 'With men, the natural passed into the spiritual, they viewed the world in its visible form and in an atmosphere of reality adapted to their senses. But with the angelic spirit, the spiritual passes into the natural, it views the world in its inward spirit and not in its form.' The correspondences that Baudelaire made so memorable were enunciated by Balzac in 1834: 'Speech is the gift of all

mankind. Woe to him who should remain silent in the midst of the desert thinking that no one could hear him; everything speaks and everything listens here below. Speech moves worlds.'

While Balzac was working on *Séraphita* he may have been thinking again of his revision of *The Unknown Masterpiece*, for in that story we find the phrase: 'like the painter who wants to put life itself on the canvas and is dashed to pieces even with all the resources of art in this vain attempt.' The old Pygmalion myth is revived and Frenhofer's two colleagues are well aware of its moral. Balzac's shift to the mythological voice is heralded by Frenhofer himself when he exclaims: 'To the abode of the departed I would go to seek thee, O celestial beauty! Like Orpheus, I would go down into the hell of art, to bring back life from there.'

With great understanding Porbus explains to the younger artist that Frenhofer is a man passionately devoted to art, 'who looks higher and further than other painters'. Yet, for all his understanding, Porbus feels obliged to give a practical critique of the older man's theory. Its chief flaw lies in the consequence: 'He has meditated deeply on colour, on the absolute accuracy of line, but he has investigated so much that he has at last reached the point of doubting the very object of his investigations.' To spare the young artist the moments of despair that led Frenhofer to insist that there is no such thing as drawing, and that only geometrical figures can be made with lines, Porbus tells him that art is, like nature, composed of an infinitude of elements, all of which can be used. However,

There is something truer than all of this; namely that practice and observation are everything to a painter, and that, if rhetoric and poetry quarrel with the brush, we reach the doubting stage like this good man who is as much a madman as a painter.

He urges Poussin to work, for 'painters ought to meditate only with a brush in hand'.

Balzac's conviction that work and works are everything is not entirely triumphant in this story. He himself never ceased to struggle with what he considered the debilitating role of thought, imagination and theory in the creative act. Doubt was just as indispensable to Balzac himself as was exhaustive work. On the one side he was convinced that excessive reflection dissipates into doubt; on the other, that no authentic masterpiece could be born without doubt. This is the essential conflict in *The Unknown Masterpiece*, and in many subsequent works of imagination in the nineteenth century. The problem of doubt is linked in Balzac's mind with the problem of abstraction. Frenhofer says that nature provides a succession of rounded outlines that run into one another, but that there are no lines in nature. The artist, then, is faced with the problem of abstracting from nature its essential forms. These, Balzac believed in an almost Platonic mode, were accessible only in that abstract realm of second sight. The abyss was infinity, feared and yet longed for by artists. 'None of your savants has drawn this simple induction', he writes in *Séraphita*, 'that the curve is the law of material worlds, and the straight line that of spiritual worlds: the one is the theory of finite creations, the other is the theory of the infinite.' (Impossible not to be struck with the

world that Mondrian and Malevich created with these very principles, almost a century later.)

Through his hunger for mystery, an artist such as Frenhofer can be tempted into other worlds, unintelligible to his confreres. Frenhofer himself recognizes this in his description to his two friends of *La Belle Noiseuse*. 'My painting is not a painting, it is a sentiment, a passion!' Porbus finds himself at a loss. Is Frenhofer sane or mad? 'Was he under the spell of an artist's caprice, or were the ideas he expressed attributable to the strange fanaticism produced in us by the long and painful delivery of a great work?' Clearly Frenhofer had gone to what Balzac called in *Séraphita* the higher abysses, 'the sphere to which meditation leads the scholar, to which prayer transports the religious mind, to which his visions entice an artist, to which sleep carries some men; for every man has his voice to beckon him to the higher abysses'. Some twenty years later Baudelaire was to identify this voice as 'modern' when he characterized modern art as reflecting intimacy, spirituality, colour and aspiration to the absolute.

The implacable thirst for the absolute made Balzac wary and he argued with himself, marshalling all his experience. He associated it with the state of trance in which an artist's highest moments occur. Yet again, he confirms his own doubts in the face of Porbus's practical suggestions and presses his notion that the artist is beside himself, outside himself, beyond himself as he creates. Frenhofer was not finally mad in Balzac's eyes, at least not incontestably mad. His view of the artist and his 'riotous nature' was always tinged with a sense of mystery he could not expunge in his own functioning as an artist. In notes for *Des Artistes*, begun in 1836, he writes of the artist:

He has recognized that he is not himself in the secret of his intelligence. He operates under the empire of certain circumstances of which the coming together is a mystery. He doesn't belong to himself. He is the plaything of an eminently capricious force . . . Such is the artist: humble instrument of a despotic voluptuousness, he obeys a master.

And:

Neither Lord Byron, nor Goethe, nor Walter Scott, nor Cuvier, nor the inventor belongs to himself; they are slaves to their idea; and this mysterious power is more jealous than a woman; she absorbs them, makes them live and kills them for her own benefit.

A few years later, in 1843, in *Les Martyres Ignorés*, Balzac reiterates the theme:

I wanted to tell you a secret: Thought is more powerful than the body; thought devours it, absorbs it and destroys it; thought is the most violent of all agents of destruction; it is the veritable exterminating angel of humanity that kills and animates, because it *does* animate and kill. My experiences have been geared to resolve this problem, and I am convinced that the span of life is in relation to the force that the individual can oppose to thought; the basis is temperament. . . . Do you know what I mean by thought? The passions, the vices, extreme occupations, sorrows, pleasures are torrents of thought.

And in *Massimilla Doni*, written in 1837:

When an artist has the misfortune to be carried away by the emotion he seeks to express, he cannot do so, because he has become the thing itself instead of being its

instrument. Art proceeds from the brain, not from the heart. When you are dominated by a subject, you are its slave and not its master.

Finally, Balzac clearly tells us his artistic intentions in his 'philosophic' works in a letter to Mme Hanska of 24 May 1837:

Massimilla Doni and *Gambara* are, in the Philosophic Studies, the apparition of music under the double form of *execution* and *composition*, submitted to the same test as *thought* in *Louis Lambert*; that is to say, the work and its execution are killed by the too great abundance of the creative principle – that which dictated to me *The Unknown Masterpiece* in respect to painting.

But were Frenhofer's ten years of work squandered? Was he suffering delusions? It is here that the wisdom of Balzac's statement that 'it is the property of a good fable that the author himself does not know all the riches it contains' is most pertinent. What has haunted the imaginations of so many artists subsequently is the climax of the fable, open to so many interpretations. When Frenhofer in a frenzied state finally reveals his masterpiece, he exclaims:

'Where is art? lost, vanished! Those are the outlines of a real young woman. Have I not . . . caught the living turn of the line that seems to mark the limits of the body? Is it not the same phenomenon presented by objects that swim in the atmosphere like fish in the water?'

But the other painters saw 'nothing there but colours piled upon one another in confusion, and held in restraint by a multitude of curious lines which form a wall of painting.'

It is this description that lingers in the memory of modern artists. Some, such as deKooning, have seen an avatar of cubism in this brief description, while others have seen in it the prophecy of totally abstract painting. Nearly everyone recognizes the peculiarly modern impulse to render the absolute, the impossible, the unknown – what Paul Klee called the prehistory of the visible.

There is yet another revelation in Frenhofer's painting. Once they have seen it as a wall of painting, Porbus and Poussin step closer:

In coming closer they noticed in a corner of the canvas the tip of a bare foot which emerged from this chaos of colours, tones, vague nuances, a kind of mist without form; but a marvellous foot, a living foot! . . . This foot appeared there like the torso of some Venus in Parian marble rising up among the ruins of a burned city.

Balzac's painting harbours the sources of the dialectical conflict of all modern painting. The presence of that foot, that living foot within the wall of paint, the web of line – the abstraction that floated Frenhofer beyond the range of communication with his contemporaries – calls up the other side of the question. Balzac says that the two younger painters were beginning to understand, but only vaguely, the 'trance' in which Frenhofer lived. We know from *Louis Lambert* that the trance was a necessary state for certain kinds of creation. In discussing the *Apocalypse* Louis calls it 'a written trance'. Yet, remembering the risks of angelism, Balzac has Porbus say, 'That marks the end of our art on earth.' Finally, Frenhofer is discovered dead the following morning, having burned his pictures.

The question, where is the picture? seems to us a modern question, and it was implicit in the dialogues of the nineteenth century. Gautier's description of Balzac's house at Jardies reminds us that for him and his circle a picture existed as much in the imagination as on canvas:

The magnificence of Jardies had slight existence save in dreams. All Balzac's friends remember having written upon the bare walls or grey paper hangings 'Palissandrian wainscotting, Gobelin tapestry, Venetian glass, pictures by Raphael'. Gérard de Nerval had already decorated an apartment in the same manner.

Victor Hugo, describing his visit to Balzac's last house, also remarks on the imaginary decor of his old abode as distinct from the final house where there were real paintings. At Jardies, Hugo remembers, there were magnificent inscriptions on the walls indicating the fictive presence of paintings by Raphael, Titian and Rembrandt. (Hugo also supplies us with the names of a few of the painters Balzac finally managed to collect, among them Porbus, Holbein, Cranach, Boucher and a Dürer portrait of Melanchthon. We also know from the sales catalogue of Balzac's widow that in 1872 there were two Chardins and two paintings attributed to Rembrandt. Some historians speculate that the paintings named in *Le Cousin Pons* may at one time have been in Balzac's collection – works said to be by Giorgione, Sebastiano dePiombo, Hobbema, and Géricault.)

Balzac's fable, or his inspiring myth, remains alive for modern art because, as Valéry intoned, 'In the beginning was the Fable!' He concurred with Balzac's view of a world without laws of time and space, the world invented by eccentric geniuses such as Frenhofer, abstract to the verge of mystery. 'What would we be', Valéry asks, 'without the help of what does not exist? Not very much, and our very unoccupied minds would pine away if myths, fables, misunderstandings, abstractions, beliefs and monsters, hypotheses and the so-called problems of metaphysics did not people the darkness and the depths of our natures with abstract creations and images.'

Frenhofer's last cogent words to his two admirers, 'one must have faith, faith in art, and live a long, long while with one's work, to produce such a creation', speak to the spiritually deprived modern soul. The necessity for myth has not retreated and certain myths are indispensable. The myth of Frenhofer's unknown masterpiece (which was unknown or unrecognized not only in the physical sense but in the moral sense as well) will continue to be astonishing and inspirational because the conundrums implicit in it are still with us. Frenhofer is the archetypal modern artist, existing in a constant state of anxiety, plagued by metaphysical doubt. He is recognizable to modern painters who have pushed beyond appearances, as Porbus says Frenhofer did, to higher and further reaches than most painters. They are regions where loneliness, or 'alienation', is the common condition; where no compromises are permitted; where there can be no *juste milieu*. Mankind, says Balzac gloomily in *Séraphita*, continues to live as it lived yesterday, as it lived in the first Olympiad, as it lived on the date after the Creation of the day before the great catastrophe: 'Doubt covers everything with its waves.'

CHAPTER TWO

Cézanne in the shadow of Frenhofer

The power of the fable of Frenhofer was unremitting in Cézanne's life. During the period when he was still exploring divergent approaches to painting, between his twenty-seventh and thirtieth years (1866–69), he amused himself by answering questions in a little eight-page booklet entitled *My Confidences*. The album, probably provided by a friend in Aix and decorated with the furbelows dear to the nineteenth-century middle classes, posed twenty-four questions of preferences ranging from favourite smells, flowers and food to favourite painters and writers. To the question: What character from literature or the theatre are you most drawn to? Cézanne had replied Frenhofer. At around the same period, he made two small sketches of a seventeenth-century artist before an easel bearing a painting of a female nude. In one of the sketches the cast of the painter's head suggests that Cézanne was thinking of Rembrandt, while in the other, the painter indicates his painting to a young onlooker who might well have been Poussin. *The Unknown Masterpiece* was on Cézanne's mind.

He was even more powerfully drawn to the Frenhofer fable in his old age. If he could identify himself with Frenhofer with such overwhelming emotion as he did in the scene reported by Emile Bernard, it was evidently a culmination of a lifetime of serious attention to the story. In his own complex nature Cézanne bore traits of all three of the painters Balzac had portrayed. Like Poussin he had been intrepidly rebellious in his youth. Later, he had learned the importance of direct experience, as had the middle-aged Porbus. Finally, like Frenhofer, he had secretly committed himself to an impossible ideal – to what he had called, in a letter to Monet, the 'chimerical pursuit of art'. Of these three painters, it was Frenhofer to whom Cézanne was most drawn, as he said in the album, and whose example he most feared. Frenhofer's excessive idealism, so familiar to Cézanne, was to be a constant warning; a worrisome tendency in himself that he watched with anxiety. Cézanne not only saw himself in Frenhofer, but he also registered the arguments in Balzac's fable as poles or referents to which he returned throughout his life. He easily understood Balzac's depressing comment that doubt covers everything with its waves. To the question in the album: What is your greatest aspiration? he answered 'certainty'. But doubt was his lifelong companion, and it was that aspect of his personality that permitted later generations to recognize him as a thoroughly modern artist. Picasso identified the Frenhofer in Cézanne when

he told us, 'It's not what an artist *does* that counts, but what he *is*. Cézanne would never have interested me a bit if he had lived and thought like Jacques Emile Blanche, even if the apple he painted had been ten times as beautiful. What forces our interest is Cézanne's anxiety – that's Cézanne's lesson.'

Many writers have echoed Picasso's observation but have offered different explanations of its source and meaning. To the frequent suggestion that Cézanne was anxious to discover the underlying structure of forms, Meyer Schapiro responded that we must see what is there. Too much stress on the invisible structures distorts Cézanne's anxious quest for an accurate rendering of what he saw. Gauguin, on the other hand, was convinced that Cézanne was a mystic: 'Look at Cézanne, that misunderstood man whose nature is essentially mystical and oriental . . .' Gauguin instinctively seized upon the Frenhofer conflict when he wrote to Pissarro: 'If he discovers the prescription for compressing the intense expression of all his sensations into a unique procedure, try to make him talk in his sleep.' Schapiro sees Cézanne as a man in whom 'the self is always present, poised between sensing and knowing, or between his perceptions and a practical ordering activity, mastering its inner world by mastering something beyond itself'. Gauguin saw him as a mystic seeking, like an alchemist, a unique synthesizing procedure. Both views hold, for the highest forms of paradox functioned in Cézanne. If, in the end, he seemed to have achieved the balance Schapiro perceived between sensing and knowing, he himself was never convinced. His early encounter with Frenhofer remained paramount. The tempted idealist hovering on the brink of the abyss was as much a part of him as the workmanlike painter of the motif.

Cézanne's irregular development as a painter was one of the sources of his anxiety. His restlessness, his wild exploratory tendencies, his unwillingness to adopt the received ideas of his day were traits that he recognized early and fretted about, as we know from his letters. At the same time, he recognized that his character, his 'temperament', was his richest resource. Much of his behaviour as a young painter newly arrived in Paris can be attributed to the strong experiences of his adolescence which, in Cézanne's case, always seem to have been vivid in his memory, and always served him as goads in his later years. Those experiences included not only the active life of the rambling romantic schoolboy foraging among the rural splendours of Aix with his friend Zola, but also the contemplative life of the reader. Cézanne was an attentive, serious reader to whom the significant phrases that had moved him in his youth returned again and again in his life. He was not, as the French like to say, *bête comme un peintre*, but rather sought confirmation of his temperament in a wide spectrum of reading. When very young he had been stirred by the poetry of Victor Hugo and Alfred de Musset, the romantics who were the modern poets of his time. But he was also an enthusiastic Latinist, reading Lucretius and Virgil and trying in his own voluminous schoolboy verses to capture Virgil's style. When he discovered Baudelaire he recognized his greatness, and throughout his life reread both the poetry and the essays.

Cézanne's periodical returns to texts that were once important to him are well documented, not only by those to whom he spoke in casual conversation, but in his letters. In 1896 he reported that he was rereading Virgil and Lucretius. In the last year of his life he wrote to his son that he was rereading Baudelaire's *L'Art Romantique* and remarked, 'one of the great ones is Baudelaire'. When he experienced intense moments of unhappiness Cézanne often retrieved quotations; after falling in love with his mother's maid in 1885, he remembered Virgil's 'Trahit sua quemque voluptas'. Those who had more than a passing acquaintance with Cézanne always marvelled at his ability to quote long passages from the ancients and to recite entire poems by Baudelaire. Given his serious attention to what he read as a youth, it is reasonable to assume that *The Unknown Masterpiece*, to which he referred so often in conversation, had engraved itself deeply on his mind. The voices of the generation that Balzac had so deftly recorded entered Cézanne's spirit and participated in his own acute argument with painting and nature.

When an experience cut deep with Cézanne, as happened so often in his adolescence and youth, he kept it alive. As a boy in Aix, for example, he had been attracted to a painting in the museum attributed to Louis Le Nain called *The Card Players*. Late in life, he himself undertook to paint the subject in several versions, and was still talking admiringly of Le Nain to Bernard in 1906. When he saw Manet's *Déjeuner sur l'herbe* and his *Olympia*, he was sufficiently disturbed to undertake parodic variations of both paintings, and referred to Manet's works frequently all the rest of his life. In his conversations with young painters at the end, he often referred to the shock Manet had administered, both to Cézanne himself and to the establishment. Sometimes he spoke mockingly, but most often with a respect that indicated the powerful impression Manet had made on him.

Of all his encounters with paintings during his early years in Paris, it was his experience of Delacroix that most moved and challenged him. The vision of Delacroix both as painter and as meditator on painting never dimmed for Cézanne. The palpable reflection of Delacroix in Balzac's fable strengthened his commitment. Cézanne was no fool, as he was fond of reminding his correspondents and acquaintances. He knew quite well that the ideals Delacroix represented had given way before the vigorous assaults of the newly selfconscious avant-garde – first, Courbet's assertions concerning realism and then the Impressionists themselves, among whom Cézanne occasionally located himself. He was well aware that, as Baudelaire had said in *The Painter of Modern Life* and other works, an artist must be 'modern' and he fully accepted the principle. But the example of Delacroix, and his attitudes towards painting, some of which Cézanne found reflected in *The Unknown Masterpiece*, were congenial to Cézanne's temperament, which could not be satisfied with the materialistic emphases of his own epoch. Nurtured in the romantic tradition, with its confused but nonetheless principled point of view, he was loath to part with the fundamental ideals no matter how often he made forays into the 'modern' view.

During the turbulent early years in Paris when Cézanne wavered between a violent romanticism and the more 'analytic' (as Zola called them) attitudes of

1 A sheet of scribbles by Balzac (c. 1825), containing inscriptions, accounts, sketches, and possibly a self-portrait at the bottom. (Collection Lovenjoul)

2 *A sketch of Balzac by Delacroix, c. 1834. (Collection Lovenjoul)*

3 *An oil portrait of Balzac (1836) by Louis Boulanger, an artist who was in the centre of the romantic movement. (Musée de Tours)*

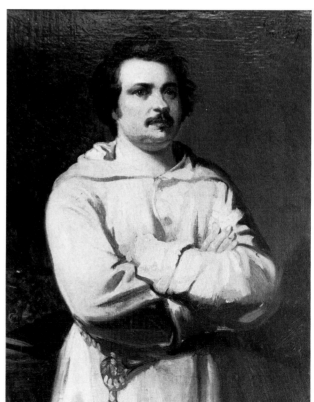

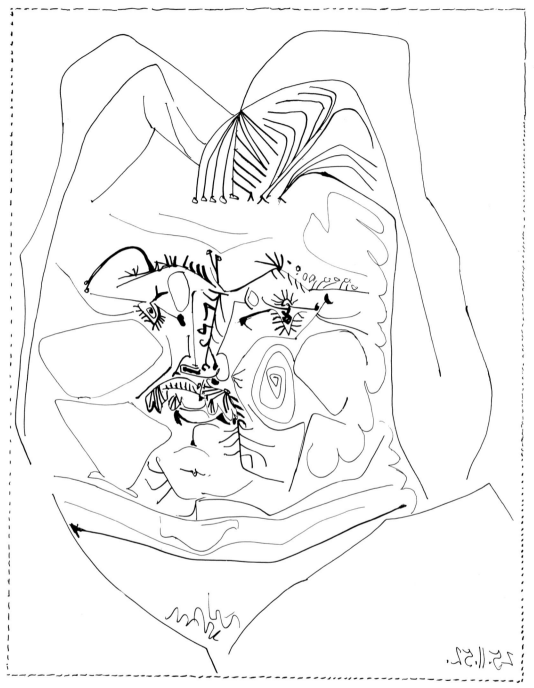

4 Head of Balzac by Picasso, 1952; lithograph printed in black. (The Museum of Modern Art, New York, Abby Aldrich Rockefeller Fund)

5 *Cézanne,* Bather on the Rock, *one of the paintings which illustrate Cézanne's admiration for the work and ideas of Delacroix. (Chrysler Museum at Norfolk, Va., Gift of Walter P. Chrysler, Jr.)*

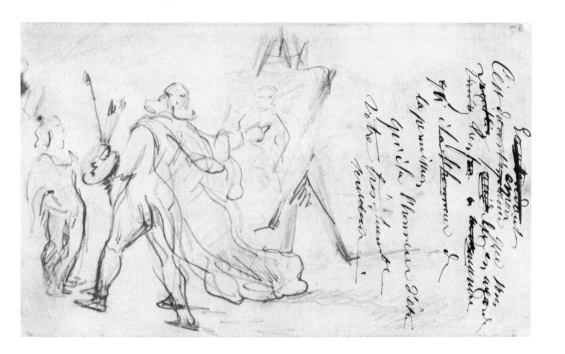

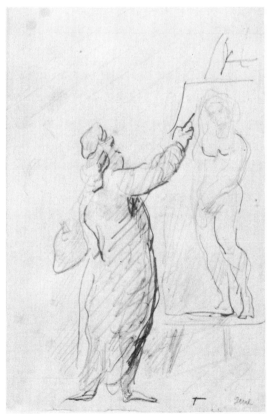

6,7 Two pencil sketches by Cézanne, the one referred to as 'Frenhofer showing his work' and the other as 'The Painter', but suggesting that Cézanne had Rembrandt in mind. (Kupferstichkabinett, Kunstmuseum, Basel)

8 Cézanne sketches for an illustration to a poem by Baudelaire, 'Une charogne'. The violent poem made a lasting impression on the artist and was in tune with his preoccupations during the 1860s. (Cabinet des Dessins, Louvre)

9 *Cézanne's painting of a murder (1870) is another example of the dark, emotional turmoil of his early years. (Walker Art Gallery, Liverpool)*

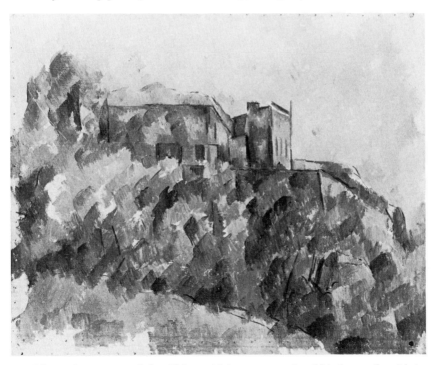

10 *Cézanne's painting of the Château Noir, an example of his late style with its characteristic rhythm of shapes and broad expanses. (Private collection, Berne)*

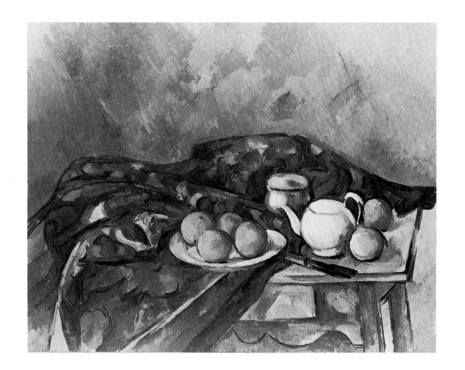

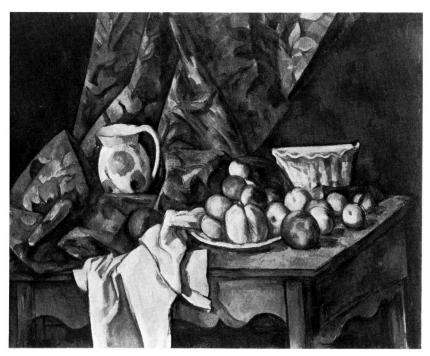

11,12 Two late paintings by Cézanne: Still-life with Teapot *(1896–1900) and* Still-life with Apples and Peaches *(c. 1905), in which he can be seen to be 'realizing' his spatial 'sensations'. (National Museum of Wales, Cardiff; National Gallery of Art, Washington, D.C., gift of Eugene and Agnes Meyer)*

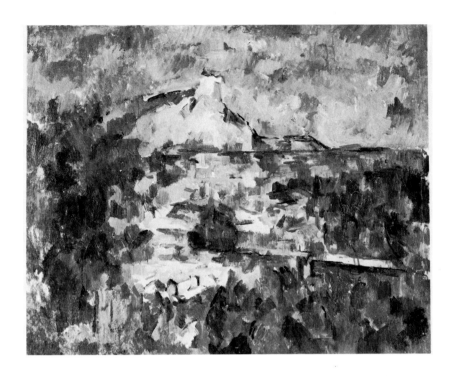

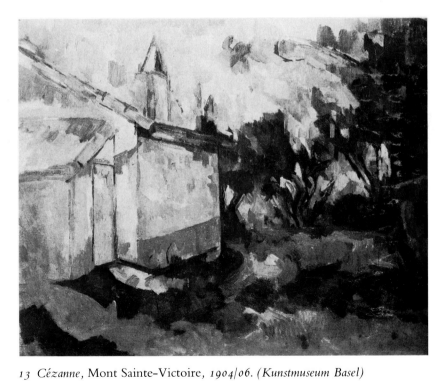

13 Cézanne, Mont Sainte-Victoire, *1904/06. (Kunstmuseum Basel)*

14 Cézanne, Le Cabanon du Jourdan, *1906. (Collection Riccardo Jucker, Milan)*

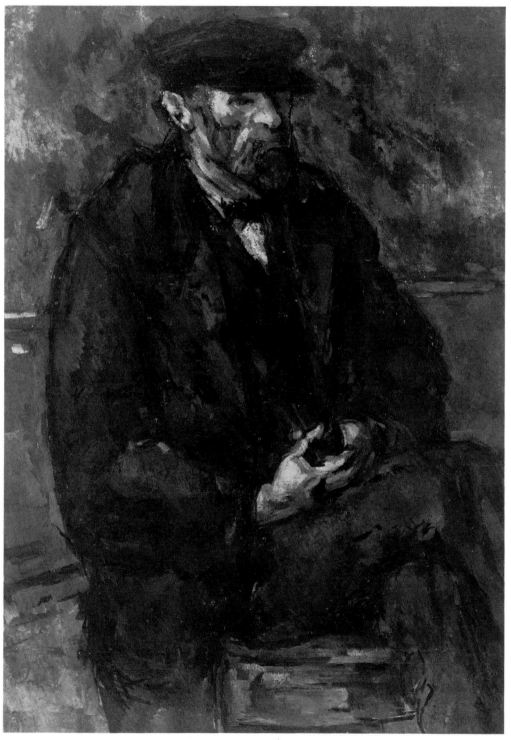

15 Cézanne, portrait of the gardener Vallier, c. 1905. (National Gallery of Art, Washington, D.C., gift of Eugene and Agnes Meyer 1959)

16 Rodin's monument to Balzac, 1898. (National Gallery of Victoria, Melbourne)

17 Rodin: a nude study of Balzac, c. 1891–92. (Musée Rodin, Paris)

18 Rodin's head of Baudelaire, 1898. Baudelaire and Dante were the two literary figures who most affected Rodin's intellectual life. (The Solomon R. Guggenheim Museum, New York)

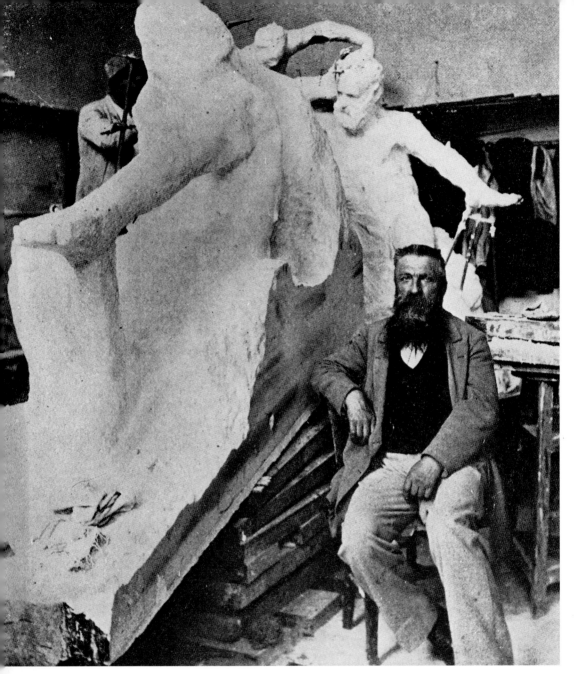

19 Rodin in his atelier in 1905. It was here that Rilke first visited the sculptor in 1902. (Photo Roger Viollet)

20 One of Rodin's most famous sculptures, The Hand of God, *1898. (Musée Rodin, Paris)*

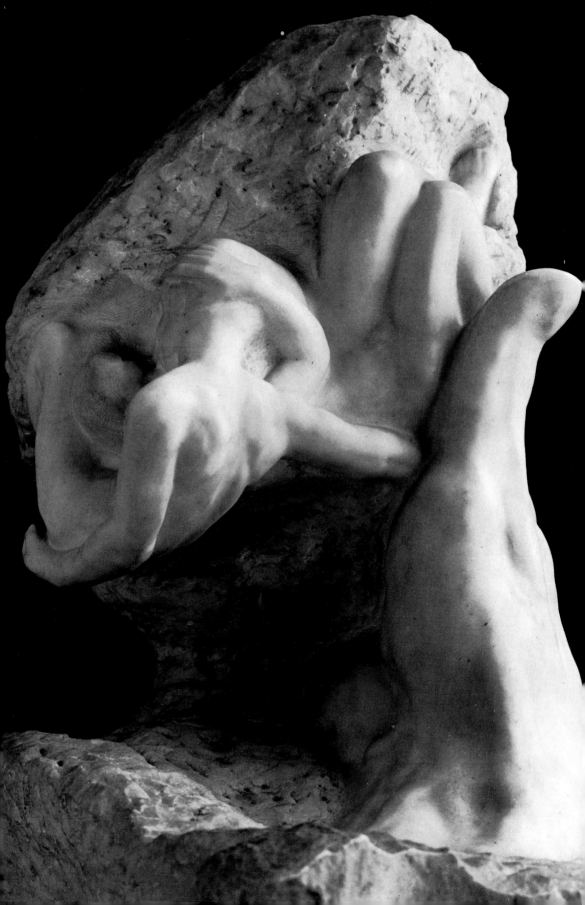

21 Paula Modersohn-Becker: Self-portrait with Camellia. *Rilke met this artist and others of the group at Worpswede in 1900. (Folkwang Museum, Essen)*

22 Paula Modersohn-Becker's portrait of Rilke, 1906. (Private collection)

23 *Tolstoy and visitors at his house in Yasnaya Polyana, 1908. Rilke called on him here during his 1900 tour of Russia. (Photo Novosti Press Agency)*

24 *Rilke (third from left) with Lou Andreas-Salomé, who introduced him to Russia in 1899.*

25 *Rilke with the village poet Spiridon Drozhin in Russia in 1900.*

his contemporaries, he strengthened his conviction that only 'temperament' could propel an artist. His special notion of temperament, born in a turmoil of emotional responses to life and to painting, was quite out of keeping with the spirit of his youthful colleagues. They also used the term, but far more conservatively. For Cézanne, temperament was identified with an elemental force – the force that Balzac's generation flatly referred to as genius. In his student years in Paris, Cézanne's 'temperament' expressed itself in the strange, troubled, expressionist fantasies he painted with so much agony. His 'temperament' led to his rejection at the Académie des Beaux-Arts where the examiner reported, 'He paints riotously', an adjective Balzac had used about Frenhofer. Tenebrous scenes, such as the scene of murder in which the violence is underscored by the use of deep blues and blackish clouds, seemed to Cézanne to express his temperament during the 1860s. The ideal of temperamental force, which, although reshaped during his mature painting years, always came first for Cézanne, made him remark to Guillemet: 'Don't you think your Corot is somewhat lacking in temperament?' Cézanne believed, as he often said, that the painter has to have 'quelque chose dans l'estomac'. The image of Frenhofer, gripped in his passion to realize a vision, was Cézanne's. He was as eager to reject the accommodations of the *juste-milieu* mentality as any of Balzac's heroes and he did it, often, by means of deliberately coarse language. The most frequently reported phrase used to fend off sycophantic admirers would be equivalent to 'a painter has to have balls'. Even if, during the months he spent with Pissarro at Pontoise in 1871 and 1872, Cézanne found a means of calming his eruptive temperament by applying the disciplines inherent in Pissarro's impressionist method, he never relinquished his original vision of the driving force, the dynamic and irresistible aspect of temperament which he would later try to reconcile with the need for what Rilke called 'work of the hand'. The conflicts so urgently described in *The Unknown Masterpiece* were intense in Cézanne's youth and revisited him in his last years.

Cézanne was in his late twenties when he did little sketches presumed to be of Frenhofer. During the same period (1866–69), he sketched illustrations for his other supremely important reading experience – Baudelaire's poem in *Les Fleurs du Mal*, 'Une Charogne'. The poem – one of the most violent, searing images in Baudelaire's entire œuvre – was to remain with Cézanne. In his old age he sometimes recited it to youthful admirers, always with emotion. It is not difficult to understand Cézanne's initial response to the poem. Preoccupied as he was during those years with fearful visions, the grotesque description in Baudelaire's poem of a rotting, maggot-ridden carrion in the hot sun would have excited him. His little sketch of a rather dandyish top-hatted young man (Baudelaire himself) gingerly poking the carcass with his cane, while a young woman leans away, shielding herself from the stench, shows his interest in coming to terms with such monstrous experiences. But there was more for Cézanne in Baudelaire's poem. Certainly the opening stanzas, with their sharp juxtaposition of a beautiful summer morning and the sudden view of 'a filthy carrion . . . legs in the air, like a lascivious woman, burning and sweating poisons', appealed to Cézanne's

sense of melodrama during those early years. The mordant realism in the description, on the other hand, satisfied the general feeling Cézanne shared with his contemporaries that the old romantic poetry was too remote and refined, lacking, as he might have said, 'quelque chose dans l'estomac'. In his earlier reading of the poem, perhaps the almost vindictive tone of the poet who addresses his companion as his soul, his angel, but nonetheless concludes by reminding her that she, too, will one day be such putrid ordure, spoke to Cézanne. A certain savage tone that recalls Baudelaire's had invaded one of his own verses. On the back of a sketch for his *Homage to Delacroix*, probably around 1875, he had echoed Baudelaire's acrid ironies in a scrawled verse:

> Here is the young woman with rounded buttocks
> How nicely she stretches out in the middle of the meadow
> Her supple body, splendidly extended.
> The adder is not more sinuously curved.
> And the beaming sun gently casts
> A few golden rays on this lovely meat.

Yet Baudelaire's poem, as Cézanne certainly knew later, was important in another more philosophical sense. The message of Victor Hugo, relayed through *The Unknown Masterpiece*, was that everything in nature, even the grotesque, must be reckoned with by the artist. Baudelaire confirms Hugo's attitude, but goes further. In a stanza which must certainly have commended itself especially to Cézanne, Baudelaire, after having described the teeming world of flies and larvae in the horse's belly, a world which 'gave out a strange music, like flowing water and wind', continues:

> The forms faded and were no more than a dream,
> A sketch slow to come
> On the forgotten canvas, and which the artist completes
> Only by memory.

In his later years, these lines probably summoned for Cézanne his struggle with both nature and the nature of painting. Once having perceived the forms – all those minuscule details among which Cézanne foraged for the essences – he too found his sketch slow to come. Painting quite often struck him as no more than a dream, or 'chimerical'. All the while, during his middle period, when he was painstakingly developing his method, restraining his hand and peering at nature until, as he said, his eyeballs seemed afire, he bore the dark lesson of 'Une Charogne' in mind. His alternately exalted and disconsolate remarks late in his life could well have resolved themselves in Baudelaire's final line: 'I have kept the form and the divine essence of my decomposed loves.'

Finally Baudelaire's insight, and Cézanne's, deposited them in that realm sometimes called objective, in which an heroic and unflinching gaze at the unthinkable results in a transcending vision of the universe. While Cézanne's vision was intensifying during the last years, the young poet Rilke was reacting similarly. In *The Notebooks of Malte Laurids Brigge* he wrote about Baudelaire and 'Une Charogne': 'What should he have done after that happened to him? It was his task to see in this terrible thing, seeming to be

only repulsive, that existence which is valid among all that exists. Choice or refusal there is none.'

Cézanne's need, not only to gaze at the world unflinchingly, but also to compose a vision of the universe, separated him from his contemporaries, and at times threw him back – with anxious glances – to the past. He continually checked himself against the past, sensing the limitations of late nineteenth-century attitudes. Aside from his sustained reverence for Delacroix and the Venetians, Cézanne frequently expressed interest in scores of painters of the past. He was consistently attracted to the ideas that had dominated the period in which Balzac wrote *The Unknown Masterpiece* and adjusted his reactions to his own times with judicious salvaging from the romantic past. The attitude of the major artists of the Impressionist movement during the 1870s and 1880s was one of irritation against the numerous epigones who had managed to make a *juste-milieu* Impressionism. Monet and Renoir grumbled, and Degas said, 'They are flying with our wings.' Cézanne, who was always jealous of his independence, distanced himself. Although he remained grateful to Pissarro who had so generously prompted him, he had already embarked on his quest in which the ideals of the previous epoch were to be sustained. Not only did he continue to scan the work of the painterly Venetians and little masters of the Netherlands, but he also noted carefully the romantic or expressionist tendencies in French painting of his period. 'He often talked of the caricaturists Gavarni, Forain and above all Daumier,' Maurice Denis said. 'He liked the exuberance of movement, relief of muscular forms, impetuosity of hand, bravura of handling.' In his arguments with both realism and Impressionism, Cézanne held in mind the emotional alternatives.

Cézanne's heroic spiritual development was as dramatic as the substance of Balzac's fable. For Cézanne, the great problem was to avoid the sin of pride (abstraction) which was yet implicit in his temperamental urge to the absolute. Frenhofer's *hubris* was a frightening warning to Cézanne, who nonetheless deeply respected the obsessions that motivated Frenhofer. The lesson of real-life Poussin, repeated by Porbus, was never to pass beyond the bounds of nature, and Cézanne was convinced of the fateful truth of that dictum. Yet the aging Cézanne, as he tremblingly indicated to Bernard, was also Frenhofer. There are innumerable quotations from Cézanne himself both about practical or technical painting matters and about moral attitudes which echo Balzac's text. When the young Léo Larguier visited him in 1900 and dined in the austere dining room in which, he said, there were no bibelots, no special amenities, he reported that Cézanne spoke only of his 'perpetual torment', and that many of his remarks about his work seemed paraphrases of Frenhofer.

Remarkable parallels can be found between Cézanne's position on drawing and Frenhofer's impassioned lecture. Frenhofer says the human body is not bounded by lines and that, strictly speaking, drawing does not exist. 'The line is the method by which man expresses the effect of light upon objects; but there are no lines in nature, where everything is rounded; it is in modelling that one draws . . .' Larguier quotes several similar comments by Cézanne:

To the degree that one paints, one draws. The precision of tone gives at once the light and the modelling of the object.

Line and modelling don't exist. Drawing is a rapport of contrasts, or simply the rapport of two tones, black and white.

Pure drawing is abstraction. The drawing and the colour are not distinct, everything in nature being coloured.

There are still more startling correspondences between Frenhofer's theory and Cézanne's. One of Cézanne's most frequently cited letters to Bernard points out that in an orange, an apple, a ball, a head, there is a culminating point and this point is always, despite the tremendous effect of light and shade and sensation of colour, the closest to our eye. Frenhofer, after his initial lecture on drawing, says: 'It may be we ought not to draw a single line, perhaps it would be better to attack a figure in the middle, giving one's attention first to the parts that stand out most prominently in the light . . .'

Bernard quotes Cézanne:

There is no such thing as line or modelling: there are only contrasts. These are not contrasts of light and dark, but the contrasts given by the sensation of colour. Modelling is the outcome of the exact relationship of tones. When they are harmoniously juxtaposed and complete, the picture develops modelling of its own accord.

And in the same passage Cézanne's words recall the final words of Frenhofer's lecture on drawing: 'Observe that too much knowledge, like ignorance, leads to negation.' Cézanne: 'One must eschew the literary spirit which is so often divergent from the true voice of painting: the concrete study of nature in order not to get lost too long in interminable speculations.'

Porbus's calm voice also prompted Cézanne. Porbus had told young Poussin: 'There is something truer than all of this; namely, that practice and observation are everything to a painter, and that, if rhetoric and poetry quarrel with the brush, we reach the doubting stage like this good man who is as much a madman as a painter.'

Not only technical matters in *The Unknown Masterpiece* point to its significance for Cézanne; there are also temperamental commitments. Cézanne's early recognition of Delacroix's genius may well have coincided with his reading of the Balzac tale. How deeply he revered Delacroix is apparent in the story of his encounter with Victor Choquet around 1875 or 1876. Choquet owned some twenty canvases by Delacroix, and innumerable watercolours. He invited Cézanne to see his collection, and spread the watercolours on the floor. Cézanne, we are told, wept with Choquet over them. Although Cézanne was frequently reported to have wept in his last years, a trait which commentators attributed to his obsessive work habits, his isolation and his illness, he had always had the gift of deep emotions. The important moments of insight in his life were always accompanied by uncontrollable emotion. He was given to excesses of despair, during which he destroyed his canvases or threw them into his garden. He often took flight abruptly, either from social gatherings, or from intimate conversations. The story that he wept over Delacroix's watercolours while he was still in his vigorous thirties, is perfectly credible. His long admiration for Delacroix was

expressed frequently all through his life, and he cherished his project – never completed – of painting an Apotheosis in homage. When Vollard presented him with a Delacroix watercolour of flowers in 1902, Cézanne carefully preserved it from the sunlight, and set about making a sensitive copy in which he sought to capture the shapes and light contrasts in the manner prescribed by Delacroix himself. (In his late versions of *Bathers*, the principles of Delacroix, who often used the flowing draperies in his figure studies as independently expressive structural elements, are still predominant. Cézanne uses trees and water rather than draperies, but the shapes are still the dominating components.) Cézanne's feeling for Delacroix was probably stronger than his feeling for Poussin, the other voice in Balzac's fable, but his respect for Poussin's grandeur remained. When he said he would do Poussin after nature he spoke from a long meditation, beginning with his copies of Poussin in the Louvre and bolstered by his readings. He certainly seemed to know Poussin's dicta, if not directly, then reflected in Balzac's story, and he continued copying from Poussin even in his old age when he worked from photographs in his studio on studies from Poussin's *Shepherds in Arcadia*.

His copies after Delacroix and Poussin often reflect Cézanne's ambivalent attitudes towards the role of effects and accidents. Frenhofer had scornfully denounced the young painter's insistence on effects, which he called the accidents of life and not life itself. He says that Porbus stops short before appearances and doesn't 'go down far enough into the intimate knowledge of form'. Cézanne, with his painstaking scan of details, carefully avoided the large generalizations that made for effect, and sought instead the kind of unity that Frenhofer described with his brush, as it 'touched all different parts of the picture'. Bearing in mind the dangers of Frenhofer's absolutism, and repeating often, as he did to Camoin in 1903, that contact with the great masters was important but 'we must hasten out and by contact with nature revive within ourselves the instincts, the artistic sensations which live in us', Cézanne nonetheless reserved a part of himself for Frenhofer's strongest message – that the whole of the painting is a greater spiritual entity than its parts. He wrote to Camoin in 1904: 'What you must strive to achieve is a good method of construction . . . Michelangelo is a constructor, and Raphael an artist who, great as he may be, is always tied to the model.'

Frenhofer's practical remarks remained with Cézanne. The preoccupation with the unity of the painting is epitomized in Frenhofer's criticism of Porbus's female nude which is 'glued to the canvas', a silhouette with a single face, a cut-out figure. One couldn't walk around her. The 'air' which came to mean so much to Cézanne is implicit in all Frenhofer's remarks. (Cézanne: 'But nature, for us men, is more depth than surface, whence the necessity of introducing in our vibrations of light – represented by reds and yellows – a sufficient quantity of blue to give the feeling of air.') Frenhofer's own conundrums became Cézanne's. On the one hand, Frenhofer firmly believed that the mission of art was not to copy nature but to give expression to it. On the other, he pressed even further than the expression to an absolute statement beyond the appearance of nature. His beclouded abstraction, with only the perfect foot to remind us of the appearance of nature, stands for Cézanne's

own conflicting drives. Cézanne's formation as a nineteenth-century man included the notions of earlier thinkers concerning the organic, instinctive role of the artist who, as he said, 'must create work as an almond tree its blossom or a snail its slime'. His basic respect for modern ideas about man as a part of nature is tempered by an old notion, close to Balzac's, that the artist is somehow, in his role as interpreter, more than nature. 'Anyone who wants to paint should read Bacon', he told Vollard. 'He defined the artist as *homo additus naturae*.' Implicit in his method was the idea of attention – an attention so intense that it transcended the object. Poussin had pointed out that there are two ways of looking at objects: one is quite simply to see them, the other is to consider them with attention. And Picasso had understood the nature of Cézanne's attention when he said, 'If Cézanne is Cézanne, it's precisely because of that: when he is before a tree he looks attentively at what he has before his eyes; he looks at it fixedly, like a hunter lining up the animal he wants to kill. If he has a leaf he doesn't let it go. Having the leaf, he has the branch. And the tree won't escape him . . .' Yet such attention, as Cézanne knew with his 'perpetual torment', can be drastically transformed into a kind of abstract reverie where the artist is no longer sure of what he has before him or how it is to be transformed by his eye and hand. In his last years, surely, Cézanne's doubts assailed him at every step. The old arguments became more insistent and at times he must certainly have feared that he had truly become Frenhofer. At that moment when he tearfully designated himself Frenhofer to Bernard, who was Frenhofer to Cézanne?

For all his belief in Porbus's opinion that a painter should meditate only with the brush, Cézanne remained a spiritually uneasy man. Like Frenhofer, he was a man of doubt, 'searching higher and further'. His need to reconcile discrete elements and to create a totality is obvious in his last paintings, in which his emotional intensity, moving from fearful darkness to the light of his 'realization', brings him to the threshold of the Baudelairean conception of universal correspondences. In his last years, Cézanne sought increasingly to realize relationships of real things – that is, in their materiality – in terms of their myriad relationships, or correspondences. Drapes corresponded to mountains, skies to waters, walls to skies. In the end, all forms for Cézanne were there only to be related, or realized. In his late paintings of the Château Noir, the equation of sky to ground is deliberately emphasized by bringing the greens of the foreground into the sky. The version in the Jacques Koerfer collection has a rhyming scheme of both colour and shape that courses over the entire canvas. Details such as foliage, tree trunks, windows merge in the tapestried surface while the precious 'air' that Cézanne so highly valued circulates in literally empty spaces where the white of the canvas elides the forms. This painting led Adrian Stokes to rhapsodize:

Certainly this Château Noir picture and some of the last landscapes of Mont Sainte-Victoire display the original Dionysiac, stubborn fire at the height of Apollonian splendour. In the representation of the steeply-treed château capped by the summit of Mont Sainte-Victoire, we may feel there are present the potent domes and deep-set grottoes of an ageless romance.

Stokes's invocation of the Dionysiac element in Cézanne's final years, with its suggestion of struggle towards the light of Apollonian splendour is most appropriate. Not only was Cézanne recasting his vision of the universe in the late works, but he was struggling with the paradoxes Frenhofer had succumbed to. His self-sustained idealism, which never permitted him to forsake the notion that there was a 'higher and further', led him to conceive of paintings themselves as descriptive of a universe in which all is related and held within a rhyming scheme that transcends even vision. The 'deep-set grottoes of an ageless romance' that Stokes found in the Château Noir painting appeared everywhere, even in the late still-lifes. The mysteries that all painters experience when they try to place forms, or objects, in the illusionary space of painting, when they try to locate the distances from here to there, emerge in these tremendous late works. The metaphors are complex. In *Still-life with Teapot* (Cardiff) the low horizon, the long waves of the rug supporting the still-life course against a low horizon like the sea. The same figured rug in the *Still-life with Apples and Peaches* becomes a host of forms. It is like a rampart, like one of the abstract draperies in Delacroix's paintings, as it moves against the crepuscular light of the background. Above all, it forms a deep grotto or nest isolating the pitcher in its own imaginary space, and it tunnels back as the fruits recede into a deep space. The vast distance between pitcher and bowl is filled with darting allusions. Seeking the depths, the Dionysiac fire, as Stokes says, Cézanne had stepped beyond the limits of his intense observation, making a universe that was more 'real' in its idealism than anything he could have achieved during his middle years. No doubt when he spoke of 'realizing' his sensations he felt as did his model, Delacroix, who pointed out that 'What are most real to me are the illusions that I create with my painting. The rest is shifting sand.'

There are numerous testimonies from his old age supporting this interpretation of Cézanne's use of the word 'realization'. Among those who reported on his struggle with his vision was the young Joachim Gasquet who, although often considered unreliable in his transcriptions of Cézanne's conversations, can probably be believed in his description of Cézanne's gesture characterizing the realized image. Cézanne held his hands far apart, very slowly brought them together, linked them, folded them tightly and said: 'This is what we must reach . . . there mustn't be a stitch too loose. . . . If I have the least distraction, the least obstruction, above all, if I interpret too much one day, if a theory today brings me something that contradicts that of the day before, if I think while painting, if I intervene, Bang! Everything falls apart [*fout le camp*].' Here again, the ideal goes back to an earlier epoch. Cézanne's notion that a painter's temperament would lead him to a direct experience of completion in which theory would not intervene was an old romantic ideal: the kind of ideal Balzac envisaged, the kind of ideal Delacroix had in mind when he spoke of the 'native' painter and said that Rembrandt was perhaps more 'natively a painter' than Raphael. Cézanne recognized, at the end, that paint, its materiality, was a means of unravelling his confused sensations. 'At the present time', he wrote to Gasquet (*c.* 1896), 'I am still searching for the expression of those confused sensations that we bring with us at birth.'

His search in the last decade brought him back to his earlier perceptions, but they were now intensified. His attitude towards colour, for instance, shifts perceptibly in the late landscapes. Where, before, an orderly succession of light tones moved rhythmically across his surface, in the late works there are deeper sonorities and more concern with chiaroscuro contrast. Just as he told Maurice Denis in 1906 that he was finding the same contrasts in the Delacroix bouquet Vollard had given him as he found in Veronese's *Marriage at Cana*, so he now found contrasts in the valleys, woods and mountains that had never been so pronounced, or so abstract, and yet had never before resulted in such an emphatic overall harmony. This ideal had been posited by Delacroix, and had confronted Cézanne all his life. Baudelaire had frequently discussed colour in terms that Delacroix had initiated, and his conclusions were not far from Cézanne's own:

Let us suppose a beautiful expanse of nature, where there is full license for everything to be as green, red, dusty or iridescent as it wishes; where all things, variously coloured in accordance with their molecular structure, suffer continual alteration through the transposition of shadow and light; where the workings of latent heat allow no rest, but where everything is in a state of perpetual vibration which causes lines to tremble and fulfils the law of eternal and universal movement . . . According as the daystar alters its position, tones change their values, but, always respecting their natural sympathies and antipathies, they continue to live in harmony by making reciprocal concessions . . . for with Nature, form and colour are one.

To reach the state of harmony, despite the maddening shifts he observed from moment to moment when he was painting *sur le motif*, Cézanne increasingly resorted to non-descriptive, or abstract means. In *Mont Sainte-Victoire seen from Les Lauves* (Basel) he masses his strokes in the foreground where the valley is inflected with the shadows of dark greens and violets. These masses, with their occasional detached vertical strokes, move upward as though in a flux of their own to the crest of the mountain. There, there is an absence, a floating ambiguous air of no form, which concedes to a sky in which the blues and greens of below resume their pulsating above. Undoubtedly the endless ambiguities here (the illusion of depth checked by the immediacy of the overall pattern of tones) were reflections of Cézanne's intense gazing. For him to rid himself of doubt, he could only reach the kind of attentive trance that Balzac had considered the optimal creative condition – the trance that was a form of second sight. His instinctive mistrust of the tricks of intellectualism spared him much, but on the other side was his mistrust of the frivolous acceptance of mere appearances. In Frenhofer's example he sought the mystery of total attention which he hoped would transport him to the realm of unity. His obeisance to 'temperament' and to primary force led him to admire those artists who, like Frenhofer, could remain solely within the dream of their ongoing work.

In a way Cézanne had his own Frenhofer in his friend, Adolphe Monticelli, with whom he professed so much affinity. Monticelli, whom Cézanne probably met around 1879 when he himself had definitively retreated to the south of France, had once been a painter of very successful rococo fantasies in pre-war Paris. After the Franco-Prussian war, Monticelli had returned to his

native Marseilles where he remained an eccentric recluse until his death. In his Paris years Monticelli had been something of a dandy described by a contemporary as a Titian out of its frame, but when he returned to Marseilles he took up a Bohemian life. Although he still loved opulence he no longer bothered to make money and lived in reduced circumstances. His attic room was small, with a purple curtain, a bed, an easel and two chairs. Here he painted his Venetian scenes and Watteau-inspired fêtes in the glowing impastos so much admired by Cézanne, who believed that Monticelli knew arcane secrets of grinding paint. Monticelli loved opera and gypsy music and, in the evenings, would hurry home after a performance, light all the candles and hasten to paint his impression. 'I give myself the luxury of placing fine notes of colour on my canvases; a rich yellow and a velvet black give me supreme pleasure.' Cézanne sought out Monticelli frequently and they were said to have made painting expeditions together during which Cézanne recited Virgil. Cézanne's references to Monticelli were always admiring. Monticelli, he said, had temperament.

Monticelli's total absorption in his world of dream tableaux was a compelling example. Cézanne felt close to Monticelli's spirit – the spirit of the celibate resisting the world. Monticelli's abjuration of the Paris art world, and his Frenhofer *furor* to paint, could be related to Cézanne's memory of the three painters in Balzac's fable. The attitudes Balzac had juxtaposed were fused in an eccentric such as Monticelli who adamantly remained within the ideals of his youth, as did Cézanne, in the last analysis. Cézanne held Balzac's contradictions in his memory when, for instance, he described how the intervention of a theory could spoil a day's work. He reflects the early nineteenth-century regard for 'enthusiasm' which embraced the notion of intuitive quickness, direct response and organic development. From Goethe's advice that painters should paint, not talk, to Gautier's theory of the artist as pure plastician, the romantic view of the artist as the unmediated creator prevailed. Cézanne never forgot Frenhofer's single-minded devotion to his ideal and his priestly rituals. In his old age he often referred to the sacrifices the true painter must make in terms of everyday life, and in this, too, he held to his youthful ideals. In *My Confidences* he had cited as his favourite lines of poetry Alfred de Vigny's refrain in 'Moïse':

> Lord, you have made me strong and solitary
> Let me sleep the sleep of the earth.

Vigny's sober vision of Moses, lamentably remote from the possibilities of ordinary life, yet charged with carrying on towards a promised land he knows he cannot enter, seems to have moved Cézanne throughout his life. Vigny's Moses is a parable of the artistic outcast, strong in his artistic will, and alone, as the early nineteenth-century poets invariably saw him. Cézanne saw himself as a tragic Moses at times, and posed the rhetorical question at the end: will I be permitted to enter the promised land or will I be like Moses? Cézanne's familiarity with the Old Testament would have reminded him that the Lord tells Moses he shall *see* the promised land with his eyes, but shall not go thither. Fearfully he contemplated a fate such as Frenhofer's.

Balzac could not have known that in the composite of the three painters in *The Unknown Masterpiece* he described the burgeoning of the modern attitude towards painting in which the fundamental stress was to be on process. The shift in the nineteenth century from the theoretical assessment of painting to the psychological, registers in Cézanne's method, which was as paradoxical as Frenhofer's own. Merleau-Ponty perceived Cézanne's paradox as his wanting 'to depict matter as it takes on form, the birth of order through spontaneous organization'. Schapiro sees Cézanne's procedures similarly as the registering of successive perceptions in which form 'is in constant naming and contributes an aspect of the encountered and random to the final appearance of the scene, inviting us to endless exploration'. But these assessments could be valid only if the other dream – the dream of a constructed ideal – is taken into account, and if Cézanne's own notion of temperament were considered. Like Frenhofer, who spent ten years on his vision, Cézanne spent more than ten years on his *Bathers* and never felt he had completed it. Again and again he returned to the large canvas, sometimes, like Frenhofer, feeling he had 'confirmed his theory' in the working; sometimes feeling he had made an heroic failure. Working only from memory, Cézanne faltered and doubted. But he also felt onrushes of despair as he confronted nature itself and acknowledged the eternal divergence between the rendition of his sense impressions and his perception, or mental image. The profusion of psychological encounters, as he gazed outward, often seemed to Cézanne beyond comprehension. He suffered in his methodical process of trancelike scanning from the chaos of successive perceptions. The troubling problem of choice never diminished. Yet he held fast to his philosophic premise that the world in its overwhelming diversity was nonetheless reducible to a universe in paint. His empirical process constantly led him beyond empiricism.

In his last year Cézanne wrote to his son:

Here on the bank of the river the motifs multiply, the same subject seen from a different angle offers subject for study of the most powerful interest and so varied that I think I could occupy myself for months without changing place, by turning now more to the right, now more to the left.

This phenomenon of successive perceptions as an organic process by which we form a relative image had been in the making long before Cézanne made it his own, but it remained for him to articulate it in paint. In poetry Coleridge and Shelley, Baudelaire and Rimbaud had already possessed the relative idea. In architecture, as the architectural historian Peter Collins has pointed out, the phenomenon of parallax, 'the apparent displacement of objects caused by an actual change in the point of observation', had long been known:

In ordinary experience this means, for example, that as one rides in a fast car, distant objects seem to be travelling at the same speed as the car relative to, say, nearby trees or poles which line the road. In architecture it means that as one moves through or past a colonnade, the columns not only appear to change position relative to one another, but also appear to change position relative to whatever is perceived through them or behind them.

Modern architecture, Collins suggests, exploits the effects of parallax which had always been used by architects, but with a view which Collins brings out

through a curious reference to Spengler's *Decline of the West*. A typical late romantic, Spengler draws together the most high-pitched observations of his aestheticizing German predecessors (many of whom had impressed the literati of Balzac's generation):

There is one and only one soul, the Faustian, that craves for a style which drives through walls into the limitless universe of space, and makes both the exterior and the interior of the building complementary images of one and the same world feeling . . . The Faustian building has a *visage*, not merely a façade.

The drive for the 'same world feeling' can be felt in Cézanne's late works. His rocks, trees and houses have visages. Increasingly, he felt their imperceptible structural affinities and sought, with surfaces and shapes, an analogue. In his late studies in watercolour of the rocks above the Château Noir, Cézanne felt his way among the seemingly unlimited possibilities of vision, finding metaphorical allusions. He could satisfy his craving for order in remarking the horizontal formations of the greater blocks of stone, and he could satisfy his old need for the baroque in the curving irregularities of his rock wall. But he went further. He explored the bizarre effects of inverted weights. His rocks sometimes seem suspended in space, or ascending with the lightness of balloons. They sometimes recall the convex forms of the buttocks in his bathers, and sometimes they dissolve in a system of lights and shadows. Like the oranges and apples, they submit to laws invented by the painter himself, laws which no longer, in the late works, derive solely from the experience of seeing, but also from the poetic ideals Cézanne always retained. During the long years of study in which he had learned to adjust forms to accommodate his psychological observations and had made the leap into composite perspectives (usually called 'distortions' in the work of the 1870s and early 1880s), he had sought 'complementary' images. In the late works, the 'one and the same world feeling' dominates, and prompts Cézanne to adhere faithfully to a principle of minute, additive perceptions recorded while his imagination held steady the vision of the whole.

To the first question in *My Confidences* asking about his favourite colour, Cézanne had replied, 'general harmony'. To the question, what seems to you the ideal of earthly happiness?, he had answered, 'to have a *belle formule*'; and to the question, what do you consider nature's masterpiece?, he answered, 'her infinite diversity'. In these replies Cézanne affirmed his solidarity with the generation Balzac described. The search for an abstract unity or harmony that would somehow show itself through the hieroglyphs of nature remained for Cézanne the worthiest ideal. Restating his position in a letter to Roger-Marx in 1905, Cézanne refers to his ideal of art as 'a conception of nature', which was his ultimate goal. The *conception* of nature is not nature itself. In building his compositions, he was building a philosophy, a view of the world, a method of decoding the universe. He told Gasquet, 'Everything we see is dispersed and disappears. Nature is always the same but nothing remains of it, nothing of what we see.' He felt increasingly that, with his temperament and his conception of nature, he could restore the continuity, the underlying harmony, without sacrificing 'the appearances of all its changes' – the paradox

which he never ceased trying to resolve. When he painted the rocks, fissures, caves, dells, forest enclosures, nests (those cavities containing the pots and fruits in his still-lifes, for instance), he sought their opposite in the spaces which could not be contained in objects alone. 'Always it is the sky, the things without limits that attract me,' he wrote to Victor Choquet. The marked stress on complex rhythms in the late works shows him searching out an absolute metaphor. If he had been a poet it would have been understood that he would seek his self in terms of interior rhythms, of 'breath'. As a painter, Cézanne undertook a similar quest. His hand would find its rhythm, which would reflect the interiority of his way of apprehending the visible world. It can be felt in those early works in which his baroque love of the curvilinear led him to expressionist excess, and it can be felt in the late work, with its grouped down-strokes coursing across the surfaces.

In his determined resistance to the ideas of his time – the naturalism his friend Zola had broadcast, and the scientific aspirations of the Impressionists – Cézanne conceived himself in a different, earlier tradition. Finally, he expressed in paint what various poets and philosophers had posited in words: the notion of universal analogy, with its concomitant principle of reciprocity. From Fourier, whose first rule was absolute doubt and whose doctrine of universal analogy must have nourished Baudelaire's, to Balzac, who found his source in Swedenborg, to Cézanne's contemporary, Mallarmé, French thinkers had kept the idea alive. Cézanne cherished Baudelaire's 'Une Charogne' for its bitter and definitive exposition of the doctrine. The dissolution of living matter which is transformed again into living matter was an experience Cézanne knew first-hand. 'Everything we see is dispersed and disappears.' Only Baudelaire's poem and Cézanne's paintings – his 'realizations' – could arrest the universal flux. Cézanne's conclusion on this score is explicit in his watercolour studies of skulls. To him as to everyone else they represent mortality. But more important, they are his parallel to 'Une Charogne'. In the *Three Skulls* (Art Institute of Chicago), the flowered rug on which they are grouped is deliberately rendered with the same shapes as the hollows in the skull. Flowers and cranial cavities are finally in a rhyming scheme, a system of analogy that is endowed at its core with his meaning.

To use the term 'a system of analogy' is not to say that Cézanne ceded to the finality of a system, or even that he had at last, as he had yearned, found a *belle formule*. But increasingly towards the end of his life he yielded to the impulse of abstraction. His sense of drama reasserted itself and he expressed his vision in the teetering rocks at Bibémus quarry, in the shivering trees and turbid skies adorning Mont Sainte-Victoire. In the end the world finally began to resemble his feelings, his deepest, most tremulous feelings, and after all the years of prudent restraint and careful checking, Cézanne would find the visual equivalent to Goethe's mysterious announcement that 'naught is inside, naught is outside/For what is within is also without'. In his very last paintings, particularly the watercolour study and oil of *Le Cabanon de Jourdan*, what Baudelaire would have called the 'musicality' of the painting is its most prominent trait. Cézanne renders the trees in a hectic vibrato that echoes rhythmically through the sky. He rhymes door and chimney, path and sky.

He eliminates, through the use of broad blocks of colour, his customary wealth of foreground detail in favour of the abstract whole. The chimney, like a tower, points into the sky, but its base is curiously eroded by an emphatic patch of blue – the environment dissolving the object or solid form (an idea Matisse later developed in such paintings as *The Piano Lesson* where the tangible space of the room invades the boy's cheek). Despite the suggestion that air and light can make a solid like a chimney give way, the abstract character of the musical beat triumphs. Totality or harmony, Cézanne's early ideal, is achieved.

Here he posits a universe, and it is a universe that has a curiously spherical shape. The certitude Cézanne sought would gradually reveal itself in his conception of nature, which he thought of in terms of *rondeur*. He had always remembered Frenhofer's lecture, in which he said that 'Nature provides a succession of rounded outlines that run into one another', and he had trained his eyes to discern the roundness in nature to the degree that he said his vision was concentric. But towards the end, the convexity that he found wherever he looked in nature was no longer tied to specific shapes, but became his ideal vision of the world – an abstraction. He had sensed his way to Pascal's idea that 'Nature is an infinite sphere, whose centre is everywhere and whose circumference is nowhere'. Even though he had earlier rendered optical effects such as the apparent entasis in a solid such as a table leg, or a wall, which he felt to be endemic to perception, Cézanne in his late years began to fuse his forms for a total, slightly convex effect, as though to reflect the nature of the earth itself. He entered a painterly metaphysics – what Gaston Bachelard called the phenomenology of roundness. Bachelard defines this sense of roundness as a cosmicizing action, and says of certain poets that they know 'that when a thing becomes isolated, it becomes round, assumes a figure of being that is concentrated upon itself'. He cites one of Rilke's *poèmes français* as an example of cosmicizing poetry:

> *Arbre toujours au milieu*
> *De tout ce qui l'entoure*
> *Arbre qui savoure*
> *La voûte des cieux.*

> Tree always the centre
> Of all that surrounds it
> Tree that feasts upon
> Heaven's great dome.

Bachelard comments that the imagination of roundness follows its own law; 'The world is round around the round being.' Rilke's tree 'propagates in green spheres a roundness that is a victory over accidents of form and the capricious events of mobility'.

When Balzac describes young Poussin's response to Frenhofer's exalted speeches he writes that, for Poussin, 'the old man had become, by a sudden transformation, the personification of art, art with its secrets, its impulses, its reveries'. Many young artists similarly felt Cézanne's presence during his last years, and sensed that his reveries were now of paramount importance. In the

late works, a strong tendency to flatness, or a screenlike character, appears, much as spaces are condensed in dreams. Cézanne's reverie articulates itself in such paintings as *Bend in Forest Road* where the tapestried blue of sky, inflected with the crenellated rhythm of an ambiguous rampart, filters down through a wall of vertical trees to the sun-flecked, bending (but strangely up-tilted) road. This screen of sky, trees and light is in turn rounded off and given that slight convexity that Cézanne told his son he perceived in all bodies in space. The painting conforms to Bachelard's insights, and typifies the abstracted, dreaming gaze of the old Cézanne. His meditations, at the end, brought him intimations of a parallel world. He had deferred to Frenhofer's vision of an intimate knowledge of form: unvanquished painters, Frenhofer had said, persevere until nature is driven to show itself to them all naked and in its true guise. Cézanne had found its true guise, as he wrote in 1897 to Gasquet: 'Art is a harmony which runs parallel with nature.' He was quoted as having said, 'The landscape thinks itself in me, and I am its consciousness.' (A curious parallel to Rimbaud's 'on me pense'.)

If there is always, in Cézanne, a complex and not easily discernible web of emotions, the late brooding quality visible in certain paintings must not be separated from a lifetime of nervous meditations. He was a man of passion, and passion, as Balzac indicated in the important fable of Frenhofer, overtakes, consumes, but also builds. Cézanne's romantic faith, layered over the years, bursts forth at the end. But so do questions, and feelings of deep uneasiness. He had shown signs, early in his career, of being preoccupied with death and violence. He dealt with mortality in fear and trembling, but also with a cool curiosity about himself as artist. At the end he wrote to his son: 'I see the dark side of things.' The dark side of combat, of love, of intimations of the universe, of space itself, found expression in the heaving forms and rhythms in the late paintings. He said he would do Poussin after nature. In the end, he did Poussin after his *own* nature. He agreed on the one hand with Balzac: 'I am convinced that the span of life is in relation to the force that the individual can oppose to thought; the basis is temperament.' And he could not, for all that, banish thought as the underlying principle of all art. These flourishing emotions can be read in the portraits of Cézanne's last year. The three paintings called portraits of the gardener, Vallier, are surely spiritual self-portraits. In them Cézanne returns to the palette of his youth – deep bottle greens, blues and earth colours. The sitter wears a visored cap that shadows brooding eyes, eyes that suggest the dark, inward reveries Cézanne might have observed both in Rembrandt's self-portraits and in the figures that Baudelaire discussed in Delacroix's paintings, or might have remembered from *The Unknown Masterpiece*.

If the transfixed eyes in these late portraits can be read, they speak of Cézanne's perpetual anxiety, his fear as he neared, again and again, the abstract abyss.

Now being old, nearly seventy years, the sensations of colour which give the light are for me the reason for the abstractions which do not allow me to cover my canvas entirely nor to pursue the delimitations of objects where their points of contact are fine and delicate; from which it results that my image or picture is incomplete.

46

This letter (to Bernard, in 1905) has been variously interpreted but remains ambiguous. In the late paintings there are in fact many white passages indicating that Cézanne's idea of the 'passage' had altered over the years. When he first speaks of the 'passage' he seems to mean the gradation of light tone as the eye follows the curving contours of an object and reaches its limit in a vibration of air. Later the 'passage' takes on the connotations of an abstract system. In the last watercolours, the shaped white absences are necessary abstractions. They are the vision, the ideal, held in the imagination as the hand and eye seek equivalences. The tension between idea and act, always important to Cézanne and maintained deliberately, finds resolution in these absences lighted by both the mind and the hand. 'Everything,' he wrote to Camoin in 1903, 'especially in art, is theory developed and applied in contact with nature. . . . This is the most honest letter I have yet written to you.'

And yet, he could see himself as Frenhofer, and tremble as he sensed that he neared an absolute. Many of his last letters suggest that he stubbornly persisted with his empirical method only because he felt himself moving closer to the impossible ideal that had rendered Frenhofer helpless. When he was rereading Baudelaire, and painting the free and emotional late works, did he seek out the passages in which Baudelaire echoes the implicit warning in *The Unknown Masterpiece*? Such passages as:

By modernity I mean the ephemeral, the fugitive, the contingent, the half of art whose other half is the eternal and the immutable . . . This transitory, fugitive element, whose metamorphoses are so rapid, must on no account be despised or dispensed with. By neglecting it, you cannot fail to tumble into the abyss of an abstract and indeterminate beauty, like that of the first woman before the fall of man.

and

But just as there is no perfect circumference, the absolute ideal is a *bêtise*.

and

Absolute, eternal beauty does not exist, or rather, it is only an abstraction skimmed from the general surface of different forms of beauty. The particular element in each form of beauty comes from the emotions and as we have our own particular emotions, we have our own form of beauty.

Like Frenhofer, Cézanne had begun with convictions drawn from his culture and struggled thereafter to make his experiences and his principles coincide. Frenhofer's tragic error always stood before him, and he never reached his dearest hope – the hope of certainty.

CHAPTER THREE

Rilke in search of the uttermost

I

If Balzac's Poussin was a fictional evocation of unseasoned genius, the young Rainer Maria Rilke was its living embodiment. His letter to the 'dear Master' when he was commissioned to write a monograph on Rodin recalls Poussin's mood when approaching Porbus. Rilke, announcing his forthcoming arrival in Paris, addressed Rodin on 1 August 1902:

It is the most tragic fate of young people who sense that it will be impossible for them to live without being poets or painters or sculptors, that they do not find true counsel, all plunged in an abyss of forsakenness as they are; for in seeking a powerful master, they seek neither words nor information: they ask for an example, a fervent heart, hands that make greatness. It is for you they ask.

A published author and poet, Rilke nevertheless thought of himself as an aspirant poised for a decisive encounter. His pilgrimage to Paris answered the same need to submit to a powerful master as had guided the steps of Poussin. Rilke had read *The Unknown Masterpiece* years before and, in the days when he was courting his wife Clara Westhoff, he had described it to her. But it was not until 1907, and then only by having passed through the experience of knowing Rodin, that Rilke felt the full impact of Balzac's fable.

Rilke had a way of speaking of the decisive events in his spiritual life as 'turnings'. Each of his signal experiences had had long preparation, as had his meeting with Rodin, and each left a lasting spiritual trace. Two years before his death, Rilke reiterated the importance of Rodin in his life: 'I had the good fortune to meet Rodin in those years when I was ripe for my inner decision and when on the other hand the time had arrived for him to apply with singular freedom the experiences of his art upon everything that can be lived.'

The ripening experiences culminating in Rilke's first visit to Rodin's studio had begun with his extraordinary liaison with Lou Andreas-Salomé. This powerful Russian woman, whose life had already included a chapter of intimacy with Nietzsche, and whose intellectual energy was a source of admiration for many men of genius (the last being Freud), had taken young Rilke in hand when he was a twenty-one-year-old student. In the Spring of 1899, Rilke accompanied her and her husband on his first visit to Russia, a trip he never ceased to recall with the same youthful wonder he had experienced then. Rilke's heightened response to Russia has given rise to many speculations about its source. Some have suggested that his Prague childhood, where he had sympathized with the Slavs who were disdained by

the German bourgeoisie, had prepared him for the overwhelming experience. Others attribute his high-keyed reactions to the presence of the exuberant older woman. It is likely, though, that what stirred Rilke in Russia was his retrieval of a distant culture that had vanished in Europe. His romantic soul – in those days still unbridled – relished Russia for its exoticism. Still in his early twenties, he had not yet developed the hard self-judgment that characterized his later years. In those days he freely engaged in soft romantic visions, and even verged on mysticism. In a letter to Baron Du Prel, written before the Russian voyage, he sounds the vaguely mystical note that he would later come to deplore in Romantic German writing:

Apart from the charm of the mysterious, the domains of spiritualism have for man an important power of attraction because in the recognition of the many idle forces and in the subjugation of their power I see the great liberation of our remote descendants and believe that in particular every artist must struggle through the misty fumes of crass materialism to those spiritual intimations that build for him the golden bridge into shoreless eternities.

Frau Lou, herself given to accesses of extreme romanticism, and avidly assimilating the arguments of the mystical Slavophils, certainly set the tone of their Russian visit. Yet, even taking into consideration Rilke's submission to Lou's perception of Russia, there was a peculiarly personal and lasting meaning in this first visit already visible in Rilke. In May 1899, he wrote from St Petersburg:

At bottom one seeks in everything new (country or person or thing) only an expression that helps some personal confession to greater power and maturity. All things are there in order that they may, in some sense, become pictures for us. And they do not suffer from it, for while they are expressing us more and more clearly, our souls close over them in the same measure. And I feel in these days that *Russian* things will give me the names for those most timid devoutnesses of my nature which, since my childhood, have been longing to enter into my art!

When Rilke returned with Lou to Germany, they spent the entire summer studying 'things Russian' as if, a friend reported, they had to prepare for a fearful examination. They studied language and history – above all, art history. One suspects that Frau Lou's developing Slavophilism affected the syllabus of this intensive course in things Russian. She was already well acquainted with the artists and literati in Moscow and St Petersburg who had lately rejected Western art and sought to revive traditions long dormant in Russia. From her journals and letters we know that she and Rilke studied the pre-Christian period and the unique church architecture of ancient Kiev and Novgorod-Pskov. They were interested in interior church structures, old enamels and filigree work, miniatures, costumes, furniture and household items, especially of the sixteenth and seventeenth centuries. Following the artists of the late 1880s and early 1890s in Russia, they explored Russian folklore, including old songs and tales of legendary heroes. They also acknowledged the latest tendency among progressive artists in Russia by admiring those who had gone back to native sources, and who, like Ilya Repin (whom Rilke had met), had travelled and learned in Germany, Italy and France, but had finally rejected Western modes.

The following year, from May to August 1900, Rilke and Lou were again in Russia. Rilke's response to the bells and spaces of Moscow, so emotional the previous year, had set his expectations high. His memory of a Moscow Easter with the bells saturating the city remained one of his most cherished images, recalling Kandinsky's paean to the grand aural spaces of the bells of his native city. With the memory of St Basil's rooted in him, Rilke took a hotel directly opposite the Kremlin. Still questing for the primitive origins of things Russian, he made a visit to Abramtsevo where two decades earlier Savva Mamontov had founded an artists' colony with the avowed intentions of reactivating the old traditions of craftsmanship and of honouring the ancient traditions of the communes. The rebels who gathered in Abramtsevo, among them Repin, had already – long before twentieth-century moves to understand the primitive experience – discerned the vitality of the old icons and artifacts. They had consciously divorced themselves from the great cities. They were critical of materialism, technology and 'progress'. Their retreat was an active effort to make tangible the virtues they felt implicit in the ancient and unchanging mores of Russian life. Rilke's emotional need for a comparable experience brought him first to Abramtsevo and then, with considerable excitement, away from Moscow and St Petersburg to the heart of this imagined ancient Russia in May 1900.

He set off with Lou to explore those sites that had stirred him in Russian literature, but also to seek out Tolstoy. They wanted to know at first hand the mores that had been so carefully described in countless Russian novels of the nineteenth century – the slow and, to Rilke, timeless existence no longer familiar to the West. Everywhere Rilke looked he seemed to see with the eyes of previous generations, those who had glorified peasant life and who, like the Narodniki, went out from the cities, donned peasant smocks and tried to fathom the stubbornly static character of rural life. Rilke's preconceptions found confirmation, as for instance when he approached Yasnaya Polyana and noted that groups of women and children were 'only sunny red spots in the even grey covering ground, roofs, and walls, like a very luxuriant kind of moss that has been growing over everything undisturbed for centuries'. Even in his ill-fated visit to Tolstoy, Rilke sought the principle of ancientness and simplicity, rather than any literary nourishment. Rilke and Lou had tactlessly arrived at Yasnaya Polyana without announcing themselves and were greeted by a 'violent, offensive, almost inaccessible' Tolstoy who let Lou in but slammed the door in Rilke's face. Tolstoy disappeared immediately into the interior where sounds of a quarrel and weeping were heard, and his son led Rilke and Lou around the grounds. They reappeared at the house where Tolstoy, apparently resigned to their unwelcome presence, distractedly offered to walk with them through the forest. During the walk he apparently discoursed on life and death, but never addressed himself personally to the pair, each of whom in later years modified his account of the visit.

Rilke's need to believe that there could be a poetic life remote from the sophisticated turbulence of Europe was quite explicit, and found expression in the high hopes he had had for the visit to the village poet Spiridon Drozhin, whose *Songs of a Peasant* Rilke had partially translated. The visit started well.

Drozhin noted their arrival in his journal: 'I led my dear guests into my log cabin prepared for them and fitted out with the requisite furniture: it was divided into two rooms, and its four windows overlooked my little garden of raspberry, gooseberry and red-currant bushes.' Rilke and Lou rose early the following day, drank 'fresh milk prepared for them by my wife, and went barefoot to the shore meadow to run about in the dew-damp grass'. Rilke wrote the next day to a friend: 'With these days we are completing a great step towards the heart of Russia after long listening to its beat with the feeling that it gave the right measure for our own lives as well.' By the fourth day, after noting the terrible labour of the peasant-poet's wife, and the less enchanting aspects of farm work, both Rilke and Lou began to wonder whether in fact Drozhin's poetry extolling peasant life was not, as Lou later wrote, 'a poetical miscolouring of Russian peasant existence'. The faint disappointment in their peasant-poet did little to dampen their ardour, however, and Rilke continued to believe that somehow things Russian could give the right measure to his life.

Rilke's search in Russia for values that had been concealed in Western Europe was comparable to the explorations of a number of modern Russian artists who themselves had felt the need to know the still-unsullied silences of village life. Wassily Kandinsky had made his own pilgrimage to the Wologda province with similar expectations. Brought up in Moscow, Kandinsky set out on his trip – an anthropological research trip – as though, he said, he were starting out for some other planet. His descriptions of the changes in landscape, the vastnesses he traversed, the aspect and dress of the people, were more than mere ethnographer's reports. They reflected his need, so much like Rilke's, to go back to the origins, to what he imagined to be the simple verities. He was as struck as any foreign tourist by the simple hospitality of the peasants who always kept food for strangers near their icons and who had a natural civility. The self-contained communes did not fail to stir Kandinsky who, like Rilke, had a 'decisive' experience on his voyage to rural Russia:

Here I first learned not to look at a picture only from the outside but to 'enter' it, to move around in it, and mingle with its very life. It happened to me on entering a certain room, and I still remember how I stood spellbound on the threshold gazing in. Before me stood a table, benches, a vast and magnificent stove. The cupboards and dressers were alive with muticoloured and sprawling decoration. All over the walls hung peasant prints, telling vividly of battles, of a legendary knight-at-arms, of a song, rendered in colours.

Kandinsky's experience, which he likened to an 'inner revelation', played a lasting role in the development of his work, not only because it tempered his entire compositional philosophy, but because this exposure to unsophisticated life freed him, as it also freed Rilke, from the grip of European conventions. Both men matured during a period when the social sciences were in the ascendant. Rilke knew the sociologist Georg Simmel and Kandinsky had been a student at Moscow University in ethnography and anthropology. Both men supported the reaction to Slavophile literature with scientific principles, but both were obviously searching for other experiences: those stemming from the intuitive awareness of the importance of old things; of

long, patient experiences such as those of the Russian craftsmen carving lintels, painting their furniture or glass windows, and making saddles – Russian things.

At first, Rilke saw Russia only through the exuberantly literary vision of Lou Andreas-Salomé, but later he made it his own in memory. The specific value of this Russia, with its invented and real aspects inextricably mingled, he was able to describe only twenty years later:

Twenty years ago it was, I spent some time in Russia. An insight prepared only in a very general way by the reading of Dostoyevsky's works developed in that country where I felt so much at home, into a most penetrating clarity; it is hard to formulate. Something like this perhaps: the Russian showed me in so many examples how even a servitude and affliction continually overpowering all forces of resistance need not necessarily bring about the destruction of the soul. There is here, at least for the Slavic soul, a degree of subjection that deserves to be called so consummate that, even under the most ponderous and burdensome oppression, it provides the soul with something like a secret playroom, a fourth dimension of its existence, in which, however crushing conditions become, a new, endless and truly independent freedom begins for it.

Rilke's vision of Russia remained intact. A few months before his death he wrote to his old acquaintance Leonid Pasternak, painter and professor at the Moscow Academy (and father of Boris), to tell him how the memory of old Russia was forever embedded in the substructure of his life, and to console him for changes (the revolution) that sent Pasternak into exile. But, Rilke said, 'the deep, the real, the ever-surviving Russia has only fallen back into its secret root-layer, as once formerly under the Tartarschschina; who may doubt that it is *there* and, in its darkness, invisible to its own children, slowly, with its sacred slowness, is gathering itself together for a perhaps still distant future?'

Rilke's insistent quest for a purity associated with primitive origins took a Russian turning, but could also be seen as an extension of traditions developed in Europe in the modern era. When Balzac takes a metaphysical look at modern life, he exclaims: 'There is a primitive principle! Let us surprise it at the point where it acts on itself, where it is one, where it is principle before being creature, cause before being effect, we will see it absolute, without a face, susceptible to a change in all the forms that we see it taking.' During Balzac's epoch, many were acknowledging the 'primitive principle', which they associated with purity and which they translated into aesthetic behaviour. The painters with whom Balzac associated in the 1830s had not forgotten their revolutionary predecessors, known as Les Penseurs or Les Primitifs. These young dissidents from David's studio had taken his classicism to heart and exaggerated it to the point where the master himself threw them out of his studio. Their sect, complete with outer symbols (they wore flowing locks and beards and tunics), advocated a return to the sources, a rejection of modern corruption, a way of life that respected the 'primitive' principle. A quarter of a century later, Gautier and his friends in the Jeunes France group resurrected the garments, if not all the principles, of these purists. They welcomed the messages, drifting in from Germany (partly through their friend Nerval's translations of Goethe), that primitive sources are to be found

in Nature, and that man must see himself as part of Nature. The story does not end with Gautier's and Balzac's period. Later, Cézanne would exclaim: 'I am the primitive of a new art', and Jackson Pollock, when asked about the role of Nature in his paintings, would reply, 'I *am* Nature.'

All through the nineteenth century there had been strong pantheistic currents in Europe, carrying artists into landscapes in which they hoped to find the primal principles. The current was particularly strong in Germany where many philosophers and even artists, such as Philipp Otto Runge, attempted to define their transcending vision of Nature. The *Naturphilosophie*, or *Naturlyrismus*, that motivated the first generation of romantic painters had been nourished by their reading of the early romantic poets, particularly Goethe and Schiller. The aesthetic doctrines of Friedrich von Schelling had acclimated nineteenth-century German romantics to the idea that 'plastic art manifestly occupies the position of an active link between the soul and nature, and can only be comprehended in the living centre between the two of them'. The living centre, Schelling contended, was the key to an art that was not merely an empty, lifeless imitation of Nature. The artist, he argued, must get to the 'unadulterated energy of things'. He must follow the process of Nature. Since 'art springs from the vivid movement of the innermost energies of the mind and spirit', the artist must contemplate Nature for its organic analogies to the movement of his own soul. Moreover, Schelling said, the living centre was capable of great freedom. He spoke of 'the higher necessity which is equally far removed from accident, and from compulsion or external determination, but which is, rather, an inner necessity which springs from the active agent itself'. The phrase 'inner necessity' grew in importance during the century until Kandinsky made it, in the early twentieth century, the cornerstone of his aesthetic theory.

By the late 1890s, there were determined dissidents among German artists who rejected the urban preoccupation with vanguardism. They advocated practising moral resistance in the pure landscapes undefiled by industrial civilization. One of these artists, Heinrich Vogeler, had settled in Worpswede, an artists' colony some ten miles from Bremen. During a visit to Italy in 1898, Rilke met Vogeler who invited him to Worpswede. Perhaps as a result of his visit to Abramtsevo, Rilke decided to accept Vogeler's invitation immediately upon his return from Russia in August 1900. This visit was to represent for Rilke another important turning. It changed, he said, his way of seeing.

All descriptions of Worpswede linger on the moody breadth of the landscape, with its deep and dark canals, its stands of birchwoods, and the infinitely extensive moors. The place immediately appealed to Rilke, as did the company of young artists settled there; and he made arrangements to rent one of the comfortably appointed houses for the winter. No doubt the devout attitudes of the artists, who spent long hours enacting their conviction that only in Nature would they find the living principles of their art, stirred him. The group, despite their belief in working directly from Nature, harboured the metaphysical preoccupations that had long haunted German artists. After the day's work, they would have long, earnest discussions, often about the work of Arnold Böcklin.

Rilke met two young women at Worpswede who were to have an important role in the development of his vision: the sculptor Clara Westhoff, who was preparing to go to Paris to study with Rodin, and the painter Paula Modersohn, whose original views on painting undoubtedly influenced Rilke. Both these young women aroused in Rilke something akin to love, and both seemed to him to answer a spiritual need. He watched as these assiduous young artists worked daily, and sometimes even in the evenings. He was quick to learn, just as Balzac had learned from Boulanger, the specific difference in the way an artist observes. In his journal, Rilke spoke of 'this daily attentiveness, alertness, and readiness of the out-turned senses, this thousandfold looking and always looking away from oneself...this being-only-eye'. The new experience served to prepare Rilke for his Rodin turning. Clara Westhoff, whom he married the following spring, was probably the immediate cause of Rilke's undertaking the study of Rodin, but he had been thinking about Rodin even before he met her. His experience of watching Clara modelling aided him in thinking about craftsmanship – the slow, organic development within a work – and about the way a plastic artist must see. By the time he approached the old master in Paris, he had known the dedication of this commune of artists, their deep convictions, and their submission to Nature itself, rather than to the vague feelings Nature had inspired in them.

At first Rilke seemed to be seeking the legendary in Rodin – his endurance and great age – much as he had unsuccessfully sought it in another patriarch, Tolstoy. He craved the vicarious knowledge of the *old* experience with its living proof of the mysterious power of endurance. In both Tolstoy and Rodin he seemed to imagine an incarnation of the patriarchal peasants whose wisdom is recorded in the nineteenth-century Russian novel. In an early description of Rodin, he wrote: 'Time flows off him, and as he works thus, all the days of his long life, he seems inviolable, sacrosanct, and almost anonymous.'

Despite the exalted tone of his early notes on Rodin, Rilke was too sensitive to remain long in a vague romantic fever, and quickly set about an attentive study of the works. The year before, he had already noted in his journal the differences in the relationships of Rodin's forms, opposing them to the isolation of traditional statuary. Even then he was on the verge of defining what, after his full experience of Rodin and his work, he would later discern as peculiarly modern about him. From an admiring amateur Rilke became an acute commentator whose writings on the sculptor remain the most penetrating criticism.

Rilke's heightened sensibility is apparent in his very first impression of Rodin's Meudon studio, recorded on 2 September 1902. In the largest atelier he was dazzled by the yard upon yard of fragments – a piece of an arm, a leg, a torso, through which he understood that 'each of these bits is of such an eminent, striking unity, so possible by itself, so not at all needing completion, that one forgets they are only *parts*'. Only twelve days later he announces to his wife that he has grasped the principle, the fundamental law to which Rodin, in his most brilliant invention, has submitted all his work. When Rodin speaks of *le modelé*, he tells Clara, 'I know what it means: it is

the character of the surfaces, more or less in contrast to the contour, that which fills out all the contours.' Later, in his book on Rodin, Rilke refines the definition further, speaking of 'infinitely many meetings of light with the object, and it became apparent that each of these meetings was different and each remarkable'.

Once Rilke isolated the underlying principle, he was able to perceive in every aspect how Rodin's work differed from all other sculpture of the period. Prophetically he analysed the characteristically modern impulse to go beyond subject matter, writing to Clara:

Do you understand, for him there is *only le modelé* . . . in all things, in all bodies; he detaches it from them, makes it, after he has learned it from them, into an independent thing, that is, into sculpture, into a plastic work of art. For this reason a piece of an arm, leg, body is for him a whole, an entity, because he no longer thinks of arm, leg, body (that would seem to him too like subject-matter, do you see, too – novelistic so to speak) but only of a *modelé* which completes itself, which is, in a certain sense, finished, rounded off.

It was not difficult for Rilke to understand that Rodin's audacity in enunciating this principle of *le modelé* was grounded in his respect for tradition, particularly of ancient and medieval sculpture. Rilke admired the life that has lost nothing and forgotten nothing, and he naturally seized upon the two literary sources that governed Rodin's spiritual life – Dante and Baudelaire. In Baudelaire, Rilke says, he felt the artist who had preceded him, who had not allowed himself to be deluded by faces, but who sought bodies in which life was greater, more cruel and more restless. Rilke was sensitive to the residue of earlier nineteenth-century speculation in Rodin's thought (Frenhofer, for instance, had a theory of *le modelé* very close to Rodin's) and his respect for the old titan was fortified by it. His first impression of the enormous volume of Rodin's work became the basis for his most important speculation concerning how such a creator works. What he emphasized in letters and later in the book was the commitment to what he called handwork, which he used both in its ordinary sense, as craft, and in its sense of mysterious, direct translation of feeling. In the ceaseless fashioning of the sculptor Rilke saw a path of artistic development peculiar to the great artist. He often quotes Rodin's 'il faut travailler, rien que travailler', and tells Clara:

The great men have let their lives become overgrown like an old road. . . . Rodin has lived nothing that is not in his work. Thus it grew around him. . . . But to make, to make is the thing. And once something is there, ten or twelve things are there, sixty or seventy little records about one, all made now out of this, now out of that impulse . . .

Nearly a year later, he reflects again on the 'way of looking and living' that Rodin alone represented for him, and meditates on the deeper lessons for his own work. Rilke reconsiders the lessons of Worpswede. Through being a 'handworker', Rodin, he says, attained his capacity to gaze – and with his gaze to make a single thing a world where everything happens. At the time he attained 'the element of his art which is so infinitely simple and unrelated to subject-matter, he attained that great justice, that equilibrium in the face of the world, which wavers before no name'. As Rilke worked and himself gazed attentively at the hundreds of works in Rodin's atelier, he began to

formulate the basis of Rodin's uniqueness in much the way the modern tradition has come to see it. He does not stop at a superficial assessment of the significance of the fragment, but defines the aesthetic that grew out of the vast experience, out of the 'handwork':

Now no movement can confuse him any more, since he knows that even in the rise and fall of a quiet surface this is movement, and since he sees only surfaces and systems of surfaces which define forms accurately and clearly. For there is nothing uncertain for him in an object that serves him as a model: there a thousand little surface elements are fitted into space, and it is his task, when he creates a work of art after it, to fit the thing still more intimately, more firmly, a thousand times better into the breadth of space, so that, as it were, it will not move if it is jolted. The object is definite, the art object must be even more definite: withdrawn from all chance, removed from all obscurity, lifted out of time and given to space, it has become lasting, capable of eternity. The model *seems*, the art object *is*.

Underlying Rilke's argument is the growing conviction that craft transformed is the secret of Rodin's art, and perhaps even of his own art of poetry. He admires Rodin, who did not 'put together in advance' while his figures were still ideas, but who 'promptly made things, many things, and only out of them did he form or let grow up the new unity, and so his relationships have been intimate and logical, because not ideas but things have bound themselves together'.

The insistence on 'thingness' or the coming-into-being-of-things (*Dingwerdung*) and the uninterrupted gaze in Rilke's thoughts on Rodin became far more lucid when Rilke later came to consider Cézanne. But already he could speak of great concentration as the key to creation. 'Everyone must be able to find in his work the centre of his life and from there to be able to grow out in radiate form as far as he can,' he tells Clara in 1903. 'There is a kind of purity and virginity in it, in this looking away from oneself; it is as when one is drawing, one's gaze is riveted on the object, interwoven with Nature, and the hand goes its way alone, somewhere below, goes and goes, takes fright, falters, is happy again, goes and goes . . .'

For himself as poet, Rilke was drawing firm lessons in his penetration of Rodin's work. He came to understand the 'plastic' abstract purity of the singular sculpture and, through Rodin's counsels, learned to 'see' the unimportance of subject-matter. He extended this 'modern' way of apprehending sculpture to his experience with all sculpture. In Rome he gazed at fragments in the ruins and berated scientists and historians for trying to give them a name and a period. The incomparable value of these rediscovered things, he observed, is that 'one can look at them so entirely as things unknown; one does not have to know their intention, and no subject-matter attaches itself to them (at least for the unscientific), no unessential voice breaks the stillness of their concentrated existence, and their permanence is without retrospect and fear'. Only the experience of Rodin's special view of the fragment could have prepared such a response. As Rilke learned the lesson, he was able to record it in his book on Rodin:

As the human body is to Rodin an entirety only as long as a common action stirs all its parts and forces, so on the other hand portions of different bodies that cling to one

another from an inner necessity merge into one organism. A hand laid on another's shoulder or thigh does not any more belong to the body from which it came – from this body and from the object which it touches or seizes, something new originates, a new thing that has no name and belongs to no one.

In isolating the principle of the fragment, and Rodin's 'system of surfaces', Rilke prepares himself for his recoil from the romanticism of his own past work. He feels that he must, like Rodin, find the radical principle – an abstract principle – on which to proceed in his work. 'Somehow I too must manage to make things; written, not plastic things; realities that proceed from handwork. Somehow I too must discover the smallest basic element, the cell of *my* art, the tangible medium of presentation for everything, irrespective of subject-matter . . .' From the Rodin lessons, carefully hoarded, eventually emerged the poems published as *New Poems*, the earliest of which, 'The Panther', written in 1902 or 1903, may have been the direct issue of Rodin's suggestion that Rilke go to the zoological gardens and look until he could make a poem of what he was looking at.

II

Rilke did not experience the full measure of change in the *New Poems* until the signal encounter with his last great master: his last and lasting model of all that he yearned for, all that he hoped to accomplish. The master to whom he always deferred with the utmost gravity was the painter Cézanne. As early as 1900 Rilke had remarked the paintings of an 'eigentümlichen' Frenchman in a Berlin exhibition. But, as he said years later, this was before he really knew how to look at pictures. By the time he saw the large memorial retrospective at the 1907 Salon d'Automne, he had learned to gaze and find the 'concentrated essences' of works of visual art. As the intense letters on Cézanne spanning three weeks indicate, he put himself to school with Cézanne. His visible descent into the essence is reported day by day to Clara. At first he only mentions that Cézanne, like Goya, painted his studio at Aix with fantasies. Two days later he reports having gone to the Louvre and notes that Cézanne's very peculiar blue has a parentage going back to Chardin. On the third day, he speaks of Cézanne himself, having read Emile Bernard's memoirs in *Mercure*.

In Bernard's description of the old painter Rilke found not only the great perseverence he had admired in Rodin, but also the warring impulses to which he himself was prey. He singles out Cézanne's most indispensable goal, *la réalisation*, and describes how the furious old painter never felt he had achieved it. In this letter, Rilke sets about finding an adequate definition of Cézanne's *réalisation*: 'The convincing quality, the becoming a thing, the reality heightened into the indestructible through his own experience of the object.' This insight into Cézanne's relationship to the object grew out of his knowledge of Rodin and strikes a deep chord in Rilke. He probably remembered Rodin again when he quotes Cézanne screaming at a visitor: 'Travailler sans le souci de personne et devenir fort – ' Immediately after this allusion to Cézanne's obsessiveness, Rilke retells, with obvious

excitement, the whole incident of *The Unknown Masterpiece*, altering Bernard's account with his own interpretation:

But in the midst of eating he stood up, when this person told about Frenhofer, the painter whom Balzac, with incredible foresight of coming developments, invented in his short story of *Chef-d'œuvre inconnu* (about which I once told you) and whom he has go down to destruction over an impossible task, through the discovery that there are actually no contours but rather many vibrating transitions – learning this, the old man stands up from the table in spite of Mme Brémond, who certainly did not favour such irregularities, and, voiceless with excitement, keeps pointing his finger distinctly towards himself and showing himself, himself, himself, painful as that may have been. It was not Zola who understood what the point was; Balzac had sensed long ahead that, in painting, something so tremendous can suddenly present itself, which no one can handle.

Yet, Rilke continues in this letter, Cézanne began again the next day, *sur le motif* before Mont Sainte-Victoire, with 'all his thousands of tasks'. Cézanne's ability to find the thousand tasks around the single motif moved Rilke immensely. He had long been preoccupied with the kind of patience old men display while seeking the key to their visions. Even before his intense concentration on Cézanne, he had been moved by the old Japanese painter Hokusai. In 1906 he had begun 'The Mountain' about Hokusai with the lines:

> Six-and-thirty and a hundred times
> did the painter write the mountain peak

But it was not until a year later, after his long communion with Cézanne, that Rilke completed the poem:

> sundered from it, driven back to seek
> (six-and-thirty and a hundred times)
>
> that incomprehensible volcano,
> happy, full of trial, expedientless –
> while, forever outlined, it would lay no
> bridle on its surging gloriousness
>
> daily in a thousand ways uprearing,
> letting each incomparable night
> fall away, a being all too tight;
> wearing out at once each new appearing,
>
> every shape assumed the shiningmost,
> far, opinionless, unsympathising, –
> to be suddenly materialising
> there behind each crevice like a ghost

Rilke's active learning from Cézanne is evident a week after his first Cézanne letter in his response to a letter from Clara in which she wrote of the autumn landscape at Worpswede. He speaks of the pageant of moor and heath, and the transformations he had once so fully experienced, but he adds:

in those days Nature was still a general incitement for me, an evocation, an instrument on whose strings my fingers found themselves again; I did not yet sit before her . . . How little I could have learned then before Cézanne, before Van Gogh. From the amount Cézanne gives me to do now, I notice how very different I've grown.

For the next few weeks, Rilke's perceptions about the nature of his own tasks mingled with his insights about Cézanne. He approached his 'turning' that would bring him, as it was bringing many other artists in 1907, to a view of art that misprized Romantic *Einfühlung*. Rilke's quest was to become more demanding, harder, more objective, but a quest it remained. He added to his first insight about Rodin's continuity (with the principle, or 'cell', out of which all work issues) a penetrating observation on Cézanne:

I went to see his pictures again today; it is remarkable what a company they form. Without looking at any single one, standing between the two rooms, one feels their presence joining in a colossal reality. . . . One also notices each time how necessary it **was** to go even beyond love; it is of course natural to love each of these things, when one makes it; but if one shows that, one makes it less well; one *judges* it instead of *saying* it . . . this consuming of love in anonymous work, out of which such pure things arise, no one perhaps has so fully achieved as this old man . . .

Then, in the first outright declaration of his own turning, Rilke adds that he has received proofs of his poems (later to be published in *New Poems*) and that 'there are instinctive tendencies [in them] towards similar objectivity'. A few days later, he speaks of the 'immense advance' in Cézanne's paintings, remarking, 'It is not the paintings at all that I am studying. . . . It is the turning point in this painting that I recognized because I had just reached it myself in my work.'

This celebrated turning point in Rilke's creative life has been widely misinterpreted, as his translator J. B. Leishman points out. Rilke's critics have said that his need for objectivity led him to fashion poems about things and not feelings, and, as a result, the poems are cold and hard. In fact, Rilke's dawning certainty was more complex and could be compared with Picasso's turning at the same time. Rilke shared with other artists in Paris during those first years of the first decade a desire to sharpen perceptions and to simplify the observed relations among things. When Picasso turned away from his own tremulous feelings so poignantly expressed in the so-called Rose period, he sought the same sharpness in things that Rilke had discovered in Cézanne. There was no question of eschewing feelings. The question was rather to permit an ensemble of meditated observations of forms to be the total bearer of the artist's responses. Picasso regarded his new way of dealing with forms and space as more 'objective' only in the sense that his subject changed and became, itself, subject to the demands of the total ensemble of more or less rationalized forms. Yet his paintings were never coldly 'objective' any more than Rilke's new poems were. 'At the time, everyone talked about how much reality there was in Cubism,' Picasso told William Rubin, 'but they didn't really understand. It's not a reality you can take in your hand. It's more like a perfume – in front of you, behind you, to the sides. The scent is everywhere, but you don't quite know where it comes from.'

Rilke had on the one hand registered the restless idealism of Cézanne (the 'anxiety' that had stirred Picasso) and, on the other, the unique form of Cézanne's sacrifice, his pitiless drive to construct his world while checking constantly against nature, six and thirty and a thousand times. In the letters on Cézanne to Clara, the word 'sachlich', translated into English as 'objective

but perhaps meaning more nearly 'thingish', begins to assume more and more importance. By 1908 he was writing to his publisher Kippenberg about Part II of the *New Poems*:

If a third volume is to join these two, a similar intensification will still have to be achieved in that ever more objective mastering of reality, out of which emerges, quite spontaneously, the wider significance and clearer validity of all things [*immer sachlicheren Bewältigen der Realität*].

Years later Rilke was still seeking to define more subtly this turning towards the 'sachlich'. Answering charges that the poems were 'impersonal', he explained to a young correspondent:

You see, in order to say what happens to me, I needed not so much an instrument of feelings as I did clay: involuntarily I undertook to make use of lyric poetry to shape (or form) not feelings, but *things I had felt*; the whole event of life had to find place in that shaping (forming) independently of the suffering or pleasure it had first brought me. That shaping would have been valueless if it had not gone so far as the *trans*-shaping (*trans*-forming) of every passing detail, it was necessary to come through to the essence.

Rilke draws near the true meaning of Cézanne's reiterated need to realize his *petite sensation*. His emphasis on things he had felt reflected not so much his preoccupation with things as such – any more than apples were mere things for Cézanne – as things that had gained through concourse with humans an intimacy, a history. He was approaching the 'thing' as a repository of human history. In this he was not far from the approach to things taken by Picasso and Braque. Apollinaire felt that the pipes, tobacco packets and wine bottles in their paintings were endowed with a history in much the same way.

In Rilke's *New Poems* this message of the importance of things is repeatedly transmitted. For instance, in the poem 'Tanagra', completed in July 1906, there is at once an evocation of a thing and a comment on the human significance of the miraculously *trans*-formed clay:

A little burnt earth, as fired
by an almighty sun
As though the once here-inspired
gesture her hand begun
had suddenly grown external,
reaching for nothing external,
leading but from within
her feeling into her feeling
over her own self stealing
like a hand around a chin
We lift and keep revolving
figure on figure thus;
we're almost near resolving
why they are undissolving, –
yet it's but given us
deeplier and still more clearly
to cling to what once was here
and smile: just a bit more clearly,
maybe than we did last year.

Another poem, begun at the same time but completed in February 1907, after the Cézanne show, is more ambitious. 'The Lace' goes to the heart of

Rilke's long meditation on the nature and meaning of craftsmanship. The value of thingness is rendered subtly, more psychologically. The first line orients us to his motif: 'Humanness: name for wavering possession', and shows how he was now able to slip between things and his feelings for them as mediator. He addresses the lacemaker who probably went blind to fashion this piece of lace-work's fine 'enwovenness', and tells her: through some small chink in destiny she drew her soul from temporality into 'this airy shaping'. Half a year later, in part two, Rilke deepens his theme. He asks: and if one day all our doings should appear strange to us, 'and it were far from clear why we should struggle out of children's shoes merely for that', would not this finely woven length of flowery lace then have sufficient strength to keep us here? 'Sieh: sie ward *getan*,' he says. (For look, it all got done.) By stressing the word 'getan' Rilke reverts to his numerous previous efforts to define the experience of the handworker. Both Rodin and Cézanne were models of *homo faber* at his most enduring; handworkers whose *trans*-shapings straddled both the real and spiritual boundaries of the imagination. The 'thingness' of Rilke's lace, 'this thing, not easier than life, but quite perfect and oh, so beautiful', is far from being cold or even objective in the ordinary sense. The conviction that, enfolded in things he had 'felt' were experiences of others, transmitted through history only by things, went deep, and was to nourish Rilke's later great cycles of poems, long after he had mastered his encounters with thingness.

Rilke's view of objectivity – that it was based on the unflinching encounter with things – was akin to Cézanne's, and he had been delighted to read in Bernard that Cézanne had held Baudelaire's poem 'Une Charogne' in such high esteem. He wrote to Clara reminding her of his own passage on 'Une Charogne' in *Malte Laurids Brigge*: 'I could not help thinking that without this poem the whole development towards objective expression, which we now think we recognize in Cézanne, could not have started; it had to be there first in its inexorability.' The artist, he says, has to deal with everything, even the repulsive; with that which is. 'The creator is no more allowed to discriminate than he is to turn away from anything that exists: a single denial at any time will force him out of the state of grace and make him utterly sinful.' Such turning away he views as an interference with the natural process, which, since his coming to Cézanne, he regards as a key. The continuity between Cézanne's gazing and his shaping is natural, Rilke feels, as can be seen in his interpretation of Cézanne's painting as primarily the intercourse of the colours with one another:

Whoever interrupts, whoever arranges, whoever lets his human deliberation, his wit, his advocacy, his intellectual agility deal with them in any way, has already disturbed and troubled their performance. The painter (any artist whatsoever) should not become conscious of his insights: without taking the way round through his mental processes, his advances, enigmatic even to himself, must enter so swiftly into the work that he is unable to recognize them at the moment of their transition.

Recognizing that the painter, or any artist whatsoever, must not become excessively conscious of his insights, Rilke honoured in Cézanne the very aspect that most attracted subsequent modern painters. His reading of

Cézanne's character as artist corresponds to Picasso's and Braque's, and to their transformations of what they saw in Cézanne. For Cubism, as Picasso said, was not the intellectual, conceptual affair that so many tried to make it, but a natural organic process growing directly out of the act of painting. Rilke's observation that the artist's advances, enigmatic even to himself, must enter so swiftly into the work that he is unable to recognize them at the moment of their transition, admirably describes Picasso's own state of mind during that year of 1907, the year of *Les Demoiselles d'Avignon*. While he sought to distance himself from the sentiments of the Rose period, he discovered the satisfactions of intent looking, of crafting forms. And yet, in the *Demoiselles*, and in many other works of that year, his advances were swift, enigmatic, and not very clear even to himself. What he saw in Cézanne was cast in a new vocabulary, but the means, as he insisted, remained the immanent means of painting of all times. He sought, as did almost every artist at that moment, the kind of total structuring implicit in Cézanne's late works, epitomized in Cézanne's mute gesture of bringing his two hands slowly together, and tightly lacing the fingers. To achieve such firmness, as painters well knew, seeing was the key and *trans*-forming the method. Already in the first rebellion against romanticism, Gautier had spoken of the value of seeing, and stressed even more the importance of making: 'The word *poet* means literally *maker*: all that is not well made does not exist.' Gautier had felt the need to 'chisel' his poetry, as Rilke was to do later after his lesson from Rodin, often speaking of his desire to 'chisel' poems, to find his own 'tool', like a hammer. In the 1840s Gautier had been preoccupied with similar problems. In his Salon of 1845, he speaks like a sculptor: 'It is sweet, for a soul not corrupted by the bitter thirst for gain, to *chisel* in solitude in marble and in verses, these two hard materials gleaming and cold, one's dream of love and beauty.' The modern artist's desire to work swiftly, with firmness, without intervention from the mind, and to work as would the marble sculptor who must always be so precise, is often expressed. Matisse in *Jazz* opens his text saying: 'To draw with scissors – to cut directly into colour reminds me of the direct carving of sculptors.'

The preoccupation of these artists, from Gautier to Rodin to Cézanne to Rilke to Picasso to Matisse, was with things and thingness in the salutary way proposed by Balzac's Porbus. The emphasis on observation was not set off in brackets, not based on unchallenged modes of mimesis, but rather based on a knowledge of the perils lying on the other side. The obverse that was thingness was only thingness because its reverse was nothingness. The abyss was known to artists and became a natural part of their experience in the nineteenth century whether it was known as the abyss, as it was by Balzac, Baudelaire and Rimbaud, or as Nothingness, as Mallarmé, Valéry and Sartre preferred. Rilke might have said, its 'enwovenness' was ineluctable for the modern artist.

III

Rilke had early known the metaphysical intimation of the abyss and spoke in his letter about 'Russian things' of finding names for it. Even in his early

poems the spatializing impulse is strong. He felt the need to draw a cosmos with vast boundaries. In his meditation on intimations of infinity Rilke entered into discussions with the Austrian philosopher Rudolf Kassner, whom he was to call 'a spiritual child of Kierkegaard', and whose nature he described as a 'brightness in space'. He had met Kassner late in 1909 in Paris and for the next year saw him nearly every day. In 1911 Kassner published a book, *Elements of Human Greatness*, that Rilke admired. But it was a sentence from one of Kassner's works of the Paris days that stuck in Rilke's mind: 'The road from creative empathy to greatness goes through sacrifice', or, in a slightly different translation: the road from inwardness to greatness goes through sacrifice. He used it as a motto for the important poem 'Turning' and he may well have had it in mind when he dedicated the Eighth Duino Elegy to Kassner. On Kassner's side, as Leishman points out, the admiration was more qualified. Kassner felt that Rilke had not really fathomed his theory and had recalcitrantly remained in what Kassner had defined as an atavistic space-world. Kassner's doctrine of *Umkehr* had apparently deeply interested Rilke. Although it is far from lucid, the doctrine had many suggestive possibilities for Rilke. Leishman characterizes *Umkehr* as follows:

The exemplary modern man has been 'converted' from the almost purely eternal, finite, static 'space-world' of God the Father, of number or quantity, of identity, of discontinuity, of magic, of chance, of happiness, to the more internal, more spiritual, infinite, dynamic 'time-world' of the Son, of quality, of individuality, of continuity and rhythm, of order and system, of freedom, of sacrifice. 'Conversion,' he writes in *Zahl und Gesicht*, 'means, lastly, and most profoundly, that we do not construct the world on any identity, whether we call this identity Will, God, Thing in itself, Duration, Primal Cell or anything else. Conversion is thus the centre of an infinite world, of a world in motion. Whoever in his soul revolts against or shocks an identity, whoever in his soul revolts against chance or a coming into existence through chance, is a convert, or feels the necessity of conversion. He is truly in motion.'

Kassner's formulation of an infinite world in motion, consistent with the new scientific image of the world in the early twentieth century, could not have been adequate for the poet who felt the aboriginal world of space corresponded to specific feelings far remote from practical experience. The lure of the abyss described by Balzac continued to attract modern artists, many of whom found it the touchstone for self-respect. If the necessity of cosmos, or form, persists, it is because the spaces through which an artist's spirit must move in order to create things or works cannot, finally, be unnameable, cannot be in eternal flux. The modern artist attracted to the abyss strives to *name* spaces, whether through forms on canvas or through verbal imagery. Rilke was naturally intimate with such spaces of the imagination.

His problem, and the problem of modern painters, was to give form to the riotous sensations of discrete spaces that occur exclusively in the imagination. Although the painters, particularly Picasso, bridled when the cubist experience was discussed in the terms of non-Euclidian geometry, the geometries in their paintings can hardly be said to conform to Euclid's certainties. Uncertainty was a reality against which form-givers had to struggle. This led many, such as Kandinsky, to cautious flirtations with mysticism. Rilke

himself in 1912 at Duino had taken part in seances with Princess Marie von Thurn und Taxis Hohenlohe, who was a member of the Society of Psychical Research and whose son Pascha was a medium. Such experiments, which Yeats, Breton, Eluard and others also undertook, fulfilled a practical need to find terms to describe psychological spatializing experiences – those Euclidian geometry cannot address. All the abysses, the infinities, the sliding spaces of dreams, the hypnogogic mobilities, the nothingnesses that haunt modern art and poetry reflect deep need. The 'spiritual', having been under siege for two centuries by rationalism, needed supplies. Despite the assault by the Philosophes, the conflict of spirit and matter had not vanished. Such experiences, as the Surrealists insisted, exist, and therefore need expression. In *Séraphita* Balzac had described the phenomenon of angelism that was to interest so many subsequent writers:

If some pregnant thought bears away a scholar or a poet on its chimera's wings and removes him from the external circumstances that hedge him in on earth, whirling him through the boundless regions where the vastest collections of facts become abstractions, where the most stupendous works of nature are mere images, woe to him, if some sudden sound strikes upon his senses and recalls his adventurous mind to its prison of flesh and blood!

Baudelaire seriously turned his attention to Swedenborg whom Balzac paraphrased: the angel is the individual in whom the inward being triumphs over the outward being. Rimbaud followed Baudelaire and lamented his prison of flesh and blood. Rilke imagined an angel in the Elegies as 'the creature in whom that transformation of the visible into the invisible we are performing already appears complete . . . The Angel of the Elegies is the being who vouches for the recognition of a higher degree of reality in the invisible – Therefore "terrible" to us, because we, its lovers and transformers, still depend on the visible.' Rilke continued to struggle with the paradox of 'objectivity' transformed, and during the last years of his life, which corresponded to the surge of the Surrealist movement, he tried again to define his attitude towards psychic experiences. Referring back to his evenings with mediums at Duino many years before, he wrote in 1924:

I am convinced that these phenomena, if one accepts them, *without taking refuge in them*, and remains willing again and again to fit them into the *whole* of our existence, which is full of no less wonderful mysteries in all its happenings – I am, I say, convinced that these manifestations do not correspond to a false curiosity in us, but in fact *indescribably concern* us . . . Moreover, it is one of the original inclinations of my disposition to accept the mysterious *as such*, not as something to be unmasked, but rather as the mystery, that, to its innermost being, and everywhere, is *thus* mysterious, as a lump of sugar is sugar throughout. . . .

Rilke's experiences had much in common with those characterized by Balzac as stemming from 'second sight', and also those of Breton when he spoke of 'thought's dictation', and those Jung alluded to when he spoke of 'tongues'. One of Rilke's strangest episodes occurred in his final years in Switzerland. He recounted how one evening he was visited by a gentleman in eighteenth-century dress who, he said, became the author of the poems in the cycle 'From the Remains of Count C.W.' Rilke's friend von Salis tells us

that Rilke always spoke of the author of these poems in the third person, now and then expressing surprise at 'how well he puts it'. Rilke explained these 'strange things, for which I, most agreeably, have no responsibility whatsoever' as the result of his not having been really in the mood or quite fit for his own work. 'I had, it seems, to invent a "pretext" figure, someone to take responsibility for whatever could be formed at this highly insufficient level of concentration: this was Count C.W.' The affair ended, von Salis tells us, when the voice started dictating to Rilke in Italian, whereupon Rilke revolted and gave him notice.

Not only was Rilke willing to navigate the spaces of the imagination with a willing suspension of disbelief, but he was willing, as he said Rodin was, to seek the almost invisible conjunctions of forms and feelings in these imagined spaces. His shaping impulse led him to seek out the finest, all but invisible, boundaries among things; to abstract with the intensity of Frenhofer. More than once he speaks of the space between the inner tree and the bark, and he wrote excitedly about an old tree on which the ancient bark remained and a new young tree grew within. Learning of silences and the smallest possible measures, Rilke set out to speak of roses; to speak, as he once said, from the experience of in-seeing which is not in-specting. Many new geometries sprang to his mind as he found in roses an incomparable source of metaphor. So gratifying was his concourse with roses that in his last will, where he directs a friend to find an old tombstone ('I detest the geometric art of modern stonemasons'), he offers two lines of verse for the stone:

> Rose, O pure contradiction, delight
> in being no one's sleep under so many lids.

During the years in Paris when he had set himself the workmanlike tasks of objectivity he had diligently studied roses, seeking the most precise similes. Around the new year in 1907, he wrote the long poem, 'The Bowl of Roses', which opens with a startling image of anger: two fighting boys bunch themselves up into a ball of something that was mere hate, and roll upon the ground like a dumb animal attacked by bees. Then Rilke sets out his still-life, the bowl of roses, standing in extreme contrast:

> the unforgettable, entirely filled
> with that extremity of being and bending,
> proffer beyond all power of giving, presence,
> that might be ours: they might be our extreme.

In the next stanza, Rilke embarks on the task he set himself of transformation. He discerns and descries the spaces, so infinitesimal, encompassed by the rose, by the 'presence' that 'might be our extreme':

> Living in silence, endless opening out,
> space being used, but without space being taken
> from that space which the things around diminish;
> absence of outline, like untinted groundwork
> and mere Within; so much so strangely tender
> and self-illumined – to the very verge: –
> where do we know of anything like this?

The space, so far, is visible; is even akin to Cézanne's spaces, with their absence of outline, and the strange juxtapositions which minimize depth. In the next stanza, Rilke transforms this still tangible space into inner space:

> And this: that one should open like an eyelid,
> and lying there beneath it simply eyelids,
> all of them closed, as though they had to slumber
> ten-fold to quench some inward power of vision.

The rose, as innerness, remained an important simile for Rilke. Months later, on 2 August 1907, in 'The Rose-Interior' he approaches the most abstract problem implicit in the earlier poem. The first line, reminiscent of Goethe's *Nichts ist drinnen, nichts ist draussen: | Denn was innen, das ist aussen* (There is naught within, naught without/whatever is within is also without), is a phenomenal description: Wherefore this inner's waiting an outer? To this question there can be no reply, but Rilke suggests in the flow of the poem that the innerness of the rose's architecture is comparable only to the inner-space of dreams.

> Themselves their whole endeavour
> scarce holds; and many are willing
> to be filled to overflowing
> with inner-space and stream
> into the days, forever fuller and fuller growing,
> till the summer has all become a
> chamber within a dream

IV

In Paris, during the years he was learning to be a handworker, Rilke moved about the city observing the spaces fashioned by human beings, sometimes with their own bodies. He was drawn to the spectacles performed by strolling players along the boulevards and, particularly, acrobats. His many days spent in art galleries, turning the leaves of art books, and browsing in the portfolios of print dealers on the rue de Seine provided him with ample background in the long French tradition of portraying the descendants of the commedia dell'arte. The rootlessness and pathos of these wandering performers had challenged poets and painters for almost a century. Already in 1833 Gautier had announced: 'When it comes to artists I esteem only acrobats.' After him came a long, uninterrupted line of eulogists, some responding to the social issues of the déclassé artist, others responding to the aesthetic of the performers, and still others harking back to another century and the mystery of Gilles as portrayed in Watteau's enigmatic painting. In the mid-nineteenth century, enthusiasm mounted to the general adoration of the mime Deburau. This gifted actor had roused Paris with his extraordinary performances. Many poets and painters characterized his Pierrot in terms ranging from pathos to popular joy. The prevalence of this art form in Paris continued to inspire artists well into the twentieth century.

Among the artists who had been inspired by Deburau and related street performance was Daumier. Rilke's first long description of *saltimbanques*

uggests that he was familiar with the Daumier drawings. One of the most affecting in the series *Les Saltimbanques* was published in the widely read journal, *L'Art*, in 1878 and elicited the following response from Henry James:

It exhibits a pair of lean, hungry mountebanks, a clown and a harlequin beating the drum and trying a comic attitude, to attract the crowd at a fair, to a poor booth in front of which a painted canvas, offering to view a simpering fat woman, is suspended. But the crowd does not come, and the battered tumblers, with their furrowed cheeks go through their pranks in a void. The whole thing is symbolic and full of grimness, imagination and pity. . . .

In his description James omits the slender child acrobat seated on a small performance carpet, the child who appears again in a still more celebrated Daumier representation, *Mountebanks Changing Place*. Here Daumier shows the old clown carrying all the props – rug and chair – as he walks, head lowered, through Paris. He is flanked by his wife holding a tambourine and his small, wizened boy. The child acrobat who moved so many artists appears in several of Daumier's drawings.

In his notebooks, Rilke has a long description of the troupe of Père Rollin that strongly recalls several painted representations. The scene is set in front of the Luxembourg gardens near the Pantheon: 'The same carpet is lying there, the same overcoats, thick winter coats, taken off and piled on a chair, leaving just enough room for the little son, the old man's grandson, to come and sit down now and then during the intervals.' The old acrobat no longer works. He has been transferred to beating the drum. 'He stands around patiently with his too-far-gone athlete's face, its features sagging in loose confusion, as if a weight has been hung on each of them, stretching it.' Rilke also describes the daughter ('one feels she has it in her blood') and the son-in-law, and then returns to the old man 'beating the drum like fourteen drummers'.

This experience recalled in 1907 was the immediate stimulus, no doubt, for a poem written a few months later, 'The Group', a compact impression of the crowd from several points of view; a gathering-in of spaces created by human movements:

> Like someone gathering a quick posy: so
> Chance here is hastily arranging faces,
> widens and then contracts their interspaces
> seizes two distant, lets a nearer go,
>
> drops this for that, blows weariness away,
> rejects, like weed, a dog from the bouquet,
> and pulls head foremost what's too low, as through
> a maze of stalks and petals, into view,
>
> and binds it in, quite small, upon the hem;
> stretches once more to change and separate,
> and just has time, for one last look at them,
>
> to spring back to the middle of the mat
> on which, in one split second after that,
> the glistening lifter's swelling his own weight.

This first issue of Rilke's attentive experience with the *saltimbanques* was a prelude to the celebrated final form, the Fifth Duino Elegy. But before the Fifth could arrive, he had undergone another change articulated in the poem 'Turning', written 20 June 1914 and dispatched immediately to Lou Andreas-Salomé because, as he writes, it 'depicts *the* turning which probably must come if I am to live . . .' He begins with the motto from Kassner, 'The road from inwardness to greatness goes through sacrifice', and in the first line describes the results of his previous turning: 'Long he was victorious in gazing.' He says that stars fell to their knees under his 'wrestling glance' and captive lions stared into his open glance as into inconceivable freedom, 'And the rumour that there was one gazing moved those less visible, moved those doubtfully visible.' Then he asks:

> Gazing how long?
> For how long already with fervour foregoing,
> Imploring in the depth of his glance?

He brings up again his long debate between judgment (gazing) and the demands of his heart, 'his nonetheless sensible heart', and comes to the conclusion:

> For gazing, see, has a boundary.
> And the more gazed upon world
> desires to prosper in love.

Then come the lines so often isolated by critics seeking to follow Rilke's turnings in order to draw the line between the sharply observed things in the *New Poems* and the abstract poems of the end of his life:

> Work of sight is achieved
> now for some heartwork
> on all those pictures, those prisoned creatures within you!
> you conquered them; but do not know them as yet.

Rilke's hoard of pictures, those prisoned creatures, was collected over a long period and intensely coloured by the work of visual artists. The spaces Rilke rendered in the *New Poems* were in many ways derived from the vision of the artists who had particularly moved him. One had only to follow his long concourse with El Greco, enriched with his pilgrimage impressions in Toledo, to reach the eventual starting point of the Duino Elegies. His first encounter with Spain was through the painter Ignacio Zuloaga whom he met in Paris in 1902 and who, he said two years later, was, after Rodin, the person with whom he had had the most important contact. At the time Zuloaga was one of the foremost proselytizers for the recognition of El Greco. In his Paris studio he kept several Greco paintings where Rilke (and probably the young Picasso) had ample time to study them. Six years later Rilke writes to Rodin: 'I am just back from the Salon where I spent an hour before Greco's *Toledo*. This landscape seems to me more and more astonishing. I must describe it to you as I saw it.' He gives Rodin a meticulous description in purely visual terms and completes the word-picture remarking, 'One should have dreams like that.'

The dreams came little by little, and always marked with the initial pictorial image by El Greco. In October 1912, Rilke writes to his publisher Kippenberg that he must go to Toledo. 'You know that Greco is one of the greatest events of my last two or three years.' A month later he writes an ecstatic letter to Princess Marie von Thurn und Taxis from Toledo. In it the complex spatializing he had begun in his description of Greco's *Toledo* in his letter to Rodin is still further elaborated:

What it is *like* here, that, dear friend, I shall never be able to say (it would be the language of angels, their use of it among men), but *that* it is, that it *is*, you will just have to believe me. One can describe it to no one, it is full of law, yes, I understand at this moment the legend that when on the fourth day of creation God took the sun and set it, he established it over Toledo: so very star-ish is the nature of this extraordinarily laid out estate, so outward, so into space – I know it forever, the bridges, both bridges, this river, and shifted over beyond it, this open abundance of landscape, surveyable, like something that is still being worked on. . . .

Eleven days later Rilke is still under the spell of his vision, the vision of spaces he had already folded away years before while waiting:

This incomparable city is at pains to keep within its walls the arid, undiminished, unsubdued landscape, the mountain, the pure mountain, the mountain of vision – monstrous the earth issues from it and directly before its gates becomes world, creation, mountain and ravine, Genesis . . . Until yesterday the weather was of the clearest, and the pageant of the evenings proceeded in quiet spaciousness, only today the sky became complicated . . . I have an inkling of what formations the atmosphere here must make use of in order to comport itself appropriately to the picture of the city: menacings rolled themselves up and spread out far away above the bright reliefs of other clouds that innocently held themselves against them, imaginary continents –, all that above the desolation of the landscape sombered by it, but in the depths of the abyss quite a cheerful bit of river (cheerful like Daniel in the lions' den) the great stride of the bridge and then, drawn wholly into the proceedings, the city, in every tone of grey and ochre against the east's open and quite inaccessible blue. . . .

These free-flowing notes of his response to Toledo indicate his increasing preoccupation with his relationship to Nature. A few years later, deeply depressed by the First World War (he wrote 'the world has fallen into the hands of men!'), he muses about his attitude to Nature – the attitude he had expressed in the poem 'Turning'. Working after Nature, he wrote in 1915, 'had in such a high degree made that which *is* into a *task* for me, that only rarely now, as by mistake, does a thing speak to me, granting and giving without demanding that I reproduce it equivalently and significantly in myself'. In the next sentence he thinks back to his Spanish experience and offers the clearest expression of this long germinating image:

The Spanish landscape (the last I experienced to the utmost) – Toledo – drove this attitude of mine to its extreme: since there the external thing itself – tower, hill, bridge – already possessed the incredible, unsurpassable intensity of the inner equivalents through which one might have been able to represent it. External world and vision everywhere coincided as it were in the object; in each a whole inner world was displayed, as though an angel who embraces space were blind and gazing into himself. This world, seen no longer with the eyes of men, but in the angel, is perhaps my real task. . . .

The coincidence of visions, and of time and space, he had so often sought when he spoke of *trans*-formation was realized in the Duino Elegies. During the long gestation of the book, Rilke had at times complained that he seemed forever to be looking through a telescope. At other times he spoke of the completeness of fragments, recovering the first insight he had had about Rodin. Looking from near and far, and finally, from within – from those infinitesimal spaces within the rose – Rilke paralleled the experiences of Frenhofer. He was tempted into the invisible where, as Frenhofer had cried, Art is vanquished. His new freedoms – to shuttle to and fro in the most rarefied spaces and in time, and in the most concrete emblems of space and time (paintings and poems) – coalesced in the Elegies. He was not impeded by 'progress'. Images stored for long periods were retrieved, enriched by their repose, and made full in the working. Rilke's objective days were over, at least insofar as his handwork was completed. All the same, the Elegies are replete with allusions to carefully noted experiences – most of all, the Fifth, where once again his experiences with works of visual art were inextricably woven in his handwork.

Scholars argue about Rilke's relationship to Picasso's great painting *The Family of Saltimbanques*, but the arguments are strictly scholastic. Rilke's habits tell more than enough about his deep reliance on the visual artist's gaze. The yoking of the Fifth Elegy and Picasso's masterpiece of 1905 is less important than seeing in Rilke's poem a confirmation of the latitude available to a great artist. It illustrates the idea that nothing is really synchronous in the history of art; that there are overlappings and thoughts that burrow through to surface finally with a new illumination. At the time Rilke returned to Picasso's painting he had already felt and understood Cézanne's work. He would probably have understood Picasso's later work after Picasso's confrontation with Cézanne. But Rilke was not always in objective focus, and the haunting Picasso of the earlier period was coextensive with his perceptions of more remote spaces and the feelings they engender. His work of sight, he had said, had been done. The heart-work was the new task at the time he was composing the Duino Elegies.

Is it important to know whether it was Rilke's own experience, recorded in 1907, with Père Rollin's troupe (which in itself was tempered by what he remembered of previous pictorial traditions) that was the first inspiration rather than Picasso's painting? Most likely both experiences mingled. It is quite possible that Rilke had known the Picasso painting for a long time. He was acquainted with Wilhelm von Uhde whom he saw in Paris fairly often. Uhde knew Picasso's work well and was a friend of André Level, whose organization, La Peau de l'Ours, had acquired the painting and was eventually to sell it on 2 March 1914 in an important auction. According to von Salis, Rilke had once prevailed upon Frau Herta Koenig to purchase the painting, and may have been responsible for her decision, later, to acquire it. If Rilke's Fifth Elegy was not inspired by the Picasso painting, why did Rilke dedicate the poem to Frau Koenig? In 1915, when Rilke requested the use of her apartment while he sought the right house in the country, he wrote:

I would beg for a bed in the guestroom for myself, a bed for my housekeeper, the kitchen, and permission to work at your magnificent desk – everything else would remain locked up; at most I would on some afternoon sit for a long time before the Picasso, which gives me courage for this beginning. . . .

On 28 June 1915, he writes to a friend: 'meanwhile I am sitting here in the apartment of friends . . . with the finest Picasso (*The Saltimbanques*) in which there is so much Paris that, for moments, I forget.' Finally, on 10 October, he writes: 'I must leave these rooms tomorrow, as the owner is returning from the country, and with them the glorious big Picasso beside which I have been living for almost four months now.'

Unquestionably the painting revived Rilke's memories of Père Rollin's troupe, and his complicated feelings about Paris. By the time he wrote the Fifth Duino Elegy, which came to him, as he said, as a radiant afterstorm of the three-week period during which he had completed the rest of the Duino Elegies, Rilke had long abandoned the 'objective' mood. The chiselled surfaces he had once valued became recessive. Description of equivalents became secondary to perceptions of inter-relationships so complex as to verge on abstraction. A new task – to interiorize like the blind angel in Toledo – assumed the greatest importance. Yet Rilke lost none of the power acquired during the days of gazing. His imagery in the Fifth Elegy does in fact parallel closely the images in Picasso's painting, and the emotional intent is identical. The forsaken atmosphere of Picasso's troupe of grave performers, their expectant stance, the whole group thrown against the timeless sky, correspond to Rilke's vision, to his sentiment. Though there are more figures in the painting, it is conceived, as is Rilke's poem, to suggest not so much subject-matter as penetrating mood. For Rilke, the painting and his early memories were fused (and some of those memories might even have owed something to Picasso's work of the period, for some of his studies of acrobats and their families had been exhibited while Rilke was in Paris). The close parallels in the two artists' conceptions are sometimes uncanny. For instance, Rilke's description of the child acrobat in his 1907 notebook:

He is only a beginner they say, and those headlong leaps to the ground out of high somersaults make his feet sore. He has a large face that can take a swarm of tears, but often they hold back inside the rim of his swollen eyes. Then he has to carry his head carefully, like a cup that is full to the brim.

The child is remembered in the Fifth Elegy:

> You, that fall with the thud
> only fruits know, unripe,
> daily a hundred times from the tree . . .

that man is clapping his hands for the downward spring, and before
a single pain has got within range of your ever-
galloping heart, comes the tingling
in the soles of your feet, ahead of the spring that it springs from,
chasing into your eyes a few physical tears.

The figure of Père Rollin is also drawn from the Paris years when Rilke described him with his too-far-gone athlete's face, 'its features sagging in

loose confusion as if a weight had been hung on each of them, stretching it'. This image recurs frequently in Picasso's studies, where he is sometimes called the buffoon.

> There, the withered wrinkled lifter,
> old now and only drumming,
> shrivelled up in his mighty skin as though it had once contained two men . . .

For Rilke the figure of Père Rollin assumed increasing importance. He had spoken of him in 1907 as he always spoke of artists: 'The strength is still there, young folks, he says to himself; not handy any more, but that's the whole point; it's gone into the roots – it's still there somewhere, the whole lot of it.' Rilke repeatedly urged his admirers to think of art as a slow process, and of artists as trees that grow slowly and patiently from deep roots. This is one of the signal themes in the Fifth Elegy, reflected in the person of Père Rollin. Rilke's long meditation on the nature of art, shaped by his experiences with Rodin and Cézanne, finds its fulfilment in the Fifth Elegy. His attraction to the old masters, the romantic old masters who never lost their wonder at their own unending urge to realization, remains and flows into the Fifth Elegy from the very first lines:

> But tell me, who *are* they, these acrobats, even a little
> more fleeting than we ourselves, – so urgently, ever since childhood,
> wrung by an (oh, for the sake of whom?)
> never-contented will? . . .

There – in the 'oh, for the sake of whom?' – is Rilke's youthful question, posed for Rodin first, and then for Cézanne who, like Hokusai, wrote six and thirty and a hundred times the mountain peak.

Rilke understood certain problems as fundamental for all artists, regardless of their medium. He speaks in the poem of the problem of maintaining the delicate balance between a highly developed skill and deep, immediate feeling. For painters it becomes the problem, as it was understood already in the nineteenth century, of 'finish' as against the quick verity of the rough sketch. Rilke suggests that these acrobats, with their countless repetitions, have perhaps lost the passion and preserved only the perfection of their art:

> Where, oh, where in the world is that place in my heart
> where they still were far from being *able*, . . .

From the moment Rilke had encountered the myriad fragments in Rodin's studio his reflections had circled this problem. He develops the thoughts inspired by Rodin's ceaseless fashioning and refashioning to their highest point, consummately stated in the lines:

> And then, in this wearisome nowhere, all of a sudden,
> the ineffable spot where the pure too-little
> incomprehensibly changes, – springs round
> into the empty too-much?
> Where the many-digited sum
> solves into zero?

The long pondered work of the hand, in the Fifth Elegy, is no longer seen in terms of simple craftsmanship. The tenuous balance between consummate

craft and heartwork could perhaps never be confidently held, but artists, he always thought, were born to transform. He tells us in a hundred ways of the ineffable spot between the pure too-little and the vacuous too-much. He had extended his understanding of the art of the painter through just such an awareness of Cézanne's reiterated problem, and he often felt, as Balzac had put it in *The Unknown Masterpiece*, that 'practice and observation are everything to a painter, and that, if rhetoric and poetry quarrel with the brush, we reach the doubting stage'. Rilke's deep respect for the gestures he felt to be pure and 'rooted' (such as the gestures of the lacemaker, the potter of the Tanagra figurine, or of Père Rollin) lay behind his constant concern for a truthful representation. In 1924 he answered a letter about 'influences' by calling himself a disciple of Rodin:

For at bottom of all the arts there operated the one, same challenge which I have never received so purely as through conversations with the powerful master who at that time, although of great age, was still full of living experience. . . . But I often ask myself whether that which was in itself unaccented did not exercise the most essential influence on my development and production: the companionship with a dog, the hours I could pass in Rome watching a ropemaker who in his craft repeated one of the oldest gestures in the world . . . exactly like that potter in a little Nile village, to stand beside whose wheel was, in a most mysterious sense, indescribably fruitful for me. . . .

In the Fifth Elegy the threadbare carpet, 'this carpet forlornly lost in the cosmos', is the stage for the ritual repetition of some very old gestures. Picasso incarnates the same feeling by clustering his troupe against a vast, empty landscape where they stand immobile, expectant, pausing before the never-to-be-realized satisfaction that Rilke envisages only in the realm of angels:

> Angel: suppose there's a place we know nothing about, and there,
> on some indescribable carpet, lovers showed all that here
> they're forever unable to manage . . .

Lovers and artists are one, for ever unable to manage, yet indefatigably seeking the perfect experience known only in rare moments. The experience lies always beyond, in the unnameable abyss that Rilke tried again and again to characterize. In his letters and notebooks he returns frequently to recollections of moments that brought him close to the angelic ideal. In 1914, for instance, he writes to Princess Marie of an early morning in a villa facing a park: 'everything was in tune with me – one of those hours that are not fashioned at all, but only as it were, held in reserve, as though things had drawn together and left space, a space as undisturbed as the interior of a rose, an angelical space, in which one keeps quite still.' These serene spaces to which Rilke gravitated more and more towards the end of his life, experiences that he described as 'content-less', seemed to him to belong 'to some higher unity of events'. All the things, with their human associations, and all the human gestures he consecrated in his poems, would attest to what he once called 'the inexhaustible stratification of our nature'; the Elegies, as he wrote in 1925, show us

this work of the continual conversion to the dear visible and tangible into the invisible vibration and agitation of our own nature, which introduces new vibration-numbers

into the vibration spheres of the universe. (For, since the various materials in the cosmos are only the results of different rates of vibration, we are preparing in this way, not only intensities of a spiritual kind, but – who knows? – new substances, metals, nebulae and stars.)

Rilke shared with many artists in the early twentieth century this urgent need to imagine a whole, a universe beyond what he called the mundane. Both Kandinsky and Klee arrived at the still spaces Rilke so often shaped in his poems through similar chains of thought, and both were tempted in their art to move beyond. Almost at the end of his life, Rilke told von Salis: 'The terrible thing about art is that the further you go into it the more you are pledged to attempt the uttermost, the almost impossible.'

Aside from this Frenhofer-like need to go the uttermost, Rilke also craved the union, the law, the root, the cell from which to craft his vision. He clarified his necessities first through his comprehension of Rodin's system of *le modelé* and next through Cézanne's unending system of reciprocity among visible surfaces. From there he moved to the sensed, the invisible, the spaces unknown to us – such as the interior of the rose – but always present to the imagination. His malaise, and the malaise of many twentieth-century artists, was rooted in metaphysical hunger that no amount of rational, scientific analysis of life could assuage. He said it clearly in the first Duino Elegy: We don't feel very securely at home within our interpreted world.

CHAPTER FOUR

Picasso and Frenhofer

'There are no poets,' Picasso said in his early youth, 'there is only Rimbaud.' For Picasso's generation, steeped in modern lore, Rimbaud, with his youthful impetus to overcome everything familiar, was a model rebel. Rimbaud had even reproached the revered Baudelaire, who, although he had insisted that it was necessary to be modern, had not, in Rimbaud's opinion, gone far enough. The will to surpass was part of the modern imperative and the sixteen-year-old Picasso was determined to live up to Rimbaud's extravagances. In a letter to his friend Bas, he wrote:

I am going to make a drawing for you to take to *Barcelona Comica*. We'll see whether they'll buy it. It must be modernist for a paper like that. Neither Nonell, that young mystic, nor Pichet, nor anybody else has reached the extravagance I attain in this drawing.

The conscious sense of the modern's mission to push beyond all boundaries is reflected again in the Catalan notebook where he writes: 'A tenor who hits a note higher than that written in the score – I!' From his earliest youth Picasso accepted the modernist contest both in its positive aspects (its optimistic attitude towards the future) and in its thorny paradoxes (its critical suspicion of modern life and its rejection of technical progress as the true gauge of modernity). The desire to surpass was matched by the desire to reject even the articles of faith of modernism itself. Picasso, even in his teens, was wary. He was critical of the vanguard movements of his time and declared that if he had a son he wouldn't send him to Paris although he himself would love to be there, but to Munich 'where they study painting seriously without worrying about fashions like pointillism and so on'.

But he himself did gravitate to Paris at around the same time as Rilke, and he did, like Rilke, set himself resolutely to the task of absorbing everything. As different as the two temperaments were, Picasso's and Rilke's backgrounds had many points of coincidence. Both artists had come to Paris with a sense of the remoteness of their cultures from the central preoccupations of Paris. Both were by nature critical. Nothing was to be taken for granted, not even the hegemony of the Parisian vanguard modes. There were even crossed paths. One of Rilke's closest friends was Zuloaga, and since Picasso was a frequent visitor at Zuloaga's during his first sojourn in Paris, Rilke might already have heard about him then. Without question, within two or three

years he knew of Picasso through his friend, the dealer and connoisseur Wilhelm von Uhde. Uhde had bought Picasso's gouache *The Death of Harlequin* of 1905 and shortly after lent it to Rilke. Both Rilke and Picasso reacted to the 1907 Cézanne retrospective definitively by drawing back from the Frenhofer-like impulse to plunge into the abyss and by eschewing expressionism. Rilke needed, as he said, the unity, the law, the root, the cell from which to craft his vision, while Picasso, who later called Cézanne his one and only master, needed the elements from which to derive a system of forms. Finally, there was also the importance to both men of Balzac's *Unknown Masterpiece*. Rilke's abiding fascination with the obsessions of old men led him naturally to seize the significance of the fable for Cézanne and, therefore, for himself. Picasso, when he undertook to illustrate the story for Vollard, had not yet experienced the full impact of Frenhofer's disaster. That was to come later. But Frenhofer was as firmly ensconced in his imagination as he was in Rilke's.

Picasso's lifelong interest in poetry must be taken as significant to his development as a painter. Everything in his history points to a serious preoccupation with the themes that reside consistently in the poetic imagination. For all his experimentation with the formal aspects of painting, he always returned to the grand themes germane to poetry. He seemed to reserve for himself an area in which his imagination could be nourished by the condensed associations of poets, and he was comfortable in the company of poets – more than he was in the company of painters. The friendships with a long line of poets – Sabartès, Salmon, Jacob, Apollinaire, Reverdy, Eluard and Ponge, to mention only those most closely associated with him – were a necessity, not merely a preference.

The need expressed itself early. When he was sixteen and already an independent artist functioning in the vivid bohemia of Barcelona, he spent many hours listening to discussions of modern poetry, philosophy and painting. Many of the habitués of Barcelona's cafés have recalled Picasso's intent manner of listening, and the acuity of the few remarks he permitted himself in the company of mostly older poets and artists. The attitudes which were to shape his lifelong struggle against the philistinism of bourgeois life were formed in those years. All Picasso's closest friends have commented on his strong identification with Barcelona and his adherence to certain of the positions so avidly discussed at the *tertulias* of Barcelona during the last years of the nineteenth century and the first few years of the twentieth.

The *modernistas* Picasso encountered in Barcelona were impatient with Spain, which they regarded as a hopeless backwater, a provincial extrusion of Europe that had never come to grips with modern life. In Catalonia the irritation was amplified by the separatist vision shared by the entire population. The intellectuals to whom Picasso listened and with whom he worked on vanguard journals sought cultural independence and even political liberation. The high pitch of their enthusiasm is easily detected in their reviews where references to the great rebels abound. Prince Kropotkin's civilized anarchism, as well as more nihilistic versions, found much favour with the artistic rebels, as did Nietzsche's soaring rhetoric, with its explicit contempt for bourgeois hypo-

crisy. Artistic influences from Europe always tended toward the exotic and consciously rebellious. Emile Verhaeren, whose works such as *Les Debâcles* (1888) and *Les Villes Tentaculaires* (1895) reminded readers of Walt Whitman, was especially revered and widely quoted. 'The poets of twenty years ago', he wrote for his Catalonian admirers, 'are different from those of today in that they obeyed general laws of prosody and grammar, while today's poets seek their own forms in themselves, forging their own order and not submitting to any rules other than those emanating from their own manner of thinking and feeling.' Verhaeren was one of the Europeans who identified for the Spanish themselves a sombre force which he characterized in the book he collaborated on with Dario Regoyos, *España Negra*. Regoyos describes a journey through Spain in which the two listened to gypsy songs, visited cemeteries, watched the stirring rituals of ecclesiastical ceremonies and sought the tenebrous Nietzschean counterpart to the bright Spain of more superficial travellers. Regoyos said that Verhaeren was the first to see the dark side of Spain, the *macabra*.

At the same time, the painters were looking towards the north, towards expressionism as Munich conceived it, or eroticism as Aubrey Beardsley exemplified it. They were also discovering their own *macabra*, as did the artist whom Picasso referred to as 'that young mystic Nonell', who sketched the misery of the poor, and, after the defeat of the Spanish in the Spanish-American war, recorded the desolate return of the refugees. Nonell was probably not the only painter who had been brooding on the power of Daumier, but he was the one who most explicitly reflected the sombre tone of Daumier's late works. Nonell has often been cited as a specific influence on Picasso because of his marked preference for dark colours and particularly blue. But blue was the common reference to melancholy during the late nineteenth century, transmitted for several generations in European poetry. (Gérard de Nerval's interest in German romanticism was probably the immediate source.) Blue becomes a reflexive allusion in French poetry, for instance, from Nerval through Mallarmé ('je suis hanté, l'azur, l'azur, l'azur'). Quite possibly the South American Ruben Darío, whose first major book was titled *Azur* (1888), knew Mallarmé's lines. In any case, Darío figures substantially in the formation of the avant-garde to which Picasso belonged in Barcelona. His first visit to Spain in 1892 had been heralded by enthusiastic critics, and by the time he visited Barcelona in 1898 he was an acknowledged master of modernism and much revered. Juan Ramon Jímenez recalled that 'Ruben Darío was considered friend and master by a part of the generation of '98, influenced as they were by some of *los raros*, by Ruben Darío and other rare souls: Ibsen, Nietzsche, Maeterlinck'. He said that poets read and copied him and 'others, including painters, surrounded him, spoiled him, loved him, treated him like a big child with genius'. On his side, Darío wrote of his visit to Barcelona, where he was delighted with the café Els Quatre Gats which Picasso frequented, and noted the constant political manifestations with their red flags and the frequent anarchist bombings.

Darío's determined modernism, his cosmopolitanism (he said that modern society builds a Tower of Babel in which everyone understands everyone else)

piqued the Catalonian poets. When his *Prosas Profanas* appeared in 1896, it was received almost as a manifesto. The book, says Octavio Paz, with its title 'halfway between erudite and sacrilegious', caused even more irritation than the earlier book. 'To call a collection of predominantly erotic poems *prosas* – hymns that are sung at High Mass following the Gospel – was more than an archaism, it was a challenge.'

Paz points out that the preface caused a scandal. 'It seemed to be written in another language, and everything it said sounded like paradox. Love of novelty, on condition that it not be of the present time; exaltation of the self and disdain for the majority; supremacy of the dream over the waking state and of art over reality; horror of progress, technology and democracy.' Among all these tendencies in Darío's work, Paz singles out the hallmark of *Modernismo*: the freedom of art and its gratuitousness, and the negation of all schools, not excluding his own.

These two preoccupations animated the artists and writers with whom Picasso associated just before his first trip to Paris. They undoubtedly helped him to thread his way through the bewildering varieties of vanguardism in Paris. By the time of his third visit to Paris in 1903, when he had managed to acquire a rudimentary knowledge of French, Picasso had been well exposed to the tumultuous intellectual life that made Paris before the First World War so attractive to foreign artists. There, the lingering romanticism of Barcelona's *Modernismo*, with its strong symbolist tendencies and its yearning for the abyss, was offset by liberal infusions of irony. The French had already during the last decade of the nineteenth century challenged the reigning princes of symbolism. 'As for ourselves,' wrote one essayist in 1896, 'the Beyond does not interest us', and went on to discuss the new 'school', called 'naturism'. Charles Maurras, whose 'school' was the 'Romanic', said of the new poets that 'not one has used the term: the infinite'. Others rejected both mystical and religious tendencies in poetry, and still others called for the abolition of abstraction in language. When Jules Laforgue passionately swept away the last of the rules and vowed to deal with 'la vie quotidienne', his ironies dispelled the fogs of symbolist yearning. And Max Jacob, the first French poet Picasso met, was an heir to Laforgue's obsessions, despite his vigorous shouting 'A bas Laforgue' and 'A bas Rimbaud'. The story of Jacob, André Salmon and Apollinaire crying 'Down with Laforgue and Rimbaud' in the streets near the Bateau Lavoir meant only, as Salmon explains in his memoirs, that 'Max wanted to teach art not to follow anyone'.

If Picasso recognized Jacob – and he maintained his deep respect always – it was undoubtedly because Jacob knew the two voices of modernism so intimately and was a creature of paradox. Jacob's challenge to the shattering force of his own deep sentiments arrived in his poetry through the medium of applied irony. Although he had deeply mystical tendencies and was a Catholic convert, Jacob shared the rebellious spirit of his time and had little use for the fine aestheticism and otherworldliness of the old symbolist legacy. The critic Wallace Fowlie said that his art 'is an affront to the languorous, the plaintive, the serious in art. . . . Superficially his poetry would seem to be largely composed of commonplaces, of witticisms, of gossip about

faits divers. But the deeper, more total effect of his poetry is one of exceptional suppleness in verbal expression, of infinite metamorphosis.'

Jacob took themes hallowed in the romantic tradition, such as the ubiquitous theme of wandering acrobats and performers, and delivered them up in robust, ironic terms, often recalling the downed Laforgue. In *The Acrobat in the Third Class Carriage*, for instance, he begins: 'The acrobat! The acrobat took the express at 9:30, took the Paris-Nantes express. Take care, care, O acrobat, that you do not miss the train when it leaves. And here is her heart singing: oh! to feel in the gracious night that you are following the direction of the great river, in the western night, in the widowed night . . .'

Characteristically, Jacob writes factually, flatly, as he begins and bursts into lyricism as he goes on, at times reaching fine poetic climaxes. But finally, he returns to everyday reality, and to his own small smile, winding up with a strutting Apache's description of the acrobat as 'beautiful and without swank; she has lips like a tomato'.

Such satire was not alien to Picasso, who had already demonstrated in his drawings his own sharp response to certain of the more excessive features of the romantic tradition in Barcelona. But in sharing his life for a time with Jacob in a small hotel room he undoubtedly came closer to understanding the double edge of irony and the inevitable distancing it demanded. Pathos, satire, lyricism and irony all mingled in his own work from around 1900 to 1904, indicating that he was accessible to the voices he heard in the new poets. Ideas and experiences came to Picasso through many channels that he carefully kept open. First Max Jacob and later Guillaume Apollinaire kept him alert to the volatile flurries of aesthetic change within the world of poetry and discourse. On his own he turned a voracious eye on the painting heroes of the late nineteenth-century avant-garde, Van Gogh, Seurat, Gauguin and Cézanne. (During his three sojourns in Paris before he finally settled there in 1904 he had had a chance to study Daumier in the huge 1901 exhibition at the Ecole des Beaux Arts, Cézanne in the Salon d'Automne, and also Redon and Gauguin.) Both Van Gogh and Gauguin, by Picasso's own testimony, loomed large in his early Paris days. The symbolist poet Charles Morice, Gauguin's first biographer, had taken an interest in Picasso and, in 1902, published an article on him in the prestigious *Mercure de France*. Morice pointed out that this twenty-year-old, who learned to paint before he could read, 'seems to have been assigned the mission of expressing with his brush everything there is'. It was Morice who gave Picasso the copy of *Noa-Noa* which he annotated and kept with him all his life. Gauguin's crouching women make their appearance in his work during this period, notably in a major work of his youth, *La Vie*. The pose itself was not unusual in paintings of the period. Rodin had often worked with the idea of crouching. But Picasso seemed to find in the Gauguin drawing the sense of an aboriginal ease in the Tahitian women. His self-conscious modern eye sought the natural expressiveness of what was then considered truly primitive and happily remote from the awkward studio poses of the academies.

Picasso's interest in Gauguin was in keeping with his pronounced concern with allegory both before and after the years of Cubism. He was able to

nourish his allegorical imagination in concourse with poets and writers, but an example such as Gauguin's *Who are we, where have we come from, where are we going?* was still more compelling. With characteristic audacity, Picasso pursued allegorical themes long after other modern Parisians had resolutely abandoned what they dreaded as 'literature' in painting. Many of his paintings and sketches of the years between 1900 and 1905 – the year of *The Family of Saltimbanques* – were legitimately allegorical in content. The word *allos* or 'else', 'other', is the key: in all the yearning, melancholy and contemplative studies, either of traditional maternity scenes, nocturnal meditations, or increasingly frequent portrayals of strolling players, there is always an intent to suggest another realm in which such dramas are played out. During these years he frequently drew circus figures and his interest is sometimes explained in terms of youthful exuberance – his ability to spend countless nights watching performances and chatting with performers at the Cirque Medrano, or on the streets of Paris where little bands of acrobats still set up as they had in Daumier's day and beat their drums forlornly. Yet, the actual contact with the scenes Toulouse-Lautrec and Seurat had already celebrated was probably not nearly as inspiring to Picasso as his own poetic identification with Harlequin, apparent not only in the early years but in his last as well. No one has better understood this poetic side of Picasso's gifts than Jean Leymarie, who speaks of

his clear personal identification with the mythical figure of Harlequin who under his fancy costume and jester's cap harbours supernatural secrets bound up with his mercurial ability, his overriding boldness, his collusion in subterranean forces and the kingdom of death. . . .

Leymarie also notes the frequency of the Harlequin theme in Apollinaire's poetry, and, apropos of *The Death of Harlequin* which Uhde had lent to Rilke probably in 1905, the year it was painted, writes:

Both Apollinaire and Rilke, each in terms of his personal system of metaphors, divined what is so profoundly implied here by Picasso: that Harlequin's original realm is that of death, whose ferryman he is, and that the 'mute rites' of the circus preserve under their travesty and degradation, a sacred tenor.

If Picasso was not directly acquainted with the tradition going back to the period of Deburau, certainly his close companions, the poets Salmon and Apollinaire, were. The theme of Pierrot, sometimes ironized, sometimes romanticized, appeared regularly in poetry, and in 1905 Picasso illustrated Salmon's first book of poems, *Pour l'ami Pierrot*. With Apollinaire Picasso obviously found much common ground. The dialogue between these two phenomenally energetic temperaments must have produced many an exchange of quick insights and cultural reference. Both were tireless foragers, and both claimed rights granted by the modern tradition. They sought points of reference as widely as possible, and preferably in remote portions of time, history and geography. If Picasso begins to emphasize purity of line, and if Apollinaire speaks admiringly of such line in relation to ancient Greek vase painting, there is no way of telling who suddenly rediscovered the Greeks. What is certain is that the two men relished the rapid enthusiasms which

26 Picasso's The Death of Harlequin *(1905), a gouache which was lent to Rilke by the German art dealer, Wilhelm von Uhde. (From the Collection of Mr and Mrs Paul Mellon)*

27 Picasso, La Vie *(1903), gives evidence in the crouching woman of the young artist's interest in Gauguin. (Cleveland Museum of Art, Gift of Hanna Fund)*

28 Picasso, The Family of Saltimbanques, *1905. This is a painting whose subject bears various parallels with the Fifth of Rilke's* Duino Elegies. *(National Gallery of Art, Washington, D.C., Chester Dale Collection)*

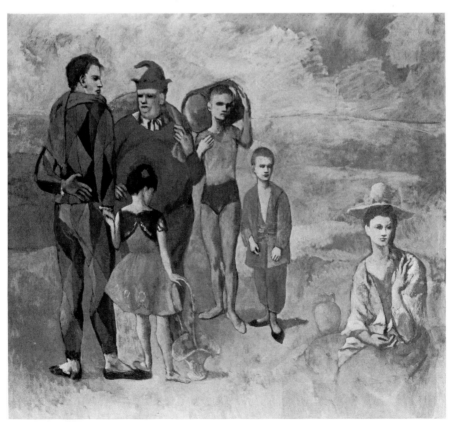

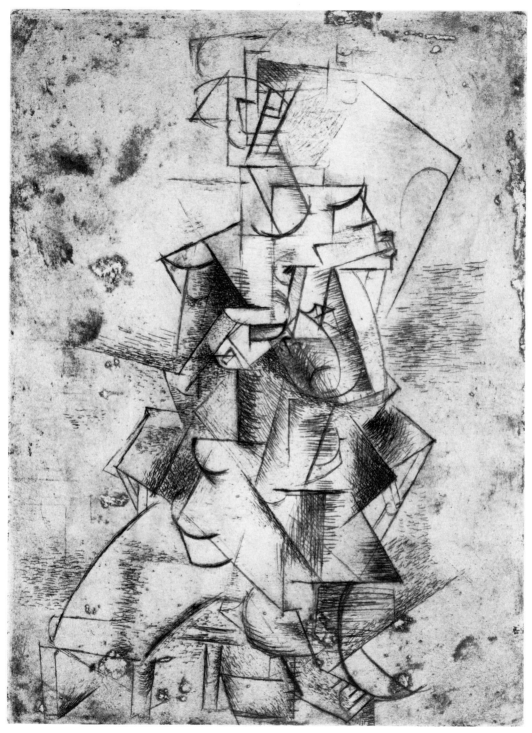

29 Picasso: Saint Matorel *by Max Jacob, plate 3 (1911), an etching of the Cubist period when Picasso and Braque were rediscovering the reality of form. (The Museum of Modern Art, New York, Louis E. Stern Collection)*

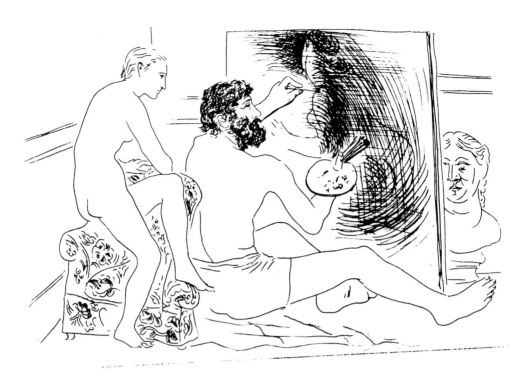

30 Picasso, etching illustration for Balzac's The Unknown Masterpiece *(published in Paris by Ambroise Vollard in 1931) of an artist painting a nude while being observed by a nude model, 1927.*

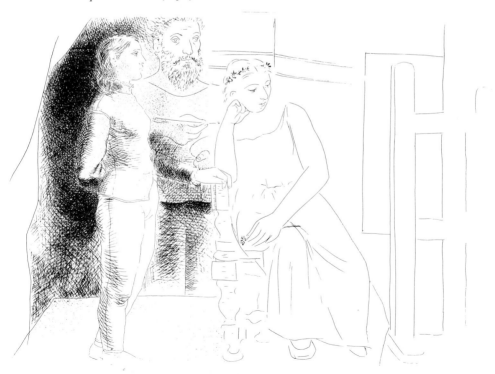

31 Picasso, illustration for The Unknown Masterpiece. *The book contained 13 etchings and 67 wood engravings. (The Museum of Modern Art, New York, Louis E. Stern Collection)*

32 Picasso, one of the introductory series of drawings for The Unknown Masterpiece.

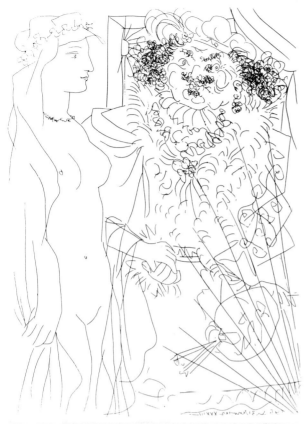

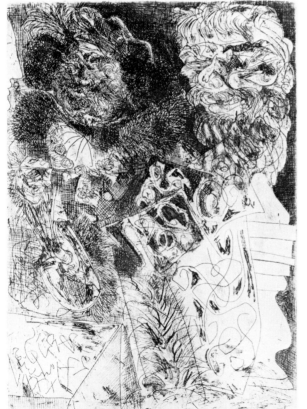

33,34 *Picasso, two etchings from The Vollard Suite with the impassioned head of Rembrandt, 1934.*

35 *Picasso, drawing from the 1945* ► *series* Nues dessins d'Antibes, *expressing some of the Dionysiac character of the ancient Greek satyr play.*

36 *Picasso, an untitled India ink drawing of 1972, in which the artist seems to be harking back to his Spanish origins. (Private collection)*

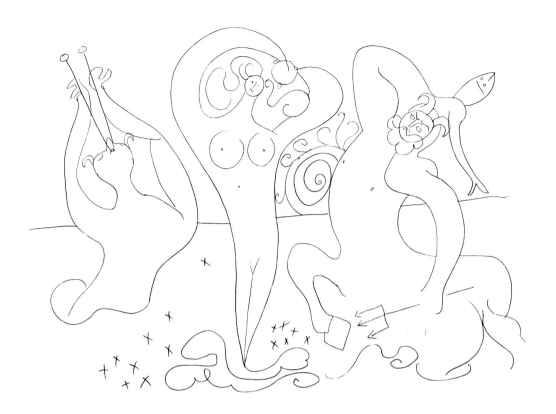

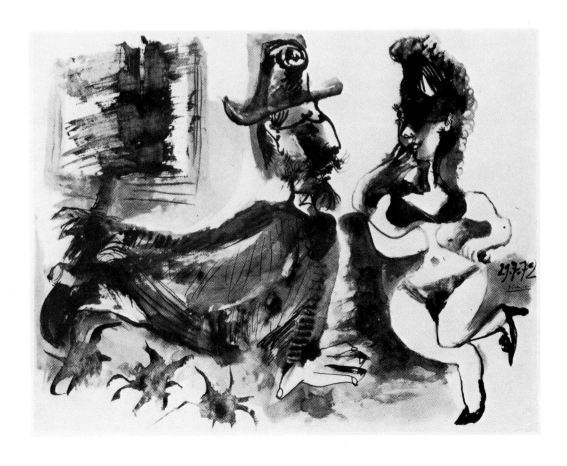

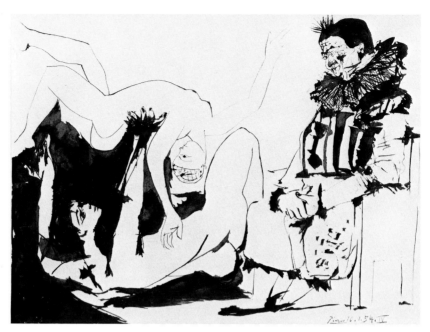

37 Picasso, In the Wings of the Circus, *1954. One of the themes throughout Picasso's career was that of the watcher and the watched. (Private collection, photo courtesy Christie, Manson and Woods, Ltd.)*

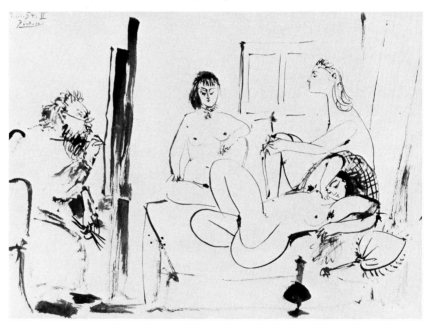

38 Picasso, ink drawing entitled The Studio (Models), *1954. The painter at work on his canvas was another of Picasso's obsessive themes. (Private collection)*

39 Arnold Schoenberg's portrait of fellow-composer Alban Berg, 1908–14. (Historisches Museum der Stadt Wien, courtesy Helene Berg)

40 *Kandinsky in Munich, 1913. He and Schoen-
berg were not only friends in this period but also
shared the exploration of new directions for art.*

41 *Kandinsky,* Composition VII, *1913. (Tret-
yakov Gallery, Moscow)*

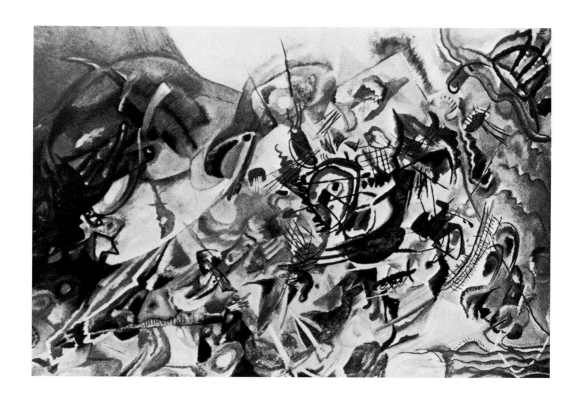

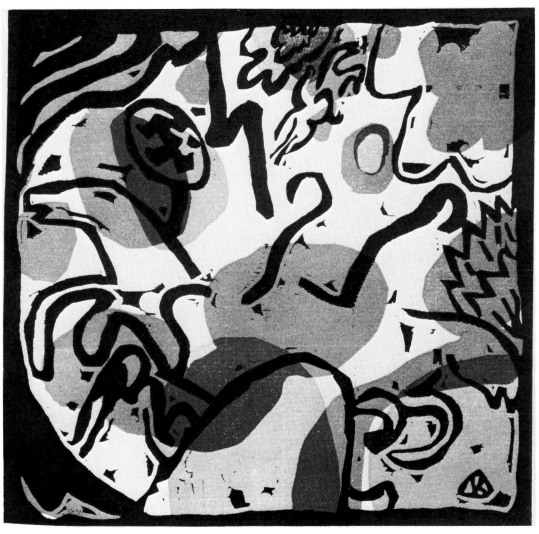

42 Kandinsky, Klänge, *plate 8 (1913). (Museum of Modern Art, New York, Louis*
E. Stern Collection)

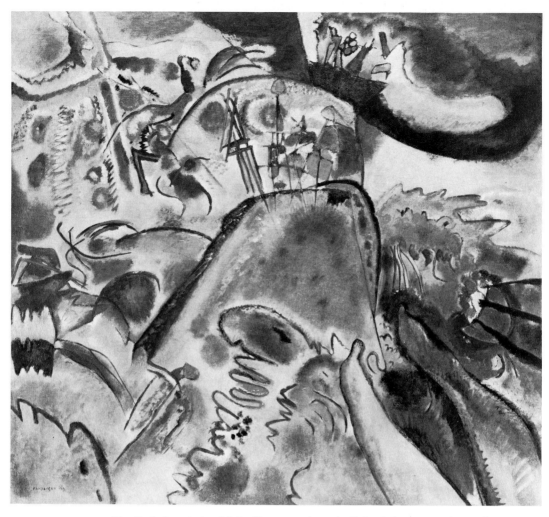

43 Kandinsky's painting Little Pleasures *(1913). (The Solomon R. Guggenheim Museum, New York)*

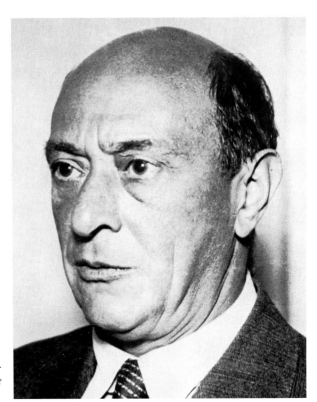

44 *Photographic portrait of Schoen-*
berg. (Bildarchiv der Österreichische
Nationalbibliothek, Vienna)

45 *Schoenberg,* Self-portrait in Blue
and Orange, c. *1910. (The Arnold*
Schoenberg Institute Archives, Los
Angeles)

46 Schoenberg, page of score of Pierrot Lunaire (1912), with an instruction to the singer (at the bottom) pertaining to the technique of Sprechgesang. (Universal Edition [Alfred A. Kalmus Ltd])

47 Schoenberg, first manuscript page of his Piano Suite Op. 25, which is regarded as the first composition in which the 12-tone system was used throughout. (Universal Edition [Alfred A. Kalmus Ltd])

48 Malevich, Supremus No. 50, 1915. (Stedelijk Museum, Amsterdam; photo The Solomon R. Guggenheim Museum, New York).

typified the effervescent days before the First World War in Paris. As Apollinaire frequented several quite different literary and artistic circles, he was able to bring Picasso a kind of syllabus of what he later called 'l'esprit nouveau', by which he meant a melange of all the often conflicting rebellions bestirring the arts. Apollinaire's natural gift for the mixture of real life and art brought him to an ideal that honoured the heterogeneous, the imperfect. He saw himself as a transformer of life itself, and not merely as mime or interpreter. In this he and Picasso had clear affinities.

When, some time after 1905, Picasso seemed to seek a more 'objective' voice, as did Rilke, it was partly in response to the menu of ideas Apollinaire produced for him. The word 'objective' became a café word for painters only after Cézanne's memorial retrospective in 1907, but it had long been a topic of debate among poets. The rebellion against the refinements of symbolism led by such poets as Paul Fort and Jean Moréas was still in force in 1904 when, André Salmon recalls, Picasso enjoyed Paul Fort's company at the famous Tuesday evenings at the Closerie de Lilas. Whether the reaction in poetry was grave and neo-classical, as in the case of Moréas, or ironic and extravagantly modern, as in the case of Jacob or Apollinaire, the effect was the same: it decisively altered the artistic climate, and Picasso, alert in every sense, responded. By the time he undertook *The Family of Saltimbanques*, the overt emotionalism of the Blue period had given way to a kind of classical restraint.

Yet there was little consistency in those years. Picasso and Apollinaire moved easily from one voice to another. Picasso's early interest in the lives of working-class families, evident in many of the Barcelona drawings, and his disdain for the bourgeoisie prepared him to understand some of Apollinaire's flirtations with social ideas that promised to relieve society of *juste-milieu* injustices. Apollinaire knew Alexandre Mercereau and Charles Vildrac, who published the journal *La Vie*. They had been inspired by the previous generation, particularly by Gustave Kahn's efforts to ally artists and workers against the bourgeoisie. In 1904 a group of writers and painters decided to form a commune. The stated intentions were to condemn the decadence of city life, elude bourgeois control of the art world and integrate the artist into popular life by transforming him into an artisan. Tolstoy, Kropotkin and William Morris were resurrected, while Verhaeren was a hero since he had reviled modern city life. They set up a press and printed the poems of Jules Romains from 1904–7 titled *La Vie Unanime*. From these poems the utopian, mildly socialist movement, Unanimism, took its credo. Apollinaire, while on the fringe of this circle, was deeply interested for a time, and may have reminded Picasso of his old Barcelona days of anarchist enthusiasm.

Apollinaire noticed a new note in Picasso's paintings around 1905, prompted no doubt by these excursions. 'Under the gaudy tinsel of his slender acrobats, one can discern the young man of the people, versatile, cunning, skilful, poverty-stricken and lying.' He also noticed Picasso's ability to mix allusions to the real – the young men of the people – with the necessary imaginative transcendence. In a poetic essay written a month later (15 May 1905), he wrote that Picasso 'had looked at human images that float in the

azure of our memories and that partake of the divine to the damnation of the metaphysicians'. Picasso's desire to express timeless truths that Apollinaire said were 'born of the profound knowledge that humanity had of itself' in ancient times, never flagged. When he was over eighty his biographers Daix and Boudaille visited him and showed him a photostat of Apollinaire's 1905 essay. 'He read the first lines aloud with an emotion to which he does not yield easily', they reported.

In 1906 at the Salon d'Automne, the Fauves burst upon Paris. Their primary motifs were landscape. Picasso, on the other hand, was still probing the meaning of his art through the human figure, either in allegorical contexts or as an isolated symbol. His search focused mainly on the female nude around whom, like Frenhofer, he wove a web of fantasies in his lifetime that are sometimes underestimated because of the events that occurred from 1906 on, and their consequences.

From 1906 until the First World War Picasso was absorbed in vertiginous adventures that historians have tried to rationalize by means of meticulous dating. They have tried, for instance, to establish exactly when he encountered African and Oceanic masks and sculptures in the ethnic museum at the Trocadéro. They have tried to trace the precise moment when the impact of pre-Roman Iberian sculpture was felt in his work. Some have sought to establish the effect of the great Romanesque murals in Barcelona in the paintings from late 1906 on, and others have tried to minimize the visual influences of the period in favour of the intellectual stimulants so readily available in those years. But to insist on these details gets us no further in understanding the volatile formative instinct that was fully released in Picasso's mid-twenties. Being a painter of considerable experience by 1906, Picasso was prepared to make good his earliest intentions: to take up the injunctions of the modern state of mind.

It is certainly true, as James Johnson Sweeney has written, that the large exhibition of Iberian sculpture at the Louvre in the Spring of 1906 startled and profoundly impressed Picasso. But everything in his previous development had prepared him for the impact. The rounded volumes of the simplified heads and the stylized features were the common characteristics of primitive art that had already been extolled by Gauguin. Picasso himself had vaguely worked the year before in linear simplification of the human body. The venturing forth in 1906 grew out of the fusion of a painter's need to push forward with formal inventions and his desire to make a fresh start. All painters know this experience. What happened in the decisive adventure, which was to become the *Demoiselles d'Avignon*, was probably pretty much as Rilke had said: 'Balzac sensed long ahead that in painting, something so tremendous can suddenly present itself, which no one can handle . . .' The fact that Picasso considered the *Demoiselles* unresolved attests to the tremendousness of the adventure.

This initial break with his own conventions was aided by Picasso's increasing interest in African and Oceanic sculptures and masks. Two aspects of them were valuable to Picasso. On the one hand, they helped him to understand the plastic value of abstraction – of forms compiled with a sense of

their own interior congruence. On the other, they were redolent of a fierce primitive truth that he had always sought out. His experiences with the peasants in Gosol, a rough, remote Catalan village where he painted during the summer of 1906, were no less important in this sense. The magical overtones of the best of the Ivory Coast masks went straight to their mark in Picasso. The fusion of paradoxical interests that the *Demoiselles* represents is a profound reflection of Picasso's complexity. At its most intense, the painting speaks both of his longing for classical serenity and his desire for eruptive, clashing values that would assail complacent eyes. In *The Family of Saltimbanques*, which had been carefully planned as a masterwork, he had fixed forever an insight of another kind of world. The figures are as still as the figures of peasants in the paintings of the seventeenth-century master Louis Le Nain. In the *Demoiselles*, also begun as a major work for which Picasso had bought expensive Belgian linen, the left side, completed earlier than the right, still lingers in a realm of formal objectivity, but the right side, in which the African masks make their appearance, is another realm, violent and full of the powerful expression of magical ritual. It is wrong to discuss this divided painting as divided, for Picasso had already used the contrast of psychological states in earlier works. There are frequent allusions to figures that seem to occupy different worlds in the sketches and paintings of 1904 and 1905. This sense of the isolation of events within a single painting was never to leave him, and became, in fact, one of the central problems animating his works to come. How to reconcile differences – both psychological and visual – within a single work of art was a challenge Picasso relished throughout his life.

Once he had embarked on the *Demoiselles*, the flood of power Picasso felt was increasingly channelled into explorations of all the implications of what he had already done. The pull to abstraction and intense concentration became irresistible, and was to be realized in the highest development of analytic Cubism. At the same time, the increasing importance of Cézanne can be felt in some of his work just after the *Demoiselles*. The great retrospective of 1907 seemed to have left no one sensitive to the evolution of modern art unchanged. Picasso's close study of Cézanne's work, particularly his many paintings of bathers, results in his increasing use of hatching to establish pictorial rhythms and his integration of figures into their settings, diminishing the differences between figure and ground. Almost fifty years later he tells Mme Parmelin: 'Now if you take a painting by Cézanne (and this is even more clearly visible in the watercolours), the moment he begins to place a stroke of paint on it, the painting is already there.' Picasso was temperamentally suited to understand the full measure of Cézanne's struggle. He had once said of Cézanne, 'Look for the Spanish influence', probably without knowing that Marius Roux had written around 1863, 'Though a great admirer of Ribera and Zurburán, our painter is however no copyist.' The enormous act of sublimation performed by Cézanne when he turned away from the Baroque emotionalism of the Spanish painters to 'objectivity' was apprehended by Picasso who at various times in his own life was to perform the sacrifice himself. Cézanne's decision to submit himself to the discipline of gazing was apparent to Picasso, who remarked:

One doesn't pay enough attention. If Cézanne is Cézanne, it's precisely because of that: when he is before a tree he looks attentively at what he has before his eyes; he looks at it fixedly, like a hunter lining up an animal he wants to kill. If he has a leaf, he doesn't let go. Having the leaf, he has the branch. And the tree won't escape him. Even if he only has the leaf it's already something. A picture is often nothing but that . . . One must give it all one's attention.

Echoing Poussin, Picasso rallies to Cézanne, recognizing the restorative value Cézanne's task has for painters who were tempted always to go beyond experience. Picasso was never a stranger to such extravagant temptations and, like Cézanne, was ever wary.

Late in 1907 Apollinaire brought Georges Braque to Picasso's studio. Braque's initial shock at the *Demoiselles* apparently soon gave way to intense interest and the two painters established the comradely relationship that was to endure until the outbreak of the First World War. During 1908 they worked assiduously, exploring both in the direction proposed by the primitive artifacts and in that proposed by Cézanne. Braque reported later that African sculpture put him in touch with 'instinctive things running counter to the false tradition so hateful to me'. Here again, the desire to shed the conventions that had so long dominated European painting reflects the conscious commitment to be modern. The absorbing effort to invent new pictorial conventions drew both Braque and Picasso into more and more radical abstract explorations and greater liberties with subject-matter. For Picasso there was an obvious satisfaction in making forms that would, as he later said, 'be there to live their own lives'. Both painters, from 1908 on, responded to a general excitement sweeping Europe. Derain, Matisse, Kirchner, Heckel, Kandinsky and scores of others had discovered in the newly discussed art of the so-called primitive cultures sources for what they considered a new truth in painting. What Rilke had repeatedly signalled as the modern trait in Rodin's sculpture – its release from subject-matter – was becoming, in 1908, a modern assumption from which the most stunning innovations would grow.

By subject-matter, Rilke meant the traditional subject-matter of Western painting and sculpture. Little by little the modern mind had discovered alternative subjects which partook of far more abstract qualities. Rilke understood that Rodin had substituted the governed relationship of minute forms among themselves as the subject of his inquiries. Plastic artists had been pondering the abstract nature of their endeavours for many decades in the nineteenth century. In the twentieth century, with the great surge of modernism challenging every assumption, scores of artists, poets and art historical theorists energetically explored alternative modes of expression.

While it is obvious that the signal events in the history of the arts are not always synchronous, there are often striking coincidences. Sometimes a work properly considered as part of the history of ideas coincides with a work in the history of art. Or to put it another way, a brilliant formula, or a striking insight of some thinker, may appear momentarily in the realm of art and elicit a response. While Picasso, Derain and Matisse were discovering the uncelebrated treasures at the Trocadéro Museum, a young German doctoral candidate was also haunting its empty halls. Wilhelm Worringer's moment of

revelation occurred there some time in 1906. His doctoral dissertation, *Abstraction and Empathy*, was published two years later, eliciting a response all over Europe that astonished the young author. Aside from its provocative title and symmetrical thesis, Worringer's book attracted attention because it was the climax of decades of speculation concerning the other tradition – the tradition of abstract art. He argued that there were two basic responses to the world. The one was 'classical' and mimetic, as Aristotle defined it; the other was 'primitive' and abstract. The tradition of 'empathy', for which Worringer goes to Goethe's statement that human nature 'knows itself one with the world and therefore does not experience the objective external world as something alien, that comes towards the inner world of man from without, but recognizes in it the answering counterpart of its own sensations', is contrasted with the tradition of abstraction. Here, man does not know himself at one with the world at all, but is harassed by a sense of disunion, perturbed by the shifting nature of all phenomena and seized with the deep desire to find redemption through a rigorous, or, as Worringer says, a 'crystalline' vision of space governed by laws, of 'translating the mutable and conditional into values of unconditional necessity . . . for these abstract forms, liberated from all finiteness, are the only ones, and the highest, in which man can find rest from the confusion of the world picture'.

Of necessity, the abstract art of primitive cultures was an art in which the illusion of space is never relativistic, as in Renaissance perspective, but is an 'other' space, created to defy relativism. Since the establishment of new conventions for depicting space on the picture plane was one of the stated objectives of the young artists at the turn of the century, Worringer's bold patterning of cultural objectives in contrasting societies would not have been as novel to them as his enthusiastic declaration of the artistic merit of the newly-considered art objects. He enters the discussion by suggesting, as Riegl had taught, that there is a 'form will', a psychic necessity in each period which governs its choice between the two poles of empathy and abstraction, that 'every stylistic phase represents for the humanity that created it out of its psychic needs, the goal of its volition and hence the maximum degree of perfection'.

These thoughts were not as remote from French ideas as is always assumed. It was in France, after all, that Worringer received his illuminating vision, and his ideas, reflecting so many previous speculations of German thinkers (including Nietzsche's 'revaluation of values'), were not unfamiliar to French literati, or to the many Germans crowding into Paris at the time. Picasso's first German admirer and collector, Uhde, was certainly *au courant*, and probably also Kahnweiler, whom he brought to Picasso's studio to see the *Demoiselles*. (Kahnweiler was the first to recognize its importance and bought all the sketches for it immediately.)

The year 1908 seemed to be a moment of importance to Picasso who in later years would sometimes express contentment by saying he hadn't been so happy since 1908. In that year he gave himself over entirely to the exploration of form in a totally new context. With Braque at his side he plunged with total attention into the adventure with Cubism. Their adventure set the tone

85

for intense speculation throughout the twentieth century concerning the nature of pictorial space – a new space in which a world-view, shaped by many fresh insights drawn from many disciplines, could be expressed. The point of view, as Braque stressed, had been narrowed in painting by Renaissance perspective which 'starts from a point of view and never gets beyond it. . . . It is as if you were to draw profiles all your life, making believe that man has but one eye.' A conclusion that there could be a 'new space' fired both painters. The pursuit of this new space was for them a daily speculation carried out in the work itself with little intervention of theory, yet quite self-consciously modern. They were determined to render the 'new spaces', and their commentators devised verbal explanations in close rapport with the works. Maurice Raynal, for instance, wrote in *Gil Blas* in 1912:

We never see an object in all its dimensions at once. . . . At the moment when I conceive of a book, I perceive it in no particular dimension, but all dimensions at once. If, then, a painter contrives to render an object in all its dimensions, he achieves a methodical work of an order superior to that of a work painted only in the visual dimensions.

Raynal uses the term 'conceptual' for those unseen dimensions the painters were striving to represent. But the implications of this new concept of seeing were not limited to the purely formal. If that were the case, how would it have been possible that Picasso was the progenitor – as Malevich readily conceded – of the very desert Malevich said he would reach, the realm of the transcendent towards which so many modern artists aspired after Picasso's first grand gestures of renunciation? 'Art reaches a desert in which nothing can be perceived but feeling', Malevich said. And there was more than a little of that romantic search for the desert in Picasso's undertaking. The mere idea that the Cubists wished to make discrete objects in a world of objects, objects that would be worlds complete unto themselves, is enough to suggest that the transcending impulse accompanied the more rational, analytic impulse in the evolution of Cubism.

There was a poetic dimension which Picasso occasionally tried to call to the attention of his critics, but which was rarely heeded. If objectivity was the café word of the moment, there were other equally powerful tendencies to which Picasso attended. In 1908, for instance, Jacques Rivière published his call for free association, *Introduction à la Metaphysique du Rêve*, in which he wrote: 'I shall light the lamp of dreams; I shall descend into the abyss.' And, when the poet and friend of Picasso, Pierre Reverdy, wrote an essay on Cubism for the first issue of *Nord-Sud* in 1917, he called it 'Le cubisme, poésie plastique'. Under the spell of daily discoveries, Picasso moved to the very verge of abstraction and felt the full release associated with its infinities. The idealistic side of Picasso's temperament was more engaged in this adventure than critics usually concede. What was at stake for Picasso during those Cubist years was best understood by the poets. Max Jacob may not have understood the inherent painting problems (which Picasso maintained never changed) but he did understand Picasso. In his letter to Kahnweiler accompanying the manuscript *Saint Martorel*, he speaks with self-irony of his poetry but changes his tone when he mentions Picasso's etchings for the book:

The secret charm of his austere art has made an impression on art lovers. To bring back to the old laws of high aesthetics a pictorial art that was losing its way amid the pretty trifles of pseudo-Japanese styling, to subject painting to the strict control of a simple complex composition, to rediscover reality only by way of style and thus to rediscover it more truly, such is the exemplary aim of this artist.

Jacob admitted to Kahnweiler that he knew little about etching, but he certainly knew, through his close association with Picasso, of Picasso's needs. To rediscover reality by way of style could be translated into the rediscovery of form as a reality in itself. It was to Jacob that Picasso had written almost ten years earlier that artists in Barcelona chided him for having too much soul but no form in his work. The form, as Jacob understood, had to be found. During 1910, when Jacob probably wrote this letter, and 1911, Picasso and Braque were drawn to the very edge of the abyss of pure form, and both were obviously exhilarated by the possibilities that emerged day by day.

In its most extravagant stages the Cubist adventure often led Picasso and Braque into paradoxical experiences. Their absorption with the disposition of forms in an integrated context led to a psychological distancing, a coolness that allowed critics to talk of 'Cartesian rigour'. Along with this distancing came, naturally enough, irony. In the paintings of 1911 and 1912 they introduced elements of reality – Braque's painted nail and Picasso's collaged oilcloth. The meditation on painting itself is amplified in these works in which a fragment of reality served to emphasize the totally *created* nature of the whole image. At the same time, the irony of the technique was not always reflected in the object, for many of the works reflect the vivid interest Braque and Picasso took in the life around them, the objects and even personalities they sometimes portrayed. Not even love and politics were banished, and Picasso's enduring interest in the grand poetic themes peers through. The lure of abstraction is countered in these high Cubist paintings by the lure of everyday life. The contradictions in these terms were probably what eventually led Picasso back to his most deeply rooted esteem for the act of attention to the visible world. But for many others they led to the other extreme.

In 1912, the year of Picasso's most abstract Cubist paintings, the notion of 'simultaneity' had become ubiquitous, finding expression in such widely separated activities as collective readings of dramatic poetry scored for many voices among the Unanimists, and the deliberate introduction of street cries, signs and pedestrians in Apollinaire's poems in *Alcools*. Apollinaire wanders through philosophy, religion, history, while at the same time he renders quite matter-of-factly the concrete details of Parisian life. The notion of simultaneity was consciously cultivated in these poems, and it was the notion he also used to describe the intentions of the Cubists who simultaneously showed the back and front sides of an object. Apollinaire was not alone in attempting a fusion of time and space in the context of the poem. Blaise Cendrars was also offering simultaneous juxtapositions of experiences in his poetry, and was sharing in the drive towards abstraction in painting by talking long hours with the painters Robert and Sonia Delaunay. Cendrars met the Delaunays

in 1912 while Apollinaire was living with them. Delaunay had already found a means to present the universe as it spoke through the steel needle of the Eiffel Tower, and was entertaining a vision of what he called 'pure painting', in which the idea of simultaneity was paramount. Cendrars himself had already experimented with such effects in his poem 'Easter in New York', written probably around the same time as Apollinaire wrote *his* simultaneous masterpiece, 'Zone'. The cross-fertilization that occurred in the few weeks of 1912 is incalculable, but it is safe to assume that Apollinaire's vision of Cubism, derived from Picasso, greatly motivated Delaunay's forthcoming plunge into abstraction. In contact with the German vanguard, Delaunay had also read the first essay by Kandinsky, 'Concerning the Spiritual in Art', and wrote immediately to Kandinsky:

The search for pure painting is currently a problem for us . . . I hope to find still greater flexibility in the laws I have discovered. They are based on the transparency of colour, which can be compared to musical notes. This has led me to discover the *movement* of colour. The things, which I think are as yet unknown, are still in embryo for me. . . .

Delaunay had placed his awakening to what he would later call a 'new reality' in 1907, after the Cézanne show. What he had seen in Cézanne was the enormous thrust towards the impossible. Cézanne, he said,

above all had a presentiment of new horizons, but his troubled and restless artist's life did not allow him to find the means of steering for them. But in Cézanne's last watercolours – what transparency striving towards a supernatural beauty, beyond anything we had seen before.

The 'new reality' which Apollinaire dubbed 'l'esprit nouveau' engulfed many during the last two years before the First World War. Cendrars himself embarked on his long voyage poem 'Prose of the Trans-Siberian and of little Jeanne de France' in 1913. In it he mixes the idiom of the Parisian tough with that of the romantic as it first flares up in Laforgue and sustains itself – despite all – in the poetry of Apollinaire, Jacob and Cendrars himself. He moves through Siberia while still roaming Montmartre, and the little prostitute at his side interrupts all his poetic flights with a plaintive refrain, 'Blaise, please tell me, are we very far from Montmartre?' He, who writes in the poem

> I spent my childhood in the hanging gardens of Babylon
> Playing hookey in stations before departing trains

is constrained to return to the Butte Montmartre through the presence of the little morsel of reality called Jeanne at his side. Yet his voice travels freely, all over the world, calling up climates and times remote and bordering on the mythic. In keeping with the spirit of the time, still determined to avoid the excesses of pure poetry, Cendrars interrupts himself to quote Apollinaire:

> Forgive me my ignorance
> Forgive me for no longer knowing the old game
> of writing poetry.

Apollinaire's semi-ironic defiance found a counterpart in the way Picasso was playing the dissembler himself. Picasso pretended he had forgotten the

old ways of making paintings and also sculptures, and played with fragments of the real – bottle labels, oilcloth, stamps, rope – inserting them in the virtual context of painting. Such cathartic forgetting functioned for Picasso as a means of asserting his independence from the conventions of any past that was not 'modern'. Delaunay, joining artists such as Kandinsky, also forgot the old game of painting paintings in order to establish an aesthetic independent of immediate objects of experience. The two poles implicit in the story of Frenhofer are here expressed as two potential extravagances of pictorial diction. If Picasso denied, finally, that there could be an abstract art, he was never unaware of the immanence of abstraction in all drawing and painting. His way of returning to what Rilke called 'heartwork' after the rigours of Cubism was to turn away from objects and their characteristics and retrieve again his old dreaming meditation on existence. Like Frenhofer, he was haunted by the desire to summarize everything pertaining to existence in Eros. What is sometimes called his classicizing period, which began during the First World War and which was never again quite abandoned, was certainly far more than a retreat from the audacities of Cubism. It was the necessary reiteration of his central preoccupation.

Modern thought, said Walter Pater in 1866, is distinguished from ancient by its cultivation of the 'relative' spirit in place of the 'absolute'. It was this 'relative' spirit, undoubtedly, that enabled Picasso to explore several modes simultaneously, and permitted him to express his complex attitudes towards both art and love. Most commentators believe that his exposure to the ancient and Renaissance art of Italy, where he worked with Cocteau on *Parade* during the winter of 1917, inspired the neo-classic tendencies of his work during the 1920s. But Picasso's interest in ancient art had appeared much earlier, in the line drawings Apollinaire had remarked as resembling Greek vase paintings, and that had almost always dealt with the female figure. His unremitting interest in the role of Eros in creative life was heightened during the 1920s and the early 1930s, as the many allegorical and ornamental drawings attest. He didn't forget that the primeval god had been a son of Chaos, as is apparent in the more turbulent drawings of rapes and abductions. But he also didn't forget Eros's associates, Pathos and Himeros, longing and desire. These themes, threading through the fine etched lines and many magnificent drawings of the early 1920s, eventually transformed themselves into a dominant theme that was to preoccupy Picasso for the rest of his life: the artist and his model. It is obvious that Picasso's query is as much philosophical as it is sensuous. He questions not only the relationships between the observer and the observed (both the beneficent and the unsavoury relationships) but also the degree to which art itself intervenes between the artist and the women he epitomizes in his drawings, paintings and sculptures.

It was not difficult for Picasso to rally to the idea of illustrating *The Unknown Masterpiece*. No one has ever been able to discover exactly how the project came about. It is possible that Pierre Reverdy, who was a great reader of Balzac and a close friend of Picasso's, suggested the story to Picasso himself, or it is possible that Vollard proposed the subject. In any case, Picasso was at work in 1927 on the etchings that would be used in the extraordinary

livre de luxe published by Vollard in 1931. In 1927 Vollard bought fifteen etchings from Picasso of which thirteen were to be designated as illustrations for *The Unknown Masterpiece*. These etchings are predominantly on the theme of the artist and his model, including, for instance, a motif that reappears in later years: the painter absorbed in painting a nude while the nude stands behind him watching. In these etchings Picasso began posing the implicit question: where, really, is the picture? What part of the artist's imagination is most fecund – that inspired by his direct attention to the model, or that lodged in the distant imagined beginnings, renewed each time he approaches his canvas and all but independent of the model? For him, Frenhofer's obsession with La Belle Noiseuse would not have been surprising, nor would Poussin's ambivalence towards Gillette have shocked him. He had for many years confronted similar feelings in himself.

If we are to judge by the etchings in the Vollard edition – the few, that is, that can be said to relate directly to the story – what most affected Picasso in the beginning was not so much the tragic story of Frenhofer as the role of women in the artists' lives, just as Balzac's first version was more directed to the love story of Gillette than to the aesthetic questions posed in the final version. Like Balzac, Picasso would only later dwell on the implications for the artist himself as epitomized in the Rembrandt-like portrait of Frenhofer. If Picasso had read the Balzac story thoroughly while at work on the thirteen etchings in the Vollard edition – no one can be sure – it is quite apparent from the etchings that what most affected him was Frenhofer's total obsession with the painting itself which, in the old Pygmalion mythology, was to become so real as to serve as mistress and beloved. The confusion of identities is a central motif (in one plate, the painter stands with two models, brush in hand, but he himself merges with the wall as though he were in fact a painting) and one pursued throughout the rest of his working life. What is a painting? Is it an image? A creation? An extension of the self? A detached object among objects? On the other hand, what does the painter love? His created embodiment of his beloved or the beloved herself; his evocation of his own feelings towards her, or the responsive, warm-blooded creature? Where is the painting? Does it hover between artist and observer? Is it in the material of the image itself, discrete from all else in the world? Or is it rather lodged in the obsessive imagination of the artist and purely re-presented so that none but the creator can truly recognize it? Was Frenhofer quite mad, or was there something in his approach which Picasso understood and recognized all too well?

These questions are implicit in the suite of etchings, among which only one has ever seemed to most critics directly related to the story. Here, the painter is shown seated before his easel with a middle-aged, fully-dressed model, knitting. On the canvas is a skein of lines that could possibly be interpreted as Frenhofer's painting, but, on the other hand, might be only a skein of wool. Of all the etchings, perhaps this has the least to do with the Balzac fable as Picasso first interpreted it. The beauty of several of the female models in the etchings suggests rather that he pondered first on the situation of Gillette. 'The sun was not always shining', Balzac wrote compassionately of the young

mistress, 'but she was always at hand, absorbed in her passion, clinging to her happiness and her suffering, comforting the genius that overflowed in love before seizing upon art.' When Poussin tries to find a way to ask her the awkward question – will she reveal her body to Frenhofer in order that he, Poussin, may learn Frenhofer's secret? – she guesses wrongly and says: 'If you want me to pose for you as I did the other day I will never consent, for at those times your eyes no longer say anything to me. You no longer think of me, and still you look at me.' Poussin although abashed, pursues his hope, vanquishes his mistress's scruples and is ready to face the truth she utters when she tells him that once she becomes the object of scrutiny for another, Poussin himself will no longer love her. As Rudolph Arnheim has said, 'Gillette, the beautiful woman, is undone by consenting to become art.'

In Part II, 'Catherine Lescault', Balzac recasts the Pygmalion myth by drawing a portrait of Frenhofer hopelessly enmeshed with his 'creation', his 'spouse'. 'For ten years past, I have lived with this woman, she is mine, mine alone; she loves me . . . Poetry and women abandon themselves naked to none but their lovers!' As he continues resisting the two painters who are determined to see his masterpiece, he rhapsodizes, assuming the full mythic proportions Balzac intended: 'Would you have me suddenly cease to be a father, a lover, and a god? That woman is not a creature, she is a creation.' Picasso, by showing his painter raptly attending to his canvas while the bemused model looks on, seems to dwell on both the erotic implications and the conflict between art and love stated in Balzac's fable. It is quite possible, though, that he was aware of the affinities he himself shared with Porbus, whose view was that Frenhofer had slipped to perdition as a painter the moment he reached his abstract ideal. 'There is no abstract art,' Picasso said in 1935. 'You must always start with something. Afterwards you can remove all traces of reality. There's no danger then, anyway, because the idea of the object will have left an indelible mark.'

Whether or not Picasso even read the story when he was illustrating *The Unknown Masterpiece*, there is much evidence that its power overtook him increasingly in later years. Frenhofer remained ensconced in his imagination, a constant reminder. In 1934, while he was at work on the etchings commissioned by Vollard (later called The Vollard Suite), a sudden apparition appeared on the plate. It was, as Balzac called Frenhofer, a Rembrandt out of its frame, an ecstatic-eyed Rembrandt who all but disappears in a mesh of wild, gyrating lines. As Balzac had been at pains to re-create the atmosphere of Rembrandt's studio and his own unquiet presence ('one would have said that it was one of Rembrandt's canvases, without a frame, walking silently through the dark atmosphere which that great painter made his own'), so Picasso seems to recall Rembrandt in his Frenhofer-like *furor*. The first plate, which came about as a result of an accident, shows Rembrandt very much as he had etched his own self-portrait, but the second, as Picasso told Kahnweiler, shows him 'complete with his turban, his fur coats, and his eye, that elephant eye of his, you know'. That plate shows a possessed Rembrandt, his eye fixed on some terrible vision. A second head, tormented beyond recognition, becomes a sculptured bust overlooking some abstract, scrawled drawings. In

the third plate, two serene young women models repose before a picture of Rembrandt which is again a wild vision of mad Frenhofer. Finally, Rembrandt appears in the fourth plate calmly looking out while holding the hand of his model, or his 'creation'. We know that Picasso had eventually taken the Frenhofer lesson to mean that the absolute reality is always beyond the reach of the painter. As late as 1959 he told Kahnweiler:

That's the marvellous thing about Frenhofer . . . At the end, nobody can see anything but himself. Thanks to the never-ending search for reality, he ends in black obscurity. There are so many realities that in trying to encompass them all, one ends in darkness.

But for all that, something of Frenhofer's excessive need to create and possess his own reality was never vanquished in Picasso. As the poet Robert Desnos wrote, 'For Picasso, what matters, when he paints, is to "take possession" and not provisionally like a thief or a buyer, for just a lifetime, but as himself the creator of the object or of the being.'

The importance of Balzac's fable for Picasso remained. Three years after the Rembrandt etchings he was offered a studio on the rue des Grands Augustins in the very building Balzac described. His excitement was great, his friend Brassai reports, and he often reminded friends of the significance of his premises. He referred to Frenhofer from time to time in conversation, and many years later, almost at the end of his life, he returned directly to the story. At least two of the plates in *Suite 347* of 1968 have been identified by Gert Schiff as inspired by the Balzac fable. In Number 344, he writes, 'we find the mature master (Porbus *or* Frenhofer) together with the young Poussin, who gazes, fascinated, at the emerging likeness of the model. In Number 39 we see Frenhofer musing in front of his senseless web of lines, surrounded by one real companion and two shadowy creatures of his imagination.'

There was much in Balzac's fable to preoccupy Picasso. First of all, certain of the principles enunciated by Balzac were similar to Picasso's own. He agreed fully that, as Frenhofer said, 'The mission of art is not to copy nature but to express it.' He had, during the Cubist years, understood Porbus's wariness of Frenhofer's idealism and stopped short of the ultimate abstraction. Pierre Reverdy, writing in 1928, even uses diction similar to that of Poussin (whom Balzac quotes almost directly) when he says that Braque and Picasso were held 'in that mysterious limit which the spirit must know how to reach and yet not go beyond'. Picasso had understood that the presence of the exquisite foot in Frenhofer's masterpiece could be read only in relation to the mystery of the vanished figure. A painting, he had said, is a sum of destructions.

Yet in many of his drawings of the last quarter of his life Picasso was tempted to follow Frenhofer to the obscure end. There are always suggestions that there is something unsayable. Picasso knew it was there. He longed to overcome it, to name everything possible. His old tendency to present two different psychological climates, as he did in the *Demoiselles*, reasserts itself in numerous drawings in which figures dissolve into scribbled extinction and re-emerge elsewhere on the page. There are many hints that the picture is not, in fact, 'unknown' but only 'unrecognized'. His long battle with critics had

taught him that only time revealed the true image, and then not to very many; and something of this desperate isolation is conveyed in the late drawings, filled with self-irony, and yet probing again his old themes. As early as 1905 he had dallied with the theme of the watcher and the watched. A watercolour shows a young man, probably Picasso himself, gazing at a sleeping girl. This was still a tender image, unsullied by irony. In his old age, the watcher is sometimes a voyeur and the watched a lascivious model. Sometimes, though, the watcher is the old jester, the *saltimbanque*, the Pierrot who haunted Picasso's youth. The distance from the young, painted Pierrot, rejected and with disaster always threatening him, to the old, furious painter is not great. The modern vision of the clown or entertainer, peripheral to the true needs of society, permeates Picasso's late works. In the old days at the Cirque Medrano he had often talked with the performers. He understood the kind of transformation that occurs in the individual once he emerges in the spotlight. The artist, as one who assumes a mask, who transforms his *self* and is totally engulfed by his effort to perform his art perfectly, is an old familiar of Picasso's. He would have understood the modern clown Zavatta, who speaks in his memoirs of waiting in the wings and feeling ridiculous. 'But the moment I go through the curtain, for the first time in my life, I feel myself *other* . . . more exactly, Him. Him, my personage. And the sense of ridiculousness that I experienced in the wings now, instead, inspires me. . . .'

Picasso, in many of the late drawings, depicts the painter with a mask. Sometimes he depicts both the painter and the model with masks. The mask, he suggests, is more nearly other, more nearly 'him' than he himself. Many modern artists have proposed the paradox that the mask is more expressive than the face itself (Ensor, Nolde, deKooning to mention a few). Picasso seems to say that what is hidden by the mask is the kind of grail that no adventurer ever retrieves. On the other hand, the masked personage is the one whom the public sees. The misunderstood old painter, the Frenhofer, the true painting genius, lives behind the mask and is not recognized. Nor is his work, which, finally, is more Him, as Zavatta said, than himself. Here, again, is the old image of Picasso's youth, the Harlequin or Pierrot with the painted mask.

If Picasso continued to draw the female model in every conceivable situation, and from points of view ranging from sarcasm to tenderness, he continued also to meditate on his own relationship to what he created. He juxtaposed fauns, dwarfs, laurel-crowned putti, courtiers, old clowns, Lady Godiva, playing-card kings and queens in a vast wilderness through which he, the artist, must thread his way, at the risk of losing himself in his own abstract meditation. His Pierrot hat bobs in and out of the crowd of personages, as he seeks to define himself. 'How difficult it is to get something of the absolute into the frog pond', he told Jean Leymarie in 1966, indicating once again that the absolute was not by any means foreign to his aesthetic. André Breton understood. He wrote:

Much more noteworthy, it seems to me, because this alone is really suggestive of the power given to man to act on the world in order to fit it to himself (and thereby fully

revolutionary), is the unremitting temptation he feels, throughout his work, to confront all that exists with all that might exist, to call forth from the never-seen whatever may caution the already-seen to make itself less often and foolishly seen.

The tragic in Picasso's early work (his melancholy Pierrots and Harlequins) is translated into burlesque in many of his late drawings. Hints of his Spanish culture, ranging from Cervantes to Velasquez to Goya, become increasingly apparent. The *burlador*, whom the Spanish define as a practical joker, jester, scoffer or seducer, seems to dominate hundreds of drawings in the late 1960s. Even more, Picasso fetches up his Spanish past in oblique references to Goya. He seems to be remembering Goya's equivocal use of mirrors (drawings of dandies regarding themselves in mirrors which reflect, instead, animals), in which the mirror sometimes appears to be a canvas rather than a mirror and in which the conundrum of who is regarding whom appears disguised as a monstrous jest. In a few of his late drawings Picasso shows the old painter, brush in hand, working directly on the model. Mirror, frame, canvas disappear and the old Pygmalion works *alla prima*. He had, as Baudelaire noticed in Goya, 'a love of the ungraspable, a feeling for violent contrasts, for the blank horrors of nature and for human countenances weirdly animalized by circumstances'. For instance, in 1972, Picasso did an ink drawing showing a glorious coquettish nude confronted by a top-hatted man with a bird's body. (And in recent X-rays of his early allegory, *La Vie*, it appears that Picasso had painted a man with the head of a bird and great wings.) These throwbacks to Goya's characterizations in animal metaphors are more than mere caprices. They indicate Picasso's unwillingness to relinquish the quest implied by allegory.

In Goya's time the theatre revived itself by stressing the conventional Spanish between-the-acts plays called *sainetes*. Life as it appeared to the most realistic, and sometimes base, vision tumbled onto the stage as a spectacle that had no true beginning and no proper ending. This, in turn, was probably a residue of the old Roman mime tradition which brought to play licentious forces in Roman society, fully ceding to the avid spectators in the pit. Horace felt compelled to warn against the debased 'jesting and mocking satyrs' that disported themselves in the Roman mime. The original of these theatrical adventures in Dionysiac abandon was certainly the ancient Greek satyr play appended to the tragic trilogies. Ancient descriptions suggest that the satyr plays were wildly unconstrained and filled with ribaldry. Their purpose has been argued, but it is thought that they were presented in order to relieve the spectators of the portentous feelings inspired by the tragedies.

In a way, Picasso's final drawings – hundreds of them – are a coda to his life's work functioning very much as did the satyr plays of ancient times: a grand parade of all the personages he had ever portrayed; of all the figures he had ever found the signs for; of all the conflicts he had pondered with his brush and pen. Their 'classicism' appears in the identification of ancient motifs: the 'old men', for instance, observing and intoning their warnings; the Cassandra (transformed from the old woman who flits through the late drawings, looking on), Aeschylus's Cassandra, whom Picasso knew intuitively, who says:

> Oh men, your destiny
> When all is well a shadow can overturn it.
> When trouble comes a stroke of the wet sponge,
> And the picture is blotted out. And that,
> I think that breaks the heart.

And mixed with these archetypes, the memory of his own past, with its vision of the great Spanish masters, Velasquez, Goya and the poets. (Otero, for instance, tells of his visits late in Picasso's life, during which they played an old game of inventing a small Spanish village, very much a Cervantes village, with a host of satirized characters, all named, who exchange old Spanish pleasantries such as: 'Well, old friend, what is new?' Answer: 'Thank god, nothing.')

Above all, Picasso himself enters the drama, now as *burlador*, now as a young aspirant to the Orphic realm, now as Frenhofer. The countless drawings of the painter at work almost always show him hunched forward, almost joining his canvas. His attention – the attention the real Poussin said was fundamental to the artist's procedure – is exclusive. Where he appears, absorbed in his work, the grand parade goes unnoticed, just as Gillette was unnoticed as Poussin struggled to transform her into art.

Finally, Picasso had eluded the Fate that overtook Frenhofer by returning always to what he knew and loved. He struggled with the problems residing between the poles of form and feeling, shuttling back and forth in his all-encompassing exploration of modern art. His temptation was always to return to the mixed, the imperfect, the modern ideal broached by Apollinaire as 'real life transformed'. Like Cézanne, he resisted the lure of the unutterable, of the desert, and was able to create the exquisite foot amidst the ruins of traditions he had already set out to defy by the time he was sixteen. He genuinely sought the universality associated with the humanist tradition, although he knew only too well the truth uttered by Rilke in his 1924 poem, 'The Magician':

> He calls it. It startles and stands,
> What stands? The other: all that he is not
> becomes being. And the whole being turns
> a swiftly wrought face, that is more, towards him.

CHAPTER FIVE

Arnold Schoenberg's ascent

I

Arnold Schoenberg, schooled in the scepticism of fin-de-siècle Vienna and proud of his association with its most acerbic aphorists, assumed from the very beginning that 'the middle road is the only one which does not lead to Rome'. A fervent and unabashed adherent of the principle of art for art's sake, Schoenberg nurtured himself in the ethical tradition of the nineteenth-century romantics. Their priestly utterances, their contempt for the *juste milieu*, were apposite to Schoenberg's experience in pre-war Vienna. Just as Balzac's generation learned to despise the *juste milieu* in which it saw the snares of the faithless bourgeois social order as well as the dangers of the pasticheur's success, so Schoenberg's generation despised the eclecticism of its own culture and took shelter in the elaborate myths, evolved during the early nineteenth century, that served to replace the lost rigours of religious, pre-bourgeois periods. Schoenberg saw the challenges of art as sacred tests of an artist's passion and integrity. He schooled himself in the past and chose to revere artists who had maintained their integrity in the most trying circumstances; who were alienated but unvanquished. His romanticism led him to address old masters much as Poussin had approached Porbus in *The Unknown Master-piece*, and as Rilke had approached Rodin. In his youth he felt he had not esteemed Gustav Mahler sufficiently, for instance, and came to make extravagant amends. Although he had been 'overwhelmed, completely over-whelmed' by Mahler's symphonies, he had not trusted his feelings. Intellect intervened and, Schoenberg hints, the opinions of his Viennese colleagues, who found Mahler's work sentimental and his themes banal, clouded his own vision. He wrote to Mahler for his fiftieth birthday on 5 July 1910 that he regretted his youthful differences with the master, and that there was still

one thing to which I should have yielded absolutely: the essential quality that emanates from whatever is great, the indefinable thing which I have so strongly sensed in your presence and which is for me the power of genius; something the existence and force of which is fully clear to my feeling.

The 'indefinable thing' haunted Schoenberg to the end of his life. He clung to his early convictions, stating again and again that he regarded his art as a sanctified action in the service of higher forces. His credo, unshaken by the hostile responses his art elicited, was restated at the end of his life when he was invited to become honorary president of the Israel Academy of Music. He

96

was too old, he explained, to take an active role, but he advised the director that the academy must teach

that there is a morality of art . . . I would have tried to make this academy one of world-wide significance so that it would be of a fit kind to serve as a counterpart to this world that is in so many respects giving itself up to amoral, success-ridden materialism: to a materialism in the face of which all the ethical preconditions of our art are steadily disappearing . . . Those who issue from such an institution must be truly priests of art, approaching art in the same spirit of consecration as the priest approaches God's altar. . . .

This association of priestly dedication with the role of the artist issues directly from nineteenth-century sources and indicates an unaltered anxiety in the face of 'success-ridden materialism'. Many modern artists from the 1830s on had made similar observations. Rilke clearly aspired to priestly artistic office; Cézanne was haunted by Vigny's *Moïse*; Matisse spoke of the necessary humility of the artist; James Joyce made it a central theme; and Miró compared the solitary rituals of the inspired artist to those of the priest. If Schoenberg obstinately held to his liturgical metaphor, it was precisely because his image of the world was based on a Nietzschean conviction that art was the optimal form of redemption. His formative experiences with the philosophy, literature, poetry and painting of the nineteenth and early twentieth centuries were of crucial significance to him, and over a span of some fifty years he repeatedly mentions the contributions that artists of other eras had made to his work.

One of Schoenberg's most persistent references was to Balzac, whose work he had known in depth during his youth. Characteristically, Schoenberg cherished that side of Balzac's undertaking that attempted to deal with philosophical themes, and that, in its fabulous rather than naturalistic bias, stressed the mystery inherent in all artistic phenomena. Some time in the early 1830s Balzac conceived of his great scheme which would encompass all he knew of the human comedy. From the beginning he intended to include 'philosophic' stories in his 'vast arabesque'. On 26 October 1834 he made notes on the plan, on the 'architecture' as he referred to it. First, he intended to make a study of manners that would portray 'every situation in life, every type of physiognomy, every kind of male and female character, every way of living, every profession, every social stratum, every French province, childhood, the prime of life and old age, politics, law and war – nothing is to be omitted. When this has been done and the story of the human heart revealed thread by thread, social history displayed in all its branches, then the foundations will have been laid.' (Balzac's eventual accomplishment of this ambitious scheme led Henry James to remark: 'Balzac's luxury, as I call it, was in the extraordinary number and length of his radiating and ramifying corridors – the labyrinth in which he finally lost himself. . . .')

Balzac did not intend to lose himself in the labyrinth, but there is no question but that labyrinthine access to central problems was congenial to him. The second stage, outlined in 1834, was to be devoted to 'philosophical studies'. Eventually he would regard some fifteen of his works in this category. He said that in the philosophic stories the depiction of effects would be followed

by the description of causes: In the 'philosophical studies' I shall speak of the origin of the emotions and the motivating causes of life. I shall pose the question – "What are the operating forces, the conditions without which neither society nor the life of the individual is possible. . . .?"' These philosophical stories to which Balzac referred frequently in his letters of the late 1830s were intended to differ from the 'study of manners'. In his attention to manners, he avowedly meant to construct 'types'. But in the philosophical stories, he said he would go beyond types and deal with individuals.

The individuals who appear in the philosophic studies consistently reflect his interest in the absorbing passion that carries the individual beyond the realm of possibility. Balzac couldn't help admiring these extravagant passions (and always identifying them with the condition of being an artist) but he was apprehensive too. Such individuals ran great risks, and almost always foundered. As Stefan Zweig said, 'they were all Icarus figures of the mind'. Frenhofer, the most fully drawn, the most powerful of all the 'philosophic' individuals, can more or less stand for them all, and reflects Balzac's most serious speculations in the philosophic category. These Icarus figures included Louis Lambert, the sensitive intellectual whose combat with ultimate questions led to a breakdown, and the musician Gambara who, in the desperate attempt to find the underlying laws of music exceeded the limits of art. Like Frenhofer, who in the end was the only one who could 'see' his masterpiece, Gambara was finally the only one who could 'hear' his own melodies. Balzac included in the philosophic category the need to deal also with the religious spirit presupposed by the question he had put to himself: what are the operating forces, the conditions without which neither society nor the life of the individual is possible? In his effort to define the individual who is in the deepest sense religious, Balzac went to the extreme in creating the androgyne, Séraphitus-Séraphita. His supreme effort was meant to result in the release of the material bonds that blind men to ultimate meanings in life. In order to do that, he had to renounce his sexuality.

In all the philosophic studies, the ambivalence Balzac felt towards the exclusive passion for any absolute ideal is legible. But on the other hand, so is his hunger, as an artist, for beauty beyond doubt. Gautier felt he had surpassed himself in this question in the story *Séraphita*: 'Never did Balzac so nearly approach or grasp ideal beauty as in this book, that mountain ascension to something ethereal, supernatural, luminous, which lifts us above this earth. The only two colours employed are celestial blue and snow-white, with some nacreous tints for shadows.' Balzac arrived in this story very near the place that Frenhofer reaches in his painting simplified beyond recognition, and yet full of a history of nuances and revisions.

Schoenberg's profound attachment was to this, Balzac's most visionary story. His first published allusion to it is in a letter to the poet Richard Dehmel whose poem, 'Verklärte Nacht', had served for one of his early romantic works (1899). On 13 December 1912, Schoenberg wrote to Dehmel to ask if he would undertake the libretto for what was to become *Jacob's Ladder*:

Originally I intended to write the words myself, but I no longer think myself equal to it. Then I thought of adapting Strindberg's *Jacob Wrestling*. Finally I came to the idea of beginning with a positive religious belief and intended adapting the final chapter, 'The Ascent into Heaven,' from Balzac's *Séraphita*.

Decades later Balzac's descriptions in *Séraphita* still compel Schoenberg, who cites them in two important essays: the 1941 'Composition with Twelve Tones' and the 1947 'Heart and Brain in Music'. The latter begins:

Balzac in his philosophical story *Séraphita* describes one of his characters as follows: 'Wilfrid was a man thirty years of age. Though strongly built, his proportions did not lack harmony. He was of medium height as is the case with almost all men who tower above the rest. His chest and his shoulders were broad and his neck was short, like that of men whose heart must be within the domain of the head.'

The essay also concludes with Balzac. On the last page Schoenberg repeats the thought that the heart must be within the domain of the head and uses it to make a statement worthy of Balzac himself:

It is not the heart alone which creates all that is beautiful, emotional, pathetic, affectionate and charming; nor is it the brain alone which is able to produce the well-constructed, the soundly organized, the logical, and the complicated. First, everything of supreme value in art must show heart as well as brain. Second, the real creative genius has no difficulty in controlling his feelings mentally; nor must the brain produce only the dry and unappealing while concentrating on correctness and logic. . . .

Schoenberg's most significant reference to *Séraphita* occurs in the 1941 essay where he uses it to offer an image – a visual image – of the musical space he had aspired to when he developed the method of composing with twelve tones. The modern preoccupation with the spatializing imagination – with the spaces that could no longer be geometrized – is obvious throughout this essay. Balzac, with uncanny prescience, had already probed the spatial ambiguities that inspired so many twentieth-century thinkers. In his philosophical stories he speculated grandly about the imagination's perception of spaces and their psychological value. Schoenberg's adaptation of Balzac's imagery for musical space was an act of acknowledgment. Like the nineteenth-century romanticists, he pitted cosmos against chaos and dreamed of a unity that lay beyond the capacity of the practical imagination. He wrote emphatically in the 1941 essay:

The unity of musical space demands an absolute and unitary perception. In this space, as in Swedenborg's heaven (described in Balzac's *Séraphita*), there is no absolute down, no right or left, forward or backward . . . To the imaginative and creative faculty, relations in the material sphere are as independent from directions or planes as material objects are, in their sphere, to our perceptive faculties. Just as our mind always recognizes, for instance, a knife, a bottle, or a watch, regardless of its position and can reproduce it in the imagination in every possible position, even so a musical creator's mind can operate subconsciously with a row of tones, regardless of the way in which a mirror might show the mutual relations, which remain a given quantity. . . .

Balzac's strong visualizations of the spaces known only to the 'pensée' came from his conviction that these ambiguous spaces were as real to the mind as the spaces described by geometers. For Schoenberg, inheritor of the

late nineteenth-century revolution in science, and of the strong current of psychological research in Vienna, it was natural to accept the vision of an absolute such as Balzac described. He was of a generation that had frequently sought such visions as an alternative to materialism. Visual artists such as Klee and Miró had moved in the same direction, seeking, for instance, in the cosmic poetry of the nineteenth-century German poet Novalis a counterpart to their own vision of new spaces. If Klee said that his task was to make the invisible visible, he was enacting the visions of uncharted spaces that had so moved him in Novalis. They are the spaces that are characteristically conceived as abysses, voids, deserts, seas, universes – in short, infinities. Scores of poets all over Europe had been tempted by such infinities ever since they were conscious of the pernicious effects of *juste-milieu* materialism. They were drawn to the fabulous spaces as they turned from the unsatisfactory present, since all these visions relate to the intangibility of the future. Schoenberg always defended the idea of music of the future on the ethical grounds that art must strive beyond the material realm. The dissolution of the laws of time and space that Balzac had said the mind alone can perform was a precise project of Schoenberg's.

The vastness of the space that is neither up nor down was a metaphorical challenge to Schoenberg. The Balzacian abyss (the 'mystery for which we are all greedy') resounds in Schoenberg's commentaries as well as in his musical themes. The musical dialogue in *Moses and Aaron* is steeped in a vision of shifting and always vastly expanding spaces. Schoenberg remembered *Séraphita*, always. In the story, when Minna tells Séraphitus she is frightened of the abyss at the bottom of the fjord, he answers, pointing to the sky: 'Why, you look without fear upon spaces far more vast.' In the boundless landscape Balzac had so meticulously described from imagination (he had never been to Norway) Minna says, 'We are very small', to which Séraphitus replies: 'With us alone, Minna, begins the knowledge of things; the little that we learn of the laws of the visible world enables us to discover the vastness of the world above.'

In *Séraphita* Balzac drew a detailed picture of a little town on a fjord, nestling in a valley between towering rock formations. It is a stark landscape full of crevasses and abysses, and always contrasted with sea or sky – the two vast abstractions that, in certain weather, were indistinguishable. He piles on the snows in order to reduce the granite cliffs with 'the sharpest peaks as well as the deepest valleys forming slight folds merely in the robe cast by nature over that landscape'. The illusion of infinity presented by Nature compelled Balzac to try, in this and other stories, to fathom its variations. The juxtaposition of spaces that can only be formulated imaginatively occurs fairly often in his so-called philosophical works, as for instance in the 1830 story *A Passion in the Desert*.

He was awakened by the sun whose pitiless rays, falling sharply on the granite, produced an intolerable warmth . . . The most dreadful despair fell on his soul. He saw an ocean without limits. The blackish sands of the desert extended beyond grew in every direction, and sparkled like a blade of steel struck by a sharp light. He didn't know if it was a sea of ice or lakes united like a mirror. . . .

The mirror image, with all its dark connotations, occurs quite often in Balzac, and was to become one of the central preoccupations of later generations, particularly the Symbolists working in the circle of Mallarmé. Schoenberg's attraction to the ambiguities of mirrors may well have been rooted in his close attention to Balzac's philosophical fables. His own dependence on 'mirror' effect in twelve-tone composing was certainly more than a mere technical resource for replacing tonal structure.

There are still other aspects of *Séraphita* that incited Schoenberg's imagination. Like his friend of the pre-war period, Kandinsky, Schoenberg was interested in occult studies, and particularly, in cabbalistic play with number. He rejected the practical evaluation of his work as 'construction', and denied that musical space was comparable to mathematical space. But he sought mystical conjunctions in numbers much as the ancient Hebrew scholars drew inferences from numerical analysis in the Cabbala. When he composed *Pierrot Lunaire*, he chose from the fifty poems of the cycle 'thrice seven' not only because it was Opus 21, but because of the numbers' mystical connotations. He was regarded by those who knew him as superstitious, but his character in this respect was probably best understood by Walter Rubsamen, a friend in Los Angeles, who wrote: 'All in all his credence in numerology befits the character of a man who seems in many ways to have been a re-incarnation of the Gothic philosopher speculating about mathematics, astronomy, and music of the spheres, blended with the Flemish contrapuntalist for whom cancrizans, inversion and mirror canons were child's play.'

Schoenberg's attitude towards abstraction of Platonic origin was frequently ambivalent, but he tended to the side of alchemy and fantasy rather than to scientific proof. In *Séraphita* he had read:

The infinitude of number is a fact proved to your satisfaction, but of which no material proof can be given. The mathematician will tell you that infinitudes of numbers exist, that it is not proved . . . Confess, therefore, that you are as ignorant of the beginning and end of created eternity as of the beginning and end of number. . . .

And:

Thus you will never find in all nature two identical objects: in the natural order, therefore, two and two can never make four, for, to attain that result, we must combine units that are exactly alike in the same tree. That axiom of your numeration, false in visible nature, is false likewise in the invisible universe of your abstractions, where the same variety is found in your ideas, which are the objects of the visible world extended by their interrelations; indeed, the differences are more striking there than elsewhere.

Schoenberg's insistence that the virtue of his method resided partly in its rule that nothing be repeated should be taken in this philosophical sense. He was striving to get beyond the immediate data of sensibility and to establish the variety in his abstractions worthy of his prospective vision. The paradox of timelessness evident in his early method, in which there were no beginnings or endings as such, expresses the visionary will. His impetus towards the infinite and absolute was as extravagant as Frenhofer's, whose originator strove incessantly to transcend his moment. It echoes constantly in Schoenberg's essays, as in the 1927 'Criteria for the Evaluation of Music':

Whether or not art of a primitive or higher kind enhances the enchanting effect of music, one conclusion seems inescapable: there is mystery. My personal feeling is that music conveys a prophetic message revealing a higher form of life towards which mankind evolves.

In his essay on Mahler, Schoenberg takes special note of how Mahler explained his notion of Faust to his wife, and remarks:

That is one way to reach the goal! Not just with the understanding, but with the feeling that one already lives there *oneself*. He who looks on the earth thus no longer lives upon it. He has already been drawn upwards.

Such a statement recalls Séraphitus's:

Listen, I have no taste for the fruits of the earth; I have learned to know too well the pleasure you enjoy; and, like the dissolute emperors of profane Rome, I have reached the point where everything is distasteful to me, for I have acquired the gift of second sight.

In this version of Balzac's 'second sight' there is a Kantian tinge, relating it to the obsession with the sublime to which Schoenberg was certainly not immune.

II

Schoenberg's philosophical turn of mind was a matter of temperament. As a native son of Vienna he had had choices. The prevalent view of existence in his youth was mildly cynical, tinged with light irony. Sophistication in the middle classes was defined largely by the degree to which its members were able to take their culture lightly. Even artists were expected to tread tactfully, keeping their arguments confined to the café. So pervasive was this atmosphere that decent young rebels had to assert their idealism in the most scathing terms, and with much more energy than would be required in other parts of Europe. The two figures in Schoenberg's youth who most impressed him, and to whom he professed his indebtedness throughout his life, were both caustic and uncompromising moralists. They were frequently characterized by contemporaries as Old Testament prophets, and both were given to castigating their society in satiric modes. They saw themselves as ethical agents, and sternly demanded total integrity in an artist. Art in the hands of these exasperated moralists could be nothing other than a thorough critique of every aspect of human existence.

Adolf Loos, four years older than Schoenberg, from the beginning of their friendship before 1900 seems to have been a spiritual mentor of tenacious power. His influence reached nearly all the significant artists and thinkers in pre-war Vienna, among them Oskar Kokoschka and Ludwig Wittgenstein. Kokoschka wrote in 1965 that knowing Loos 'was an experience that determined one's fate'. Although Loos was an architect by profession, he gave a lot of his energy to the propagation of his excoriating opinions on the condition of Austrian spiritual life. He attacked the servility of the upper middle classes that turned themselves over to the 'experts'. He attacked the society that accepted any novelty, including the novelties of avant-garde art,

provided that it was superficial and short-lived. He commented on every facet of life, from plumbing to the way people sat in their living rooms, and generally found his home town totally lacking in taste and vision. Many of these thoughts were published before the turn of the century in one of Vienna's most widely read newspapers, and some in *Ver Sacrum*, a vanguard publication of art nouveau tendencies. In 1898, Loos launched an attack on art nouveau itself in an article called 'The Potemkin City', damning equally the historicizing eclectic architects and the new architects who sought to cover a lack of fundamental architectural philosophy with applied new forms. His revolt against the exterior forms of modernism won him many enemies, but a small band of faithful adherents understood the tremendous importance of his ethical austerity. Schoenberg was predisposed to understand an architect who, as Loos did, designed a house from the *inside*, and whose entire life was consecrated to the task of distinguishing the true from the false. In 1930 Schoenberg wrote to Thomas Mann that Loos was 'one of the Very Great'. Later he went to the trouble of sending Mann a copy of Loos's collected essays from 1897 to 1900, published in 1921 with the telling title *Ins Leere gesprochen* (Speaking into the Void), exclaiming: 'What he knew before 1900!' In his own efforts to purge music of ornamentation and the inevitable filler passages in the tonal Western tradition, Schoenberg paralleled Loos's theory of architecture – even more, Loos's uncompromising search for the timeless, the interior laws of aesthetics. When Schoenberg heaped scorn on his acolytes for believing that there was something called *twelve-tone* composing, as opposed to his own notion of twelve-tone *composing*, and when he insisted that they study the old masters rather than his own method, he undoubtedly remembered Loos. 'New forms?' Loos had said. 'How dull! It is the new spirit that matters. Even out of old forms it will fashion what we new men need.' The totality of the idealism that could speak of the new spirit rather than incidental new forms marked Schoenberg's lifelong approach to his art.

In the writings of Karl Kraus Schoenberg found the scathing tone and satirical wit that he often emulated in his own writings. Kraus's review, *Die Fackel*, which he published and largely wrote himself for some thirty years, was a relentless critique of Viennese society and modern life in general which, in Kraus's view, had fallen into a multitude of dangerous vices. Among them was the vice of regarding superficial stylistic change as authentic change. Kraus was particularly sensitive to the abuses in his own profession, journalism, and devoted his most serious articles to analysing the degeneration of language – and with it, truth – in the public press. As a guardian of language, Kraus was considered by many to be a central thinker in twentieth-century research into the function and proper limits of language. His influence on Wittgenstein was unquestionable, and readily conceded by Wittgenstein. Perhaps the clearest statement of Wittgenstein's Krausian view is in an important letter to Paul Engelmann written from the front in 1917 in which he says:

And this is how it is: if only you do not try to utter what is unutterable then *nothing* gets lost. But the unutterable will be – unutterably – *contained* in what has been uttered!

Schoenberg's attitude towards the unutterable reflects that same Krausian integrity. His frequent attempts to explain how the materials must be contained but not explained in his music attest to it. That he grasped Kraus's importance for a critical approach to modern art is attested in an essay published in the *Blue Rider Almanac* (1912), 'The Relationship to the Text':

When Karl Kraus calls language the mother of thought, and Wassily Kandinsky and Oskar Kokoschka paint pictures the objective theme of which is hardly more than an excuse to improvise in colours and forms and to express themselves as only the musician expressed himself until now, these are symptoms of a gradually expanding knowledge of the true nature of art. . . .

Since the thrust of Kraus's undertaking was essentially ethical (all language, even artistic language, was to be tested against truth) there could be little compromise for a Krausian. Schoenberg's response to most situations in his life, both musical and social, was identical with that of Kraus, who used to say: 'If I must choose the lesser of two evils I will choose neither.'

Given the climate of ethical revolt created by Loos and Kraus, it was not surprising that Schoenberg should have made common cause with the painter Wassily Kandinsky who was struggling during the period before the First World War to establish an art that he could verify as pure and transcendent. Kandinsky was also wary of vanguardism, and saw its unsavoury connections with a society that cared very little for authenticity. He had also concluded that the basis of his art must be changed from within, and that the hunger for mere novelty was alien to his goal. When Schoenberg began painting intensively Kandinsky encouraged him, appreciating the expressionist intention and the absence of mannerism in Schoenberg's moody work.

Both Schoenberg and Kandinsky took for granted the notion that the artist creates from inner necessity. The way had been prepared by such art historical theorists as Alois Riegl, who in a well-known book, *Stilfragen* (1893), had argued against materialistic and deterministic theories of art. Riegl posited what he called a 'Kunstwollen', a 'will to form', as a psychical inner necessity (a term going back to Schelling) governing the development of historical periods in art. Wilhelm Worringer extended Riegl's theory and referred directly to the idea of 'inner necessity'. Kandinsky had known Worringer in Munich in 1908 during the period when he was beginning to prepare his thoughts for *Concerning the Spiritual in Art*. The circles Kandinsky and Schoenberg frequented undoubtedly debated the meaning of historical changes in art, and were open to the anti-materialist doctrine of inner necessity.

For Schoenberg, who saw himself both in a logical line of history and outside of history, the notion of inner necessity was sufficiently ambiguous to permit his temperament to contend with the growing problems he faced in his music. As his attitude towards his own work shifted in the early years of the century he came to refer to its inner necessity with more assurance. In 1908 he began the *George-Lieder* which he completed in 1909 and had performed in January 1910. The work was generally considered representative of Schoenberg's new radical style by the few serious followers of his evolution.

He himself recognized it as a turning point in his creative life. In a note for the first performance he wrote:

But now that I am conscious of having broken through every restriction of a bygone aesthetic, and though the goal towards which I am striving appears to me a certain one, I nonetheless already feel the resistance I shall have to overcome. I feel now how hotly even the least of temperaments will rise in revolt, and suspect that even those who have so far believed in me will not want to acknowledge the necessary nature of this development . . . I am being forced in this direction . . . I am obeying an inner compulsion which is stronger than any upbringing.

Here, although Schoenberg seems to refer to a personal inner compulsion, he also suggests that he is prey to the force of history itself. Schoenberg, Kandinsky and many members of their generation keenly sensed conflict between individual development and determined historical force. The problem was not to be resolved by this combative generation but it was able to shape the issues with great care.

Both Kandinsky and Schoenberg had a strong sense of having broken definitively with old patterns, yet both maintained intact certain assumptions inherited from the nineteenth century. They never doubted, for instance, that creation in Nature and creation in the individual artist were analogous. Their attitudes remained within the tradition so eloquently argued by Goethe: that the laws of Nature, or growth, governed the arts no matter how obscure the evidence might be. Schoenberg's faith in the organic view was apparent when, during the days of his greatest intimacy with Kandinsky and his Blue Rider Circle, he wrote 'The Relationship to the Text' for the *Blue Rider Almanac*. In it he said that he composed his songs 'inspired by the first words of the text' from which he 'divined everything that obviously had to follow the first sound with inevitability':

Thence it became clear to me that the work of art is like every other complete organism. It is so homogeneous in its composition that in every little detail it reveals its truest, inmost essence. When one cuts into any part of the human body, the same thing always comes out – blood.

This early conviction based on a long and fruitful tradition was never to be altered. In his Mahler essay, Schoenberg reiterated it:

For the work of art, like every living thing, is conceived as a whole – just like a child, whose arm or leg is not conceived separately. The inspiration is not the theme but the whole work.

In keeping with this attitude is Schoenberg's fondness for the metaphor of a tree – a fondness found also in the writings of Cézanne and Rilke. In his 1938 study of George Gershwin we find:

An artist to me is like an apple tree: when his time comes, whether he wants it or not, he bursts into bloom and starts to produce apples. And as an apple tree neither knows or asks about the value experts of the market will attribute to his product, so a real composer does not ask whether his products will please the experts of serious art. He only feels he has something to say and says it.

And in 'Folkloristic Symphonies' published in *Musical America* in February 1947:

A real composer does not compose merely one or more themes, but a whole piece. In an apple tree's blossoms, even in the bud, the whole future apple is present in all its details – they have only to mature, to grow, to become the apple, the apple tree, and its power of reproducing.

Faith in the organic nature of his undertaking sustained Schoenberg, although, like many others of his generation, he was prey to deeply unsettling doubts. During the years before the First World War, he managed to forge a point of view out of a mélange of cultural acquisitions and his own temperamental predispositions. His goal was to insert himself into what he conceived of as a higher history of his art. But he was never spared the ultimate dilemma posed by the modern aesthetic. The dilemma, as Frenhofer exemplified, was as clearly graven on the prospects Schoenberg surveyed from within the centre of his art as it was in Frenhofer's exalted imagination.

On the one hand there was the imperative imposed by genius. Schoenberg's view of genius was no different from Balzac's. Genius, he thought, 'already possesses all its future faculties from the very beginning . . . It is an eternal metamorphosis, an uninterrupted growth of new shoots from a single kernel.' Such genius incurs an obligation to pursue an individual vision, and to encompass profound feeling.

On the other hand, there was the instrumental power of theory, the work of the logical mind – the structuring imagination which knew its own limits. Schoenberg argued with himself, seeking an equilibrium between the demands of strong emotion and its tendency to visionary abstraction, and the calm order ordained by workable theory. His defensive statements throughout his life indicate how, even after he had established his 'method', he remained doubtful whether the dilemma could ever be resolved.

He recognized, as he said a number of times, that in the light of future history his work, and the work of his antagonists (namely Stravinsky), would appear much more homogeneous. He counted on the distance of time to justify his work. The deepest meaning of his work both in its formative stages and after his establishment of his method would coincide with what might be called, in Riegl's way, the form will of the epoch – or at least with the major thrust of the epoch, which was to envisage other spaces. The essential accomplishment of such experiments as Cubism and even Expressionism was the foundation of other ways of perceiving space and its occupants. Schoenberg's preoccupation with musical space, so often parallel with the other arts of his time, drew him far into regions totally unfamiliar to other musicians, but never to a resolution.

Already in the expressionist phase of his earliest works – works that relate to Wagner and Mahler – Schoenberg had envisaged alternative spaces. His 1900–1 *Gurrelieder* were based on poems by J. P. Jacobsen whose poetical spaces were far from conventional. We know from Rilke that Jacobsen's audacities had startled his young admirers at the turn of the century. Rilke spoke of the strong effect of Jacobsen's poetry on his own life's work. He had first read him in Munich in 1896–97 and, in thinking about him later, compared him to Rodin: 'Both have made things, things with many sure boundaries, and countless intersections and profiles . . .'

These countless intersections and profiles were equivalent in Schoenberg's work to the digesting of chromaticism in its last phases, and its reconciliation with the Brahmsian order to which Schoenberg was then still devoted. In them, also, lay the snares of excess, to which Frenhofer had succumbed, and of which Schoenberg was ever wary. In the years following *Gurrelieder*, Schoenberg shared in a general movement towards 'countless intersections', not only within the separate arts themselves, but among all the arts. Wagner's notion of the *Gesamtkunstwerk* had survived, and most of all in Vienna. The Vienna important to Schoenberg (we know from his devotion to Loos) was the Vienna that made a common field of the arts and humanities, and in which an artist of merit would set himself the task of knowing himself at home in more than one art. Schoenberg's readiness to take up painting, for instance, was certainly encouraged by the general atmosphere of enlightened dilettant-ism in Vienna. At the same time, there was, even in Schoenberg and his young associates at the time, a counter-tendency which derived from their intimacy with the pitched battles of the Wagnerites and Brahmsians. Argu-ments pitting 'pure music' (by which was generally meant Bach) against 'programme music', meaning Wagner, still seethed during Schoenberg's youth. The foremost proponent of 'pure' music, Edward Hanslick, had been holding forth for nearly half a century by the time Schoenberg was exposed to his theories. Hanslick's view was that music could not be a language of feelings except in the vaguest of terms. It did not derive from any sentiment or idea outside of itself, but rather from within music itself – within the terms of its own logic. The 'musical idea' was the sole source for the composer and the theme was the only subject in a piece of music. Hanslick's ideas on the purity of musical logic were widely defended even among the young rebels with whom Schoenberg associated, and he himself was soon to direct his efforts towards purifying his own music.

Both Kandinsky and Schoenberg, who were working respectively in 1910–11 on *Concerning the Spiritual in Art* and *Harmonielehre*, were reflecting on the notion of purity and logical reduction. Both were inclining towards the development of an orderly aesthetic in which the antinomies of their youth could be resolved. Kandinsky lends force to his own argument by quoting Schoenberg:

Every combination of notes, every advance is possible, but I am beginning to feel that there are definite rules and conditions which incline me to the use of this or that disonnance.

To which Kandinsky adds:

Schoenberg is endeavouring to make complete use of his freedom and has already discovered mines of new beauty in his search for spiritual structure.

Around this time, just before the First World War, much discourse both in painting and music was veering towards the notion that new structures must be defined, and that the 'laws' implicit in works of art must be enunciated in order to contain the new freedoms. In painting, the notion of 'simultaneity', founded in Balzac's day by the chemist Chevreul, explored knowledgeably by the painter Seurat, and given a new twist by Apollinaire and Delaunay,

was mentioned with increasing frequency. As Delaunay wrote to Kandinsky after reading his book, 'The search for pure painting is currently a problem for us . . . I hope to find still great flexibility in the laws I have discovered . . .' For Rilke, Rodin's fragments, complete unto themselves, and his works with their myriad intersections, represented the same law that Kandinsky had broached.

III

What Kandinsky had called Schoenberg's 'search for a spiritual structure' had already borne fruit by 1908 – a fruit that was to ripen eventually into a whole organism that Schoenberg called his 'method'. Roughly between 1908 and 1912 Schoenberg worked intensively to clarify to himself the nature of his genius. He sought, as Kandinsky said, a 'spiritual' structure in which he could contain his powerful emotions. During this period Schoenberg's works became increasingly intense and abbreviated, as did the work of other composers availing themselves of bitonality. They were making discoveries that corresponded closely to the painters' and poets' vision of simultaneity. The broad search for new forms led to what have been called micro-forms, and to a situation that commentators have sometimes likened to the scientific revolution. Unquestionably the finite reductions in the physical sciences were a source both of wonder and despair to the artists. Kandinsky in his autobiography lays great emphasis on his discovery of the disintegration of the atom which, he said, led him to doubt the materialistic interpretation of the world and turn to a spiritual view. In an instant, he said, the mighty arches of science lay shattered once the framework that had sustained scientific thought for centuries was proven faulty. Uncertainty as a principle had entered discourse and had revived again the paradox Balzac had stated when he said that numbers were as abstract in imagination as in the realm of science. The desire to reduce experience to its unique components, symbolically speaking, led many artists to speculate in the Platonic mode and to arrive, as did Kandinsky, at the statement that all form winds up in number. When Delaunay spoke of the movements of colour, he was keenly aware of the micro-forms – the light waves – which could be reduced to number, just as musical sound could.

The problem for many artists was how to return from this newly revealed realm of the infinite, even the infinitely small. Schoenberg confronted the problem for many years before he designed his method. In the early phases, he often said, he had to destroy while creating. When he departed from tonality, which, he pointed out, was used by composers 'like somnambulists', he regarded his defection as a healthy movement towards the restoration of genuine musical values. The great impulse to strip, reduce, condense, derived from a thorough disaffection with the tedious redundancies in conventional music. Schoenberg found the repetitious phrasing and banally predictable rhyming forms in the Viennese music of his youth an offence to his sensibility and intelligence. Since the world no longer appeared governed by the cause and effect symmetries that had so long been taken for granted, it seemed

appropriate to release art from the tyranny of symmetrical law and pointless repetition. There were many composers interested at that time in what was loosely called musical prose, just as poets such as Apollinaire were engaged in experiments with 'conversation poems' and free verse. In music, the urge was to release every element from its obligation to the symmetrical whole, or, paradoxically, to see only a whole simultaneously with its components through extreme brevity and concision. In Schoenberg's case, the results were the intense, dramatically brief works of his expressionist period from around 1908 to 1912. These reflected the general impulse of the period in all the arts. The musicologist H. H. Stuckenschmidt characterizes Schoenberg's work after 1908, when he had 'liquidated' tonality, as:

Dissociation, i.e. juxtaposition of unconnected sections; breaking up of syntax; arbitrary linking of ideas; alogicality of the harmony . . . asymmetry in the forms and their components; atonality, i.e. lack of a pull towards a tonal centre; ametricality, i.e. lack of a regular beat . . .

Kandinsky's compositions after 1910 could equally well be characterized by this statement. What it locates is precisely the Balzacian vision of the imaginative spaces in which there is neither up nor down, beginnings nor endings. Once Kandinsky abjured vanishing-point perspective, and once Schoenberg abandoned tonality, there were infinite possibilities, which they tried to encompass by reducing their materials as much as possible to their singular characteristics. To achieve the intensity they felt had been stifled by outworn conventions, both artists charged their compositions with disparate forms that teemed in various levels in space. The pianist Charles Rosen in his monograph on Schoenberg speaks of the 'saturation of musical space' in the expressionist works just before the twelve-tone method was firmly established:

The massed chromatic movement at different speeds, both up and down and accelerating, is a saturation of the musical space in a few short seconds; and in a movement that gets ever faster, every note in the range of the orchestra is played in a kind of *glissando*. The saturation of musical space is Schoenberg's substitute for the tonic chord of the traditional musical language.

Kandinsky's compositions of 1910–13 also tended to move at rapid speed in a centrifugal way which suggested that the forms at the extremities of the two-dimensional plane were of equal significance to those of the base. Moreover, he established enclaves of spaces at the four corners of the canvas that could be read as discrete elements moving inexorably beyond the bounds of the canvas. Schoenberg's compositions of the same period work towards the principle of equidistance from a centre. Later, Schoenberg would develop this as an ideal to be respected within the serial method. The new spaces these men described were to be both a *reductio* of all possible spaces and an extrapolation from the principle of infinity.

This reductionism that so strongly impelled the artists of Schoenberg's generation was in the service of an ideal that had hovered for almost a century in the art for art's sake movement. It had appeared in all the arts. What Rosen says about music, and specifically about Schoenberg's musical language, could be transposed. It could stand for Cézanne's life's work of

reduction and recomposition of spaces, and for many subsequent paintings in the twentieth century. What was true for composers was equally true for artists in other media. For instance, Rosen says that between Mozart and Schoenberg what had disappeared was the possibility of using large blocks of prefabricated materials in music:

It seemed as if music now had to be written note by note; only chains of chromatic or whole-tone scales were possible, and these only sparingly. The renunciation of the symmetrical use of blocks of elements in working out musical proportions placed the weight on the smallest units, single intervals, short motifs.

Schoenberg's spatializing diction, even in his mature years, always harks back to the new conception of musical space of the first decade. If he 'placed the weight on the smallest units' in his work of 1908–12, he was inventing a mode similar to what Picasso and Braque had proposed in painting. The impulse springs from a similar shift in the conception of how we perceive space. Maurice Raynal spoke of the new concepts in 1912 when he discussed Cubism, saying 'we never see an object in all its dimensions at once . . . At the moment when I conceive of a book, I perceive it in no particular dimension but in all dimensions at once. . . .' When Schoenberg speaks of the absolute and unitary perception of musical space, he also alludes to the new psychology of spatial perception, pointing out that to the imaginative and creative faculty, relations in the material sphere are independent from directions and planes, 'Just as our mind always recognizes, for instance, a knife, a bottle, or a watch, regardless of its position, and can reproduce it in the imagination in every possible position, even so a musical creator's mind can operate subconsciously with a row of tones, regardless of the way in which a mirror might show the mutual relations. . . .'

Both Schoenberg and Kandinsky were sensitive to the existence of occult relationships within their compositions that, to earlier sensibilities, might never have been apparent. The effort to move away from an obvious or single centre was in keeping with the principles they enunciated between 1910 and 1912. Schoenberg was aware of the affinities between the two arts he was practising at the time, musical composition and painting, as is apparent in the essay for the *Blue Rider Almanac* in which he bows to Kandinsky's theories and points out that 'the outward correspondence between music and text, as exhibited in declamation, tempo and dynamics, has but little to do with the inward correspondence, and belongs to the same stage of primitive imitation of nature as the copying of a model. . . .' Later, the 'inward correspondence' was to be subsumed by Schoenberg's mature notion that music is basically the musical thinker's representation of musical ideas. But before 1914, Schoenberg's views were very much in keeping with the views of the painters, especially Kandinsky. In the period before the First World War, there were numerous centres in Kandinsky's compositions, and these disparate centres entered the vocabulary of painters permanently. Miró later composed paintings in which the activity is dynamically spread in numerous directions, without ground lines or horizons, and still later, Mark Tobey and Jackson Pollock worked in a direction that came to be called 'all-over' painting. The profound importance of this new view of both pictorial and musical spaces

for Schoenberg can be understood when we find Schoenberg, many decades later in 1941, reiterating his conception in 'Composition with Twelve Tones':

The two-or-more dimensional space in which musical ideas are presented is a unit. Though the elements of these ideas appear separate and independent to the eye and the ear, they reveal their true meaning only through their cooperation, even as no single word alone can express a thought without relation to other words. All that happens at any point of this musical space has more than a local effect. It functions not only on its own plane, but also in all other directions and planes and is not without influence even at the remote points.

Schoenberg's need to spatialize in a new mode was pressing during the spring and summer of 1912 when he composed *Pierrot Lunaire*. In its three-times-seven scheme, there is an incredible range of experiment, including prototypical elements of set theory. But the compelling effects in *Pierrot Lunaire*, effects that still move audiences with their mystery, occur in the distinctly original feeling for space exhibited in his invention of *Sprechgesang*, an uncanny fusion of speaking, singing and incantation. In a single stroke Schoenberg found the means of using the idiosyncrasies of the speaking voice as a musical material that would establish the emotional tenor of his expression. His instructions to the singer were that the rhythm and duration of her performance must be like a conventional sung line but that the intervals and pitch would be – as they are in the natural speaking voice – completely relative. The result is the incomparably moving sense of shifting spaces, infinite gradations in spaces, scarcely graspable transitions that he had begun to envisage as his new structure. Even here, his search for 'one unifying idea' is evident, despite the extraordinary variety of musical invention in the scoring and setting. The one unifying idea became, in this piece, the use of *Sprechgesang* as a positively incantatory musical experience, equally indepen-dent of the words of the nineteenth-century romantic poem and the intense scoring for piano and single instruments one by one.

Schoenberg's new spatialization was to depend on what he called the 'emancipation of the dissonance', which has visual associations. Charles Rosen defines a dissonance as 'any musical sound that must be resolved, i.e. followed by a consonance'. A consonance is 'a musical sound that needs no resolution, that can act as the final note, that rounds off a cadence'. If then Schoenberg emancipates the dissonance, he assigns to it a position in the vertical and horizontal composition different from that of past practice in the visual schema. In principle, however, it is the same, since via substitutions and revisions of what dissonance is supposed to be, Schoenberg finds a new structure. The 'remote points' of which he speaks are no longer visualized in the linear framework of the score but in 'planes' moving in many directions. If dissonance becomes the primary interest of the composer, then there must be an effort to achieve 'resolution' in other terms. And here the problem became exacerbated for Schoenberg and resulted in the long silence from 1912–23 (a silence that both Rilke and Valéry would have understood profoundly). The challenge for Schoenberg (and for his students Alban Berg and Anton Webern) was always in the balancing of the desire for infinity with some mode of restraining its excesses. Schoenberg's passion for the

psychological spaces he descried in *Séraphita* would bring him dangerously close to the necessarily 'unresolved' condition of the mystic. This he combated by means of reduction and renunciation, even in the emancipation of the dissonance.

After the years of relative silence he emerged with his twelve-tone method in which he hoped he had resolved the implicit conflicts of his first radical gesture of emancipation. But he never really felt he had. His struggle towards purity, transparency and above all comprehensibility was fraught with the problems innate in the paradox of 'emancipation of the dissonance'. More-over, the ideal of *Innerlichkeit* from his romantic youth never faded, and provided Schoenberg with interior challenges of an ethical character that all but paralysed him at times. It was to be, it had to be, through sacrifice and renunciation that he could purify himself and therefore his work. The austerity he cultivated was a reflection of a great need to curb rich passions. He con-sidered the preference of the primitive ear for bright colours as childish. 'More mature minds resist the temptation to become intoxicated by colours and prefer to be coldly convinced by the transparency of clear-cut ideas.'

The struggle to live by this principle was arduous. It could perhaps be said of Schoenberg, as Valéry said of Rilke after his death: 'You seemed to me locked up in pure time, and I feared for you the transparency of the too monotonous life which through the line of eternally similar days gives a clear view of death.' Like Rilke, he had deliberately denied himself the youthful surrender to extravagant emotion and *Einfühlung* to achieve what seemed a more 'objective' approach. But neither Rilke nor Schoenberg sought thing-like objectivity. The emotional value of *Innerlichkeit* was too important. Both men saw its achievement only in sacrifice and condensation. Schoenberg's feeling, expressed during the same period that Rilke was wrestling the angels for the Duino Elegies, is revealed in his instructions to Hermann Scherchen for a performance in 1914:

But the main thing is the *Adagio*: you must take it almost allegro!! Of course it mustn't be treacly slow, but must have an inward emotion . . . This begins quietly and con-templatively, and its intensification must *not* be *passionate*, but 'inwardness intensified.' It's a remarkable thing: passion's something everyone can do! But inwardness, the chaste, higher form of emotion, seems out of most people's reach.

As a true son of the nineteenth-century romantic view of art, Schoenberg saw his way as one of sacrifice and purification. Deprivation was to lead him spiritually back to purity and wholeness. The real problem for him and his friends was to find their way back to a wholeness comparable to that they had felt in the music of the past. Schoenberg's profound study of masters in the past led him to attempt to dismantle music as he would a watch, with great care, in order to clean and reclaim the old parts. The sense of tragedy, if not pathos, inhering in this intense effort is well described by Adorno when he speaks of Berg:

The intense inner beauty of Berg's late works is indebted for its success no less to the hermetic surface structure of his works than to the basic impossibility which they embody: the hopelessness of the undertaking which is indicated in the surface of the work; and to the morbidly mournful sacrifice of the future to the past.

Adorno also calls attention to the dilemma Schoenberg grappled with all his life and which remains, to this day, an open, living debate for modern composers: what happens to the perception of music when the composer substitutes the tone-row for traditional structures of organization? The order Schoenberg invented to circumvent the 'somnambulist's' dependence on old fixed forms could never hold completely true to its theoretic claims:

Schoenberg has pointed out that the traditional theory of composition has essentially treated only beginnings and closings, but never once the logic of continuation. Twelve-tone melody exhibits similar shortcomings. Each of its continuations reveals a moment of arbitrariness . . . As mere derivation, continuation disavows the inescapable claim of twelve-tone music that it is equidistant in all its moments from a central point.

Schoenberg, however, was not given to futile speculations about how short he fell of his theoretical ideal. His dilemma lay elsewhere. It was the inherited problem of the nineteenth-century romantic who knew a deep desire for unity and order, but who also knew that order, strained through honesty of emotion, is often disrupted. Schoenberg's drive for 'comprehensibility' was derived from the same need that drove Rilke to seek 'objectivity' and Cézanne to leave behind his violent fantasies for a form of emotional order. Yet, as Rilke said of Balzac, he sensed that 'in painting, something so tremendous can suddenly present itself which no one can handle'. The move towards imposed order lifted Cézanne out of the familiar and presented him with the modern sense of anxiety by which Picasso recognized him. In Schoenberg's lifelong meditation, anxiety was a constant. He sensed what Rimbaud sensed when he declared 'I is Another' and knew that without the Other, the I is dangerously isolated. The modern artist, alienated (in the root sense of the word, coming from 'allos' – other), seeks a wholeness, a 'comprehensible order' that is perhaps available only to the mystic. Schoenberg harboured deep hopes that in addressing himself in all purity to some higher order, he would succeed in overcoming the contradictions in his aesthetic. This fervent hope was precisely what Adorno, in casting Schoenberg in his social context, deemed an impossible idea. In his chapter on the 'Antinomy of Modern Music' he states:

Polyphonic music says 'we' even when it lives as a conception only in the mind of the composer, otherwise reaching no living being. The ideal collectivity still contained within music, even though it has lost its relationship to the empirical collectivity, leads inevitably to conflict because of its unavoidable social isolation. Collective perception is the basis of musical objectification itself, and when this latter is no longer possible, it is necessarily degraded almost to a fiction – to the arrogance of the aesthetic subject, which says 'we' while it is still only 'I' – and this 'I' can say nothing at all without positing the 'we'.

Schoenberg was not unaware of the contradiction Adorno discusses. But his background had prepared him for a different confrontation than Adorno might have suggested. The Viennese milieu in which he formulated his aesthetic sponsored in him a mighty will to enter the realm that encompassed both the I and the We; he found his only hope in the aspiration to God that he had felt so keenly in Mahler who, he thought, had been 'drawn upwards'. Like Wittgenstein, he believed that there were 'higher things' which might

never find expression in human utterance, but through the work 'the un-utterable will be – unutterably – *contained* in what has been uttered'.

Schoenberg's preoccupation with the unutterable emerged early in his life as a composer, and accounts for his frequent recourse to texts. From the early period he had sought to find a way to fuse his feeling for the text with his sense of the probity of musical form. What was to be uttered had to be purged of all extrinsic values, but at the same time had to be the ground on which all motives could honestly subsist. It had to be, as he sometimes said, an 'other' way of expressing the inexpressible. The great stress the Krausians had laid on the integrity of language was a source of constant anxiety for Schoenberg who examined from many angles the role of spoken language in relation to what he sometimes called 'absolute' music. He was right to be irritated with those who saw him only as a constructor, a mind remorselessly imposing rigid order. His whole life's endeavour had been oriented to the recovery of purity, whether in language, emotions or thought. He was misunderstood in exactly the way Wittgenstein was misunderstood. Wittgenstein had to tell his readers:

My propositions serve as elucidations in the following way: anyone who understands me eventually recognizes them as nonsensical, when he has used them – as steps – to climb up beyond them. (He must, so to speak, throw away the ladder after he has climbed up it.)

This ladder, which preoccupied both men – a Jacob's ladder, an Old Testament image that resides in the Western psyche without any truly explicable source – Schoenberg was quite up to kicking away. In fact, he drove himself heroically to relinquish all supports if they stood in the way of higher things. In his later years, he freely departed from his own support – the twelve-tone method – when his emotional needs required it. Schoenberg's respect for passion was at the heart of his entire endeavour.

The great task he set himself was to respect the boundaries of his method while yet transcending them, an heroic programme that he was not able to fulfil. The most ambitious of all his attempts was the unfinished opera *Moses and Aaron*, on which he worked from 1930 to 1932. Here, he proudly tested the limits of his system by setting out to base a whole, incredibly complex opera on a single set, or row. To succeed was to acknowledge the superior power of law and its necessity in the order of human existence. But the 'musical idea', the row, was not the only challenge for Schoenberg. In *Moses and Aaron*, for which he wrote his own libretto, he pursued his medita-tion on language and its possibilities for transformation within musical composition. He had dreamed of a language that was neither formal and regulated by the laws of grammar in a sophisticated way, nor primitive and restricted to only elementary expression. The dream was announced in his early choral works and worked upon during the years he was fashioning his method. What he seemed to hear echoing from the abyss was a language that was on the threshold of song. In *Pierrot Lunaire* he used the human voice as an unearthly counterpart to the clear colours his instruments produced. His ambition lay in the direction of the kind of grand abstraction he had described

in his *Almanac* essay, envisaged as parallel to the abstractions of the vanguard painters he knew. Looking back in 1932, while he was at work on *Moses and Aaron*, he speaks of the earlier use of texts:

My music, however, took representational words into account in the same way as abstract ones: it furthered the immediate, vivid rendering of the whole and of its parts, according to the measure of their meaning within the whole. . . .

In the same essay he elucidates on the invention of *Sprechgesang*:

During fairly expressive speaking, the voice moves between changing pitches. But at no time does one remain on any one particular pitch, as in singing. Now, in the endeavour to gain a sung melody from the natural intonation of the words in spoken melody, it is obvious that one will have to evade the principal notes in singing, as much as one will avoid the fixed pitches in speaking. . . .

By moving in the interstices between the spoken and the sung, Schoenberg seeks to infuse the whole of his vocal composition with the emotional value he sensed in a concept of the universe such as he found in *Séraphita*.

As with many artists of Schoenberg's generation, there was an effort to discern the pure outlines of aboriginal experience. Originality, as such, was no longer confused with novelty. The artists of the new century literally researched their origins; they checked every stylistic innovation against the truth to its origins. Such origins they tended to find, often simplistically, in societies that seemed more simple – primitive in fact. Schoenberg, however, was never seriously engaged by the simple, the primitive, the folkloristic. His quest for origins led him primarily to the source of Western religion: to the Old Testament. It is a measure of his profound seriousness about going back to his own origins that his two major Old Testament works, *Jacob's Ladder* (1917) and *Moses and Aaron*, remained unfinished.

Schoenberg's religious experiences had included a conversion to Protestantism in 1921, and a reconversion to Judaism in 1933. Various motives have been suggested for this second gesture, including the possibility that it was a move of defiance and solidarity rather than a true conversion. But all Schoenberg's subsequent actions seem to suggest that his embracing of Judaism had a profoundly religious, or perhaps philosophical, basis. In fact, he wrote to Berg in 1933 that his 'return to the Jewish religion took place long ago and is indeed demonstrated in some of my published work', citing among others *Moses and Aaron* which, he tells Berg, was begun around 1923. Certainly the choice of Moses and his brother Aaron as protagonists of an unfinished drama indicates a serious philosophic intent. In exploring the gulf that separates Moses, the man of God (whom he envisages as Michelangelo's 'not human at all'), from both Aaron and the people, Schoenberg was taking all his moral courage in hand for a tragic *agon*. He was performing the ethical act which he conceived to be the artist's primary task. He questions not only the position of the artist but also the nature of the artist's task. Although commentators have taken varied positions on just how much the characters in the opera reflect Schoenberg's view of himself, there is really little reason to doubt. He himself wrote to Berg while he was working on the opera: 'Everything I have written has a certain inner likeness to myself.'

The inner likeness to Schoenberg of all four symbolic figures in the opera is not difficult to discern. God, whom Schoenberg sometimes referred to as 'the great commander', is the ultimate source, although God remains un-imaginable except through oblique symbol. Moses is the flawed genius who, as Schoenberg makes him say, can think but not speak: the man of ideas who, like Schoenberg himself, knew the value of laws. Though a stammerer and remote from all others, Moses had an idea which finally would be appre-hended through the intervention of Aaron, the performing artist. The in-sights Moses could think but not speak were essential to the survival of the race, the Volk, and Schoenberg implies that the whole drama is played out because of the existence of the Volk, although no one, and above all not the composer, can ever be sure to enlighten them.

Harking back to his great admiration for Karl Kraus, Schoenberg attempts an overwhelming catharsis in this opera. The spoken word, as given in the *Sprechstimme* voice of Moses, is subjected to the most arduous test. In Moses's solos, the rhythms are portentous, and when he is joined by the *Sprechchor* there is an extraordinary effect of incantation. Schoenberg suggests a return to an origin in which language was in direct service to true feeling. Aaron, on the other hand, referred to by Schoenberg as a coloratura tenor, embellishes through song the inner meaning of Moses's prophecy, and, finally, obscures it. Yet – Schoenberg seems to assert – without the song the words never reach comprehensibility. Similarly, without the law humanity founders. But also, without rich feeling and an intuitive sense of God, it founders. The dilemma that accompanied Schoenberg throughout his life is epitomized in *Moses and Aaron*.

The towering ambition in this opera covers every aspect of Schoenberg's inner life, and the questions he poses, both musically and philosophically, were the questions that arose from his initial insight that there can be no separation between art and ethic. There must be meaning, and there must be a message to humanity. Style is nothing in the light of history, and new music must convey a new message (here he echoes Loos) 'because: Art means New Art'. He saw inner necessity as the primary source of creation:

Though there is no doubt that every creator creates only to free himself from the high pressure of the urge to create, and though he thus creates in the first place for his own pleasure, every artist who delivers his works to the general public aims, at least un-consciously, to tell his audiences something of value to them.

Schoenberg's and Wittgenstein's stress on value and their conscientious examination of the valuable stand on one side of the rebellion known as art for art's sake. Neither of the two Viennese moralists would have conceded the more extravagant claims of the French proponents of art for art's sake, yet both undertook the Nietzschean revaluation of values which brought them to the catharsis first advocated in the nineteenth century. The decision to deal with the unutterable vaulted them both into agonies of irresolution. And to silence where silence was the most ethical position. Schoenberg left *Jacob's Ladder* and *Moses and Aaron* unfinished, and Wittgenstein wrote of his *Tractatus*:

The book's point is an ethical one. I once meant to include in the preface a sentence which is not in fact there now but which I will write out for you here, because it will perhaps be a key to the work for you. What I meant to write, then, was this: My work consists of two parts: the one presented here plus all that I have *not* written. And it is precisely this second part that is the important one. . . .

There are many honourable contradictions in Schoenberg's attitudes, contradictions that represent not only his personal quest but that of his epoch. For instance, in devising his method – a system which enabled him to elude the chaos of total artistic freedom – he had to assume that in the mind there was the possibility of *knowing* the order (the twelve-tone row) regardless of whether it could be 'heard'. In all his instructions to his listeners, he always stressed that the whole composition could somehow be apprehended by a cognitive faculty that would recognize and hold in suspension the greater structure – the abstraction on which he based his aesthetic. On the other hand, he assumed that for all the complicated order the twelve-tone method permitted, the musical values (emotional values) would dominate. Everything that is written must also be audible, he insisted, always discouraging the zealots who endlessly analysed his system. As he wrote to Rudolph Kolisch, warning him against cold analyses, 'After all they only lead to what I have always been dead against: seeing how it is *done* whereas I have always helped people to see: what it *is*!'

In stripping his means to a minimum (nothing gave him more delight in his youth than reducing his initial impulse to a group of three notes from which he could expand prodigiously) Schoenberg felt a certain righteous pleasure, a monkish virtue in renunciation. Before he had firmly established his method he went through experimental steps that all led to reduction. His search for a radical law was not unlike Rilke's when he spoke of 'discovering the smallest basic element, the cell of his art, the tangible medium of presentation for everything irrespective of subject matter'.

In fact, Schoenberg's search for the 'law' at one point seemed directly to echo Rilke's. When Schoenberg composed *Four Orchestral Songs, Opus 22* between 1913 and 1916, he chose for one of the songs Rilke's poem 'Alle, welche dich suchen', a poem directly concerned with the higher laws, the laws Moses was eventually to represent in the opera. (One of the other songs, significantly, was 'Séraphita'.) This poem of Rilke's, as Robert Falck has suggested, foreshadows the arguments Schoenberg developed in his libretto for *Moses and Aaron*. It begins:

> All who seek you, test you
> And those who find you,
> bind you to an image and an appearance . . .

But the poet says he wants only to comprehend God as the earth comprehends Him. He says:

> Perform no miracles for my sake
> Follow your own laws
> Which are more apparent from generation to generation.

This God of Rilke's, as Falck speculates, is much like the 'unvorstellbarer

Gott' in Schoenberg's libretto. 'Can these lines have been in Schoenberg's ear when he was composing *Moses and Aaron*? The dramatic and intellectual conflict between the "unvorstellbarer Gott" of Moses and the "Bilder" (image) demanded by Aaron and the people of Israel is precisely what Rilke's poem is about.' Probably this need not have been posed as a question. Schoenberg's preoccupation with the Moses image, or non-image, and with the Word, clearly was nurtured for a very long time. Like Rilke, he sought to find the means of transmitting an imagery that transcended the notion of 'an image and an appearance'. He tried to keep 'subject-matter' from over-whelming both his musical idea, and his religious sentiment.

Yet, for both artists, subject-matter was to remain of great concern, and led them again and again to the brink of Balzac's *abyssus abyssum*. Schoenberg told himself repeatedly that what he was after was comprehensibility; that eventually his work would be recognized just as the works of the old masters had finally been understood. His hope that he could achieve his goal with the 'transparency of clear-cut ideas' was always threatened by his innate need to push beyond the frontiers of such clear-cut ideas. He bore out Kant's claim that the metaphysical is implanted in human beings by nature itself. Even the rigour of Schoenberg's system could not spare him the risks that the natural desire to pass beyond experience entails. The specific risk, undertaken by so many significant modern artists, lay in the possibility that their artistic problems would remain unresolved, that the inchoate condition of openness against which they strived to build form would prevail.

When Thomas Mann characterized Schoenberg's endeavour in *Dr Faustus*, the risks that Adrian Leverkühn undertook as a composer brought him to madness, just as Frenhofer ended in madness and death. Although Adrian Leverkühn failed as a portrait of Schoenberg (at least in the opinion of Schoenberg himself and many of his admirers), Mann's characterization of him as an alchemist driven beyond the bounds of nature is perhaps not as far from the mark as Schoenberg thought. In the novel, Adrian says: 'Reason and magic may meet and become one in that which one calls wisdom, initiation; in belief in the stars, in numbers. . . .' And when Leverkühn de-scribes the twelve-tone method to his friend, sketching the basic idea and its forty-eight possible permutations, and his friend comments, 'Squaring the circle', Leverkühn does not correct him. The lure of alchemy as an artistic working principle was strong for both Schoenberg and his fictional derivative. Even as Schoenberg protested Mann's portrayal, he confirmed its premises. In 1948, writing about his disappointments as a teacher, Schoenberg mentions trying in vain to teach his pupils some discoveries in the field of multiple counterpoint. 'This experience taught me a lesson: secret science is not what an alchemist would have refused to teach you; it is a science which cannot be taught at all. It is inborn or it is not there.' He continues: 'This is also the reason why Thomas Mann's Adrian Leverkühn does not know the essentials of composing with twelve tones. All he knows has been told him by Mr Adorno who knows only the little I was able to tell my pupils. The real fact will probably remain secret science until there is one who inherits it by virtue of an unsolicited gift.'

Schoenberg himself was uncertain of the final results of his great and risky undertaking. His critics have often been ambivalent as well. Adorno, whose judgments are not always coherent and persuasive, but who studied Schoenberg closely and admired him, wrote:

One of the most outstanding characteristics of Schoenberg's later style is that it no longer permits conclusions. Furthermore, since the dissolution of tonality, cadential formulae no longer exist in harmonic context. Now they are eliminated on the level of rhythm as well. With increasing frequency the closing of a work falls upon the weak beat of the measure. It becomes no more than a breaking-off.

Others point to the inherent consistency in Schoenberg's more important works, and suggest that while his masterpiece may be 'unknown' to contemporaries, it will fall into place in future periods, and will be seen as a logical extension of tonality (as he himself hoped). Yet it was not only the 'logic' that Schoenberg hoped to prove irrefutable. In looking back to describe his so-called Expressionist period, Schoenberg stressed that:

A piece of music does not create its formal appearance out of the logic of its *own* material, but, guided by the feeling for internal and external processes, and in *bringing these to expression*, it supports itself on their logic and builds upon that. No new procedure in the history of music! – at each renewal or increase of musical materials, it is assisted by feelings, insights, occurrences, impressions and the like, mainly in the form of poetry . . .

Even though he discusses here earlier works, the ambition to keep alive the poetic cell remained even when he had devised the method which permitted more extensive development. The task he set himself in, for instance, *Moses and Aaron* was to sustain on a grand scale the verity of the lyrical utterance. For his shorter songs, he said,

One must provide each tiniest element – as in an aphorism, or in lyric poetry – with such a wealth of relationships to all other component elements, that the smallest reciprocal change of position will bring forth as many new shapes as might elsewhere be found in the richest development sections. The various shapes will then be as in a hall of mirrors – continually visible from all sides, and displaying their mutual connection in every possible way.

The hall of mirrors remained alluring to Schoenberg to the end of his life, and in some ways the twelve-tone method was merely a means to remain on the high road leading to further conundrums for which he thirsted. It became a matter of faith that there was no possibility for art outside of some container – a frame, a law. Rilke said in his letters to a young poet, 'Don't be bewildered by surfaces; in the depths all becomes law.' Yet both Schoenberg and Rilke had intrepidly sought the exceptions to all rules. Schoenberg eventually found the extreme anarchism of early modern music intolerable, but he never renounced the ambition to supersede past law, even his own past law. As Anthony Payne describes it:

For in lighting upon a method whereby a single ordered pattern of twelve different notes would supply the material for a complete work, Schoenberg had gravitated from mere compositional techniques to a law, something which he could view as, in a sense, existing outside himself, and which his world of feeling could live by.

The world of feeling remained a world that transcended immediate experience for many of the most courageous explorers in twentieth-century art. For Malevich, whose visionary writings are filled with references to an ideal of 'pure feeling', the desert was the ultimate image. He purged his paintings of all intermediate imagery in order to reach what seemed to him a transcendent vision of pure spaces, uncluttered with the trivial details that obscure our vision. Schoenberg, who saw his works as 'moral facts', similarly expunged gracious detail in order to fulfil a vision which may well have had its initial realization when he found Balzac, whose audacity fired imagination. The philosophical puzzles Balzac discovered led him to paradoxes that to Schoenberg were all too familiar. Schoenberg's path to 'higher things' was strewn with similar paradoxes. It could easily be said of him, as Baudelaire said of Balzac, that he made strange excursions through philosophy. And Baudelaire's comments on Balzac can stand for any modern artist of the visionary temperament:

Everyone knows *Séraphita*, *Louis Lambert* and a multitude of passages in other books in which Balzac, a great mind devoured by a legitimate encyclopedic pride, has attempted to harmonize in a unified and definitive system different ideas drawn from Swedenborg, Mesmer, Marat, Goethe and Geoffroy Saint-Hilaire . . . It is certain that when specifically literary minds put themselves to it, they make strange excursions through philosophy. They cut abrupt openings and see sudden vistas on paths which are entirely theirs.

Select bibliography

Chapter One

Badt, Kurt, *The Art of Cézanne* (tr. Sheila Ann Ogilvie). London, 1965.

Balzac, Honoré de, *Le chef-d'œuvre inconnu*. Oeuvres Complètes, Paris, 1956–63, 28 vols.

——, *Le cousin Pons*. Oeuvres Complètes, *op. cit.*

——, *The Fatal Skin*, tr. Cedar Paul. London, 1949.

——, 'Lettre à M. Schlesinger, rédacteur de la Gazette Musicale, Mai, 1837', *Correspondance*, ed. R. Pierrot. Paris, 1960–69, tome 3.

——, *Lettres à Mme. Hanska: 1832–1848*. Paris, 1967–71, 4 vols.

——, *Lost Illusions*, tr. Kathleen Raine. London, 1951.

——, *Louis Lambert*. Oeuvres Complètes, *op. cit.*

——, *La Peau de chagrin*. Oeuvres Complètes, *op. cit.*

——, *Séraphita*. The Novels of Honoré de Balzac, tr. G. Burnham Ives. Philadelphia, 1899.

Baudelaire, Charles, 'Théophile Gautier', *L'Artiste*, 13 March 1859.

Bellori, Giovanni Pietro, *Vite de pittori, scultori et architetti moderni*. Rome, 1672.

Bernard, Emile, 'Souvenirs sur Paul Cézanne et lettres inédites', *Mercure de France*, 1 and 15 Oct. 1907.

Boime, Albert, *The Academy and French Painting in the Nineteenth Century*. London, 1971.

Bonard, Olivier, *La Peinture dans la création Balzacienne*. Geneva, 1969.

Cassagne, Albert, *La Théorie de l'art pour l'art en France*. Paris, 1959.

Chesneau, Ernest, *Louis Boulanger*. Paris, 1880.

Delacroix, Eugène, 'Delacroix, letter on competitions', *L'Artiste*, vol. I, 1 March 1831, 49–51.

Félibien, André, *Entretiens sur les vies et sur les ouvrages de plus excellens peintres anciens et modernes*. London, 1705, 4 vols.

Fizelière, Albert de la, 'Boulanger', *L'Art*, Paris, 1875, tome I.

Gautier, Théophile, *L'Art moderne*. Paris, 1856.

——, *Emaux et Camées*, ed. A. Boschot. Paris, 1954.

——, *Famous French Authors*. New York, 1879.

——, *Honoré de Balzac, sa vie et ses œuvres*. Bruxelles, 1858–Paris, 1859.

——, *Les Jeunes-France*, ed. R. Jasinski. Paris, 1974.

——, *Mademoiselle de Maupin*. Paris, 1966.

Hoffmann, E. T. A., *Selected Writings of E. T. A. Hoffmann* (tr. Leonard J. Kent and Elizabeth C. Knight). Chicago, 1969, 2 vols.

Hugo, Victor, *Choses vues.* Oeuvres Complètes, Paris, 1880–89, 48 vols.

——, *Préface de Cromwell.* Paris, 1827.

James, Henry, *Balzac.* Philadelphia, 1905.

Laubriet, Pierre, *L'Intelligence de l'art chez Balzac.* Paris, 1961.

Maurois, André, *Prométhée.* Paris, 1965.

Picon, Gaetan, *Balzac.* Paris, 1956.

Les portraits de Balzac connus et inconnus. Maison de Balzac, Paris, Fevrier–Avril, 1971.

Pritchett, V. S., *Balzac.* London/New York, 1973.

Quincy, Quatremère de, *Collection des lettres de Nicolas Poussin.* Paris, 1824.

Tennant, P. E., *Théophile Gautier.* London, 1975.

Valéry, Paul, *Selected Writings of Paul Valéry.* New York, 1950.

Chapter Two

Arnheim, Rudolf, *Toward a Psychology of Art.* Berkeley, Calif., 1966.

Ashton, Dore, ed., *Picasso on Art.* New York, 1972.

Bachelard, Gaston, *La Poétique de l'espace.* Paris, 1957.

Baudelaire, Charles, *Art in Paris*, ed. Jonathan Mayne. New York, 1965.

——, *L'Art romantique*, ed. Jacques Crépet. Paris, 1925.

——, *Les Fleurs du mal*, ed. Crépet et Blin. Paris, 1950.

——, 'Salon of 1846', *Art in Paris*, op. cit.

Bernard, Emile, 'Paul Cézanne', *L'Occident.* July, 1904.

——, *Souvenirs sur Paul Cézanne.* Paris, 1925.

Catalogue pour la vente de Madame Veuve de Balzac, 22 Avril 1872, Hotel Drouot, Paris.

Cézanne, Paul, *Cézanne: Letters*, ed. John Rewald. London, 1941.

Chappuis, Adrien, *The Drawings of Paul Cézanne.* London/Greenwich, Conn., 1973, 2 vols.

Collins, Peter, *Changing Ideals in Modern Architecture.* Montreal, 1967.

Delacroix, Eugène, *The Journal of Eugène Delacroix*, tr. Walter Pach. New York, 1972.

Denis, Maurice, 'Cézanne', *L'Occident*, September, 1907.

Fry, Roger, *Cézanne.* New York, 1927.

Gasquet, Joachim, *Paul Cézanne.* Paris, 1921.

Geffroy, Gustave, 'Paul Cézanne', *Le Journal*, 25 May 1894.

Larquier, Léo, 'Balzac, amateur de curiosités et critique d'art,' *Le Courier d'Epidaure*, 7–8, July–August 1949.

Lindsay, Jack, *Cézanne, His Life and Art*, London, 1969.

Mack, Gerstle, *Paul Cézanne.* New York, 1935.

Merleau-Ponty, Maurice, *Sense and Non-Sense* (tr. Dreyfus). Evanston, 1961.

Perruchot, Henri, *Cézanne.* New York, 1963.

Rewald, John, *Paul Cézanne.* New York, 1948.

Rubin, William, ed., *Cézanne, The Late Work.* New York, 1977.

Schapiro, Meyer, *Paul Cézanne.* New York, 1952.

Stokes, Adrian, *Cézanne*. London, n.d.
Venturi, Lionello, *Cézanne, son art, son œuvre*. Paris, 1936.
Vollard, Ambroise, *Paul Cézanne*. New York, 1926.

Chapter Three

Ashton, Dore, ed., *Picasso on Art, op. cit.*
Bernard, Emile, 'Souvenirs sur Paul Cézanne', *op. cit.*
Binion, Rudolph, *Frau Lou, Nietzsche's Wayward Disciple*. Princeton, 1968.
Graff, W. L., *Rilke*. Princeton, 1956.
Kandinsky, Wassily, *Concerning the Spiritual in Art*. New York, 1947.
——, *Text Artista*, 'Wassily Kandinsky Memorial', Solomon R. Guggenheim
 Foundation, New York, 1945.
Lieven, Peter, *The Birth of the Ballets-Russes* (tr. L. Zarina). New York, 1973.
Rilke, Rainer Maria, *Duino Elegies and the Sonnets to Orpheus* (tr. A. Poulin,
 Jr). Boston, 1977.
——, *Duino Elegies* (tr. J. B. Leishman and Stephen Spender). New York,
 1939.
——, Letters of Rainer Maria Rilke (tr. Jane Bannard Greene and M. D.
 Herter Norton). New York, 1969. 2 vols: 1892–1910 and 1910–26.
——, *Letters to a Young Poet* (tr. M. D. Herter Norton). New York, 1934.
——, *New Poems* (tr. J. B. Leishman). New York, 1964.
——, *The Notebooks of Malte Laurids Brigge* (tr. M. D. Herter Norton). New
 York, 1949.
——, *Rodin*. New York, 1945.
——, *Sonnets to Orpheus* (tr. M. D. Herter Norton). New York, 1942.
——, *The Tale of the Love and Death of Cornet Christopher Rilke* (tr. M. D.
 Herter Norton). New York, 1934.
Salis, J. R. von, *Rainer Maria Rilke: The Years in Switzerland* (tr. N. K.
 Cruickshank). Berkeley, Calif., 1966.
Schelling, Friederich Wilhelm, 'Concerning the Relation of the Plastic Arts
 to Nature' (tr. Michael Bullock), *The True Voice of Feeling* (H. Read).
 New York, 1953.
——, *Schelling: Of Human Freedom* (tr. James Gutmann), Chicago, 1936.

Chapter Four

Aeschylus, *The Oresteia* (tr. Robert Fagles). New York, 1975.
Apollinaire, Guillaume, *Alcools*. Oeuvres poétiques, Paris, 1959.
——, *Apollinaire on Art*, ed. LeRoy C. Breunig. New York, 1972.
Ashton, Dore, ed., *Picasso on Art, op. cit.*
Balzac, Honoré de, *Le chef-d'œuvre inconnu*, ill. by Pablo Picasso. Paris, 1931.
Brassai, Gyula Halász, *Picasso and Company*. London/New York, 1966.
Breton, André, *Surrealism and Painting* (tr. Simon Watson Taylor). New
 York, 1972.
Cela, Camilo José, 'El viejo picador', *Papeles de Son Armadans*, 17, no. 49,
 April 1960.
Cendrars, Blaise, *Selected Writings*, ed. Walter Albert. New York, 1966.
Cohen, Arthur, *Sonia Delaunay*. New York, 1975.

Daix, Pierre and Boudaille, Georges, *Picasso: The Blue and Rose Periods*. Neuchatel, 1966.

Darío, Rubén, *España Contemporanea*. Madrid, 1901.

Díaz-Plaja, Guillermo, *Modernismo Frenta a noventa y ocho*. Madrid, 1966.

Eluard, Paul, *À Pablo Picasso*. Geneva, 1944.

Fowlie, Wallace, ed., *Mid-Century French Poets*. New York, 1955.

Hartley, Anthony, ed. and tr., *The Penguin Book of French Verse*. Harmondsworth/Baltimore, 1959.

Jacob, Max, *Max Jacob*. Poètes d'aujourd'hui No. 3, Paris, 1947.

——, *Max Jacob: Morceaux choisies*. Paris, 1937.

Jímenez, Juan Ramon, *El Trabajo gustoso*. Mexico, 1961.

Labib, Jacques, *Viva Zavatta, souvenirs recueillis*. Paris, 1976.

Laforgue, Jules, *Selected Writings of Jules Laforgue* (tr. and ed. William Jay Smith). New York, 1956.

Leymarie, Jean, *Picasso, the Artist of the Century*. New York, 1972.

O'Brian, Patrick, *Picasso, a Biography*. New York, 1976.

Parmelin, Hélène, *The Artist and His Model*. New York, 1965.

Paz, Octavio, *Children of the Mire*. Cambridge, Mass., 1974.

——, *Cuadrivio*. Mexico, 1965.

Ráfals, José F., *El arte modernista en Barcelona*. Barcelona, 1943.

Raymond Marcel, *From Baudelaire to Surrealism*. New York, 1949.

Regoyos, Darío de and Verhaeren, Emile, *España Negra*. Madrid, 1899.

Reverdy, Pierre, 'Le cubisme, poésie plastique', *Nord-Sud*, 1, 1917.

——, *Le Gant de crin*. Paris, 1927.

Sabartès, Jaime, *Picasso: portraits et souvenirs*. Paris, 1946.

Salmon, André, *Souvenirs sans fin*. Paris, 1955, 3 vols.

Schiff, Gert, ed., *Picasso in Perspective*. Englewood Cliffs, New Jersey, 1976.

Vriesen, Gustav and Imdahl, Max, *Robert Delaunay: Light and Color*. New York, 1969.

Worringer, Wilhelm, *Abstraction and Empathy* (tr. Michael Bullock). New York, 1953.

Zervos, Christian, ed., *Pablo Picasso: Œuvres*. Paris, 1932.

Chapter Five

Adorno, Theodor W., *Philosophy of Modern Music* (tr. Anne G. Mitchell and Wesley V. Blomster). New York, 1973.

Boretz, Benjamin and Cone, Edward T. ed., *Perspectives on Schoenberg and Stravinsky*. New York, 1972.

Falck, Robert, 'Schoenberg's (and Rilke's) alle welche dich suchen', *Perspectives of New Music*, Fall–Winter 1973, Spring–Summer 1974.

Janik, Allan and Toulmin, Stephen, *Wittgenstein's Vienna*. New York, 1973.

Kandinsky, Wassily and Marc, Franz, ed., *The Blaue Reiter Almanac*. London/New York, 1974.

Kandinsky, Wassily, *Concerning the Spiritual in Art*, op. cit.

Leibowitz, René, *Schoenberg and His School* (tr. Dika Newlin). New York, 1970.

Mann, Thomas, *Doctor Faustus* (tr. H. T. Lowe-Porter). London/New York, 1948.

Munz, Ludwig and Kunstler, Gaston, *Adolf Loos, Pioneer of Modern Architecture*. London/New York, 1966.

Novalis, 'Hymns to the Night'. *Transition Workshop*, New York, 1949.

Payne, Anthony, *Schoenberg*. London, 1968.

Reich, Willi, *Schoenberg* (tr. Leo Black). London, 1971.

Rilke, Rainer Maria, *Les Roses*. Foreword by Paul Valéry. Bussum, 1927.

Rosen, Charles, *Arnold Schoenberg*. New York, 1975.

Rubsamen, Walter H., 'Schoenberg in America'. *The Musical Quarterly*, October 1951.

Rufer, Josef, *The Works of Arnold Schoenberg*. London, 1962.

Schoenberg, Arnold, *Arnold Schoenberg Letters*, ed. Erwin Stein. London, 1964.

——, *Style and Idea* (tr. Dika Newlin). New York, 1950.

Stuckenschmidt, H. H., *Arnold Schoenberg*. New York, 1959.

Whittall, Arnold, *Schoenberg Chamber Music*. London, 1972.

Wittgenstein, Ludwig, *Letters from Ludwig Wittgenstein*, ed. Paul Engelmann. New York, 1968.

Yates, Peter, *Twentieth Century Music*. New York, 1967.

Zweig, Stefan, *Balzac* (tr. William and Dorothy Rose). New York, 1946.

Index

Figures in italics refer to the illustration numbers